ADOLPH MENZEL
1815-1905

MASTER DRAWINGS FROM EAST BERLIN

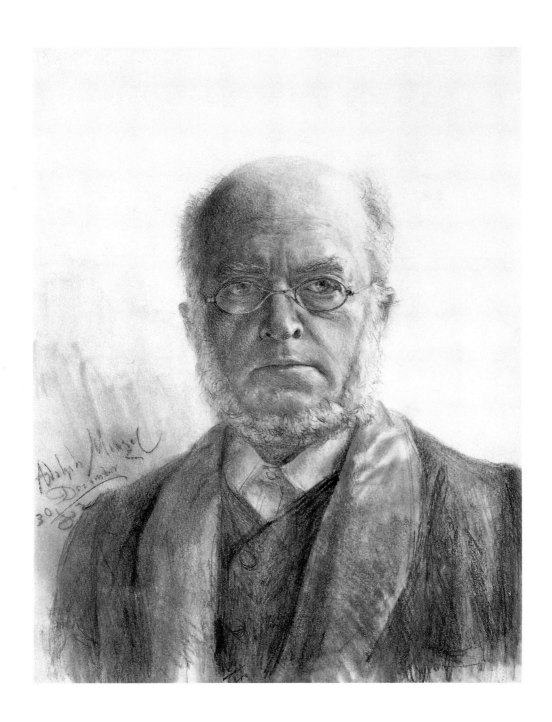

ADOLPH 1815-1905 MENZEL

MASTER DRAWINGS FROM EAST BERLIN

PETER BETTHAUSEN

CLAUDE KEISCH

GISOLD LAMMEL

MARIE URSULA RIEMANN

Art Services International
Alexandria, Virginia
1990

11 September–18 November 1990	The Frick Collection New York, New York
1 December 1990–27 January 1991	Museum of Fine Arts Houston, Texas
16 February–7 April 1991	Frick Art Museum Pittsburgh, Pennsylvania
27 April–23 June 1991	Busch-Reisinger Museum Harvard University Art Museum Cambridge, Massachusetts

The exhibition is organized and circulated by
Art Services International, Alexandria, Virginia.

It is supported in part by a grant from the National Endowment for the Arts, a Federal Agency, and by an indemnity from the Federal Council on the Arts and the Humanities.
Additional support for the catalogue has been provided by The Andrew W. Mellon Foundation.

Copyright 1990 by Art Services International, Alexandria, Virginia
All rights reserved
ISBN 0-88397-096-1

Library of Congress Cataloging-in-Publication Data

Menzel, Adolph, 1815–1905.
 Adolph Menzel, 1815–1905 : master drawings from East
Berlin / Peter Betthausen . . . [et al.].
 p. cm.
 Catalog of the exhibition held Sept. 11 to Nov. 18, 1990 at the
Frick Collection, New York, N.Y., Dec. 1, 1990 to Jan. 27, 1991
at the Museum of Fine Arts, Houston, Tex., Feb. 16 to March
31, 1991 at the Frick Art Museum, Pittsburg, Pa., and April 27
to June 23, 1991 at the Harvard University Art Museum, Cam-
bridge, Mass.
 Includes bibliographical references (p.).
 ISBN 0-88397-096-1
 1. Menzel, Adolph, 1815–1905—Exhibi-
tions. 2. Nationalgalerie (Germany : East) I. Betthausen,
Peter. II. Nationalgalerie (Germany : East) III. Title.
NC251.M45A4 1990
741.943—dc20

Translator: Tawney Becker
Editor: Nancy Eickel
Designer: CASTRO/ARTS, Baltimore
Photographer: H. Peter Treuholz
Typesetter: Monotype Composition Co., Baltimore
Printer: South China Printing Co.

Cover illustration: no. 6
Frontispiece: no. 71

Printed in Hong Kong

Contents

Acknowledgments

In today's politically turbulent world, the remarkable changes that are occurring in East Germany promise great hope for peace and prosperity. Just as we are witnessing the advent of a new era in German history, so too did Adolph Menzel. He experienced both the reconstruction of monarchy, with the coronation of King William I, and the rise to power of Otto von Bismarck. During the ninety years of his long life, Menzel studied Germany's future by documenting its past in a cycle of history paintings on the life of Frederick the Great. Yet contemporary Germany and its industrial revolution did not escape his scrutiny. Beyond these enormous canvases is a substantial body of superb drawings, gouaches, and watercolors—ranging from studies of antique armor to portraits of family members and sketches of everyday objects—that until now have been virtually unfamiliar to the American public. Examining Menzel's drawings through this exhibition not only offers a special opportunity to broaden our knowledge of the artist, but it is also an appropriate way to recognize Germany at its crossroads.

It has been our great honor and pleasure to work closely with Dr. Peter Betthausen, Director of the Nationalgalerie in East Berlin and Guest Director for this exhibition. He has proven an invaluable partner in organizing this show, and his dedication has ensured its success. We are also pleased to acknowledge the key support provided by Dr. Gunter Schade, General Director of State Museums in East Berlin.

Our gratitude extends as well to the scholars who contributed to the catalogue: Dr. Claude Keisch, Dr. Gisold Lammel, and Marie Ursula Riemann. They have graciously shared with us and with the American museum community their extensive research on the extraordinary collection of Menzel drawings at the Nationalgalerie. Their expertise and cooperation are greatly appreciated.

After more than eight years of negotiations, this exhibition is a reality, and the assistance we have received from the Embassy of the German Democratic Republic has proven vital. We are priviledged that Ambassador Gerhard Herder has agreed to serve as Honorary Patron of the exhibition. Norbert Kobuch, Peter Janz, Heinz-Peter Woida, and Wolfram Bauer at

the Embassy have also been instrumental at various stages of the project.

The exhibition has been supported in part by a grant from the National Endowment for the Arts, a federal agency, and our thanks go to John E. Frohnmayer, Chairman, and to David Bancroft for their contributions to this exhibition. We are similarly indebted to the Federal Council on the Arts and the Humanities, and specifically to Alice Whelihan, for supporting this tour with a federal indemnity and for making possible another important ASI exhibition. Once again we recognize The Andrew W. Mellon Foundation and its Executive Vice-President, Neil L. Rudenstine, for the continued generous funding of our catalogue program.

From the outset, the directors and coordinating curators of the museums on the national tour have been extremely enthusiastic about the work of Menzel. Our sincere appreciation is extended to Dr. Charles A. Ryskamp and Edgar Munhall at The Frick Collection, New York City; Dr. Peter C. Marzio and Dr. George T.M. Shackelford at the Museum of Fine Arts, Houston; De Courcy E. McIntosh and Alan Fausel at the Frick Art Museum, Pittsburgh; and Dr. Edgar Peters Bowron and Peter Nisbet at the Busch-Reisinger Museum, Harvard University, Cambridge.

As always, our editor, Nancy Eickel, has adeptly prepared this catalogue for publication. We cannot fail to mention the sensitivity and careful attention to detail displayed by Tawney Becker in her translation of the German texts. Catalogue designer Alex Castro accomplished his work with great skill, and his expertise was a true asset to the project. Peter Lawrence of South China Printing Co. Ltd. saw to the high quality of the book's printing. It has been a privilege to work with such professionals in producing this significant catalogue.

With great pleasure we offer our personal thanks to Mrs. John A. Pope, Trustee of Art Services International and a consultant on this endeavor. Her continued support and assistance contributed immeasurably to the realization of this exhibition. Dr. Hinrich Sieveking has been helpful as well.

Finally, we express our gratitude to the staff of Art Services International— Marcene Edmiston, Elizabeth Hooper, Sally Thomas, and Lucy Blank-stein—for overseeing the myriad details of this undertaking.

Lynn Kahler Berg Joseph W. Saunders
Director Chief Executive Officer

Foreword

The beginnings of this exhibition date back to the early 1980s, but as the German saying goes, "Good work takes time." Preparations for the exhibition entered a decisive phase after the success of *The Romantic Spirit: German Drawings, 1750–1850*, a joint exhibition of works from the Nationalgalerie and the Kupferstich-Kabinett, Dresden, which was shown at The Pierpont Morgan Library in New York in 1988. Menzel, who was represented by nine sheets, received undivided attention. Many visitors discovered his work for the first time. News of this inspired us, and we confidently look forward to the reception of this Menzel exhibition by the American public.

The Nationalgalerie, Staatliche Museen, Berlin, possesses the richest holdings of drawings by Adolph Menzel in the world. From this wealth, all aspects of Menzel's mastery of drawing can be presented. Such a splendidly endowed collection also poses difficult decisions in the selection process. These seventy-eight sheets fully represent what may be considered the quintessence of Menzel's oeuvre of drawings.

The exhibition will travel to four American cities over a period of almost one year. We stand firmly behind our decision to send these drawings on such a long journey, especially now that our country, the German Democratic Republic, has broken with its past and embarked on a new path in its economic development. We hope that this exhibition will be received as a greeting to one of the oldest democracies in the world.

We offer our thanks to Art Services International, especially to Mrs. Lynn Kahler Berg, Mr. Joseph W. Saunders and Mrs. John A. Pope, to our colleagues Marie Ursula Riemann and Claude Keisch, and to Tawney Becker for her excellent translation of the catalogue texts as well as to Nancy Eickel, who saw to the editing of the catalogue.

Gunter Schade Peter Betthausen
Director-General, Director, Nationalgalerie
Staatliche Museen, Berlin

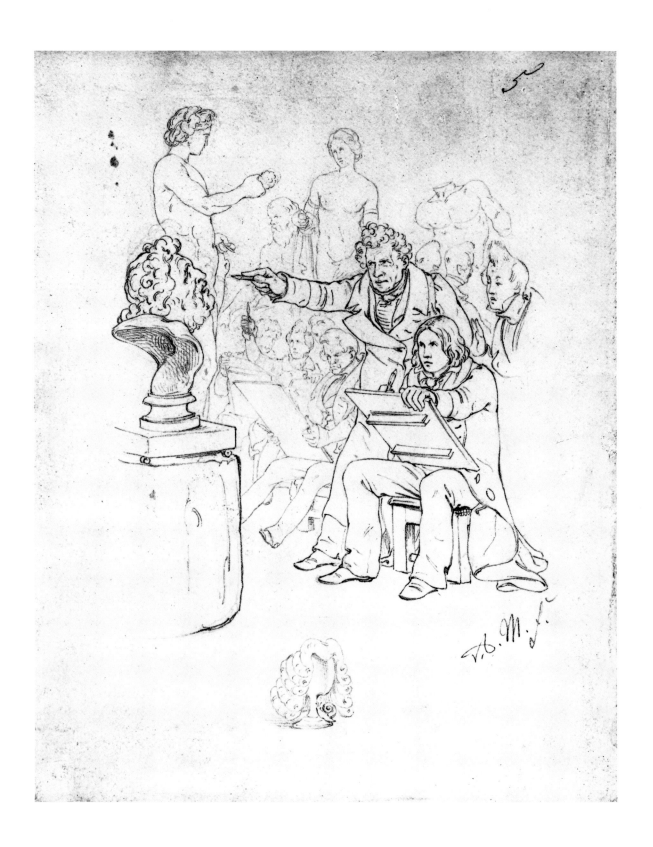

Menzel's Life and Work

GISOLD LAMMEL

Menzel, who spent nearly seventy-five years of his life in Berlin, was born in Breslau in 1815, the same year as Otto von Bismark. His father, Carl Erdmann Menzel, was the principal of a girls' school until 1818, when he bought a lithographic press, with which he barely managed to support his family. Adolph, who finished school in 1829, assisted in the workshop. In the spring of 1830, the family moved to Berlin, where the elder Menzel hoped for better economic opportunities. At first they lived at Wilhelmstraße 39 and once again established a modest lithographer's workshop in one room.

When his father died on 5 January 1832, scarcely at the age of forty-five, the sixteen-year-old Adolph Menzel continued to operate the workshop and thus secured a livelihood for his two younger siblings and his mother. Menzel primarily produced commercial pieces, such as invitations, place cards, menus, letterheads, and greeting cards (fig. 1). Stubbornly, he struggled to obtain an education in art at the same time. In 1833, he attended classes in drawing from plaster casts at the Academy of Arts, but he broke off his studies after only a few months because he could not agree with the Academy's teaching methods, and working to support the family left him little time to study.

Thus, Menzel was essentially self-taught. He wrote the Munich art essayist Friedrich Pecht in 1878, "Later, this, my so-called wild youth, was still considered, of course, [to have been a] great fortune for me. I do not share this view, for I know best what it cost me." [1] Menzel schooled himself not only in depicting reality, but also devoted equal attention to older and contemporary art. Because he strove to render the truth and not to glorify

Fig. 1 Preparatory drawing for sheet 3, "School," from Goethe's *Künstlers Erdenwallen*
From series of 12 lithographs published by L. Sachse & Cie., Berlin, in 1833
Graphite
19.6 x 15.4 cm
Kat. 18, Sammlung der Zeichnungen, Nationalgalerie

11

reality or outer beauty in his images (which earned him, like so many other realists of his time, the reputation of being a painter and draftsman of the ugly), he sought a certain orientation in bourgeois and realistic works. Artists from past centuries that he especially revered were Albrecht Dürer, Rembrandt, and Daniel Chodowiecki. Menzel felt a particularly close affinity with the latter, a distinguished, late eighteenth-century Berlin illustrator and genre artist. He wrote in a letter about Chodowiecki, "I am not alive, except [when I am] his pupil." [2] In 1859, he painted a recognizable, life-size portrait of Chodowiecki and presented it to the inn where the Berlin Artists Society met. [3]

During his early years in Berlin, Menzel (fig. 2) concerned himself with the extremely popular prints of his contemporaries, Frank Burchard Dörbeck, Adolf Schroedter, and Theodor Hosemann, which significantly affected some of his commercial work and illustrations. He actively followed the work of the Düsseldorf artists as well. Their accomplishments were held in high regard at the time, but in the end they included too many idealizing and romanticizing tendencies for his taste. Foreign painters of the nineteenth century who especially aroused his interest were the Englishman John Constable, the Frenchmen Ernest Meissonier, Charles-François Daubigny, Theodore Rousseau, Gustave Courbet, and Edouard Manet, and the Belgian artist Louis Gallait.

Above all else, Menzel was a draftsman. His immense, gracefully drawn oeuvre attests to his unequaled passion for work and his hungry eye. His motto was "To *draw* everything is good, to draw *everything* [is] better still" ("Alles *Zeichen* ist gut, *alles* Zeichnen noch besser"). [4] And in fact, whether at a court ball or at a burial, on the street or in a moving train, he exploited every opportunity that presented itself and recorded on paper whatever caught his eye. Menzel was always equipped with all the necessities for drawing. His friend, the painter Paul Meyerheim, described his accouterments in the following manner. "In his overcoat he had eight pockets, which were partially filled with sketchbooks, and he could not comprehend that there are artists who make the smallest outings without having a sketchbook in their pocket. On the lower left side of his coat, an especially large pocket was installed, just large enough to hold a leather case, which held a pad, a couple of shading stumps and a gum eraser." [5] Menzel drew for practice and to create a reserve of sketches for paintings or gouaches already in progress, planned, or possible. Another motive for him was to capture a situation or an architectural structure for posterity. As an illustrator, Menzel was unsurpassed in Germany during his lifetime. His four hundred wood engravings for Franz Kugler's *Geschichte Frederich des Große* (Leipzig, 1840) are among the best book illustrations produced in the German-speaking regions in the nineteenth century.

His sharpness of intellect, his powers of observation, his strength in rendering form, and his technical perfection also enabled Menzel to achieve a level of success as a painter that assured him a place in the more recent art history of Germany. In their liberal view of a modern ruler, his paintings

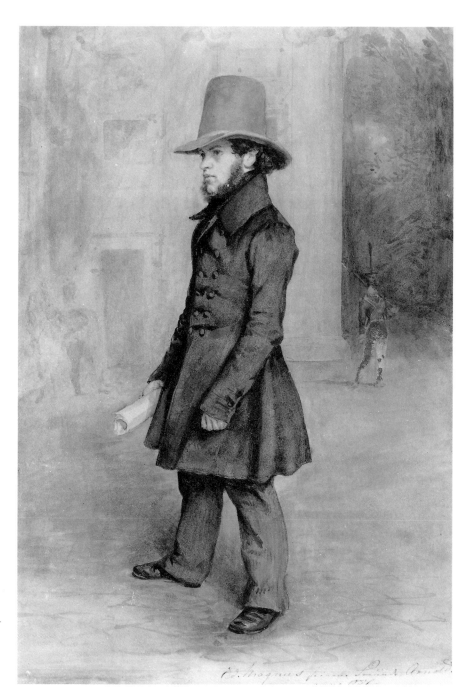

Fig. 2 Eduard Magnus
 Portrait of Adolph Menzel at
 age 22, 1837
 Drawn for their mutual
 friend Carl Heinrich Ar-
 nold, who had moved from
 Berlin to Kassel in 1835
 Watercolor
 40.7 x 27.7 cm
 Nr. 14, Sammlung der Zeich-
 nungen, Nationalgalerie

of the 1840s and 1850s on the life and work of Frederick II of Prussia belong among the most prominent achievements of realistic history painting. The unfinished *Honoring of the Insurgents Killed in March 1848* (Hamburger Kunsthalle) became an important artistic document of the bourgeois revolution of 1848–49. With *The Iron Rolling Mill* (1875), Menzel created one of the most significant representations of the processes of industrial production in German art history of the nineteenth century. Not to be overlooked

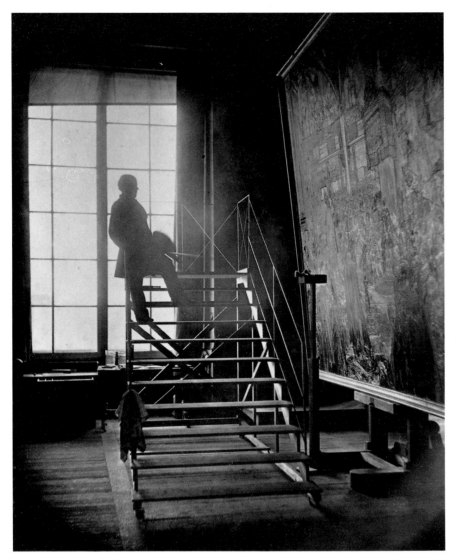

Fig. 3 Menzel on scaffolding while
 working on *The Coronation
 of William I in Königsberg
 on 18 October 1861* in the
 Garde-du-Corps Hall of
 the Royal Palace in Berlin,
 ca. 1864
 Photograph made after the
 original in Menzel's album
 documenting the creation
 of the "coronation picture"
 Kat. 843a, Sammlung der
 Zeichnungen, Nationalgal-
 erie

is his painterly early work, which includes pre-impressionistic works of European quality, such as *The Balcony Room* (1845).

During the course of his long life, Menzel worked for a wide range of patrons and customers. Before the revolution of 1848, they were almost exclusively from bourgeois circles, being primarily publishers, art dealers, owners of lithographic workshops, businessmen, and members of art associations. In the period between the revolution and the founding of the empire, he received his most lucrative offers from the royal court. After 1871, however, the number of his commissioned pictures dropped off sharply, but Menzel no longer found that kind of work to be necessary. Bankers, above all, bought many works from his late period.

The most extensive painting Menzel created for the court was the "coronation picture" (1861–65, Nationalgalerie; fig. 3), in which he depicted the coronation of William I on 18 October 1861 in Königsberg. Menzel

assessed the event from a liberal, bourgeois perspective. He utilized his freedom as an artist to allude to the cherished hopes of many for the unification of a divided Germany. His sympathies toward the liberal cabinet ministers of the so-called New Era cannot be disregarded, and yet at the same time, an uneasiness with the Hohenzollern demonstration of power and their absolutist tendencies also becomes clear. This painting is unusual in that it includes no fewer than 132 portraits, for which Menzel carefully prepared individual studies, and it lacks the polished homogeneity typical of such ceremonial representations.

Menzel, however, was never a court painter in the conventional sense. He wanted to remain independent and to maintain control of his work. After 1871, when the leading artists of the country were expected to glorify the Prussian-German war of unification, he refused to do so and left the task to others. Nevertheless, Menzel enjoyed high esteem in the eyes of the Prussian monarch. Frederick William IV, who had ruled since 1840, valued Menzel predominantly as an illustrator. The lack of idealization in Menzel's paintings displeased the king, and he was not fond of the series on the life of Frederick II, which smacked of the pre-revolution period and suggested a comparison between him and the just and enlightened "Volkskönig." His successor, William I, who was king of Prussia from 1861 until he became the German emperor in 1871, highly respected Menzel as a painter. Beyond loving realistic detail in art, William I held a different view of Frederick II than had his predecessor, Frederick William IV. He promoted devotion to Frederick II because as emporer, he continued to benefit from that leader's military plans and his goal to unite Germany under Prussian leadership.

In this manner, Menzel's series on Frederick found renewed acceptance. William I, like William II (the German emperor from 1888 to 1918), attempted to collect these paintings as well as Menzel's art in general. William II especially showered the artist with honors. With an unmistakably critical undertone, the Dutch painter Jan Veth commented on Menzel's increasing fame during the rule of William II. "The capital of Prussia, which has now become the Imperial Residence, has felt the need to proclaim an emperor also of painting; the Hohenzollerns, proud of their heritage, wanted to honor the visual historian of the great Fritz and his heroic deeds in an ostentatious manner, and regarding the peculiar man of great age, interest in his distinguished personality is ever increasing." [6]

Menzel led a highly independent life. Although he had become wealthy in the 1860s and could afford many luxuries, his living quarters and his studio were rather modestly furnished. The writer Julius Hasselblatt called his workshop at Sigismundstraße 3, where Menzel worked from 1875 until the end of his life, "perhaps Berlin's ugliest artist's studio." [7] And he observed: "How austere, bare, and sober is this studio in comparison with the ostentatious workrooms of so many other artists, which resemble as much a museum, an antiquarian bookshop, or an arts and crafts store." [8]

His personal appearance was also conspicuous. He was slim and only 140 centimeters (4 feet, 6 inches) tall. Overall, his figure seemed dispro-

portionate. On a dwarf-like body sat an overly large head. In his youth he was called "Mushroom" and often "Poisonous Mushroom," when in anger he tried to defend himself against mockery. His hair grayed very early. He wore a "Freesenbart," a style of beard trimmed along his jaw line, which glistened with red but which over time became as white as snow (fig. 4). Already as a young man, his grayish-blue eyes required glasses. He spoke with a Silesian accent and usually in a soft voice. To emphasize his speech, he was given to accompanying his carefully chosen words with passionate gestures. He was accustomed to going to bed very late and to sleeping for relatively long hours. In his old age, he would get up around ten o'clock in the summer and not until eleven o'clock or twelve noon in the winter. After his morning toilet, he would make his way to the studio, where he would work until nine in the evening. During the day, he usually ate only one cold, light meal. Towards nightfall, he allowed himself to have a hot meal (which he quite often omitted) at Frederich's Weinstube on Potsdamerstraße, and as a rule, he complemented it with a half pint of white wine. After dinner at Frederich's, he often went to Josty, an old confectioner's shop on Potsdamer Platz, where he would drink two cups of black coffee and two small glasses of cognac while he leafed through illustrated magazines with great pleasure. He enjoyed alcoholic drinks until the end of his life, but he showed no interest in smoking, card games, or sports. He had no romantic involvements.

Passionate about music, Menzel especially loved compositions by Haydn, Mozart, Beethoven, and Schubert. In 1836, he wrote to his friend Carl Heinrich Arnold, "I am . . . convinced that music, if it is not perhaps the first art, is undisputably the one that affects the soul most directly." [9] He went regularly to the symphony evenings at the royal chapel and attended the concerts of the Joachim Quartet at the Choral Academy until he was quite old. Although Menzel drew Wagner at work and also witnessed the first Wagnerian festival in Bayreuth, he did not find that composer's works very accessible. He felt removed from contemporary composers and playwrights in general.

Menzel owned a vast quantity of books. The art essayist Friedrich Eggers wrote about him, "Educated in many areas, he delighted literary circles with the sharpness, conciseness, and originality of his views." [10] In 1850, Menzel became a member of the literary society "Tunnel über der Spree," which brought together writers, journalists, visual artists, and officials interested in the arts.

The artist undertook many journeys, some of which were for the purpose of commissions. In 1839 and 1840, he traveled by train to Leipzig and Dresden to work on illustrations for Kugler's *Geschichte Friedrichs des Großen*; in 1847–48, he visited Kassel to complete the cartoon of *The Entry of Sophie Brabant with Her Little Son Heinrich into Marburg in 1247*; in 1855, he went to Marienburg to paint both murals of the Grand Masters Siegfried von Feuchtwangen and Ludger von Braunschweig; and in 1876,

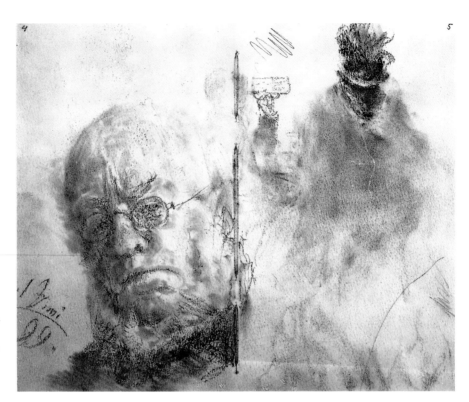

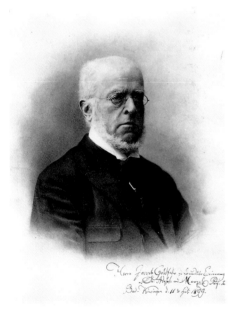

Fig. 4 Self-portrait, 1899
 From Sketchbook No. 71, pp.
 4–5
 Sammlung der Zeichnungen,
 Nationalgalerie

Fig. 5 Portrait photograph of Men-
 zel, 1903
 E. Bieber, Berlin and Ham-
 burg, Nationalgalerie Ar-
 chives

he journeyed to Holland to prepare illustrations for *Der Zerbrochene Krug* by Heinrich von Kleist.

In his mature and later years (fig. 5), when he had more than ample financial resources and felt the yoke of commissions less often, Menzel regularly left Berlin for many weeks during the months of July, August, and September. On these trips, he was a keen observer who spontaneously sketched and collected various impressions. He recorded people and their environs above all, but he drew little of the purely natural landscape. As a draftsman, the ocean or the mountain ranges and massifs of the Alps were of little interest.

Menzel often sought out those places that appealed to him. The year 1852 marked his first trip to southern Germany and Austria, areas to which he returned repeatedly in years to come. His excursions to these regions became more frequent, especially after 1871, as he grew fond of the richness of the baroque and rococo art there. He particularly enjoyed stopping in Munich and Salzburg. In later decades, he always accompanied his sister to Kissingen, where he preferred to study the behavior of the spa's guests and the inspiring location of the bathing resort rather than partake in spa treatments. Another spot to which Menzel returned was Hofgastein in the Gasteiner Valley. From 1872 to 1874, he stayed there for some weeks, together with his sister, brother-in-law, and his nephew and niece, as the guest of the Berlin banker and art collector Magnus Hermann. He traveled there once again in 1879, where he no doubt prepared his two paintings

Procession in Hofgastein (1880) and *Grinding Shop at the Smithy in Hofgastein* (1881).[11] For the most part, Menzel made excursions to regions where the German language was spoken. The fact that he did not speak a foreign language quite likely played a certain role in this. Nevertheless, he visited Paris three times (1855, 1867, and 1868) and Amsterdam once (1876).

Especially in his younger years, Menzel suffered from his unusual appearance. He once said to Dr. Max Jordan, the first director of the Nationalgalerie, "But it would have been quite useful for me to have attended the Academy longer; only that, you know, a certain pride stood in the way: one pitied the cripple—the small one was smiled at. I sensed that strongly my whole life long, most strongly in my youth." [12] His malformation affected his behavior in many ways. He was often gruff and brusque, because he did not want to give any cause for sympathy or pity, or perhaps he believed he was respected too little. Thus, he distrusted many signs of friendship that were shown him. Naturally, his physical appearance also influenced his relationships with women. In his will, he admitted, "Not only did I remain unmarried, throughout my life I dismissed every kind of relationship with the other sex (as such)." [13] The art essayist and critic Ludwig Pietsch, who knew Menzel well, believed that "the eternally feminine, so much as one could notice, had never played an important role in his life, had never drawn him in or drawn him away, like so many other artists." [14] Menzel, however, was not a misogynist. Carl Johann Arnold, his longtime pupil, commented that "he enjoyed conversing—often long into the evenings—with women who could also captivate him intellectually in pleasant conversation." [15]

It is clear that Menzel wanted to compensate for his physical handicaps through his art. For him, art took precedence over all else. He confessed to the writer Ottomar Beta, "I had a principle; I began with it, and I will end with it: to do all that I endeavor as well as possible, even if it is trifling in the eyes of the people." [16] His ambition was focused solely on achieving great success as an artist, and thus, the honors that were heaped on him in the second half of his life were, all in all, only pleasant incidences. Theodor Fontane, the most significant German critical-realist novelist of the second half of the nineteenth century, emphasized that "he was a lifelong master of concentration and, because of this, made a career of art without ever being a careerist." [17]

1. Letter of 6 October 1878 to Friedrich Pecht, reprinted in Gustav Kirstein, *Das Leben Adolph Menzels* (Leipzig, 1919), pp. 104, 106.

2. Letter of 1 July 1879 to Friedrich Pecht, reprinted in Gustav Kirstein, ibid., p. 113.

3. The likeness, which depicts Chodowiecki drawing on the Jannowitz Bridge in Berlin, is in the collection of Georg Schäfer (Schweinfurt) and is on exhibition at the Germanisches Museum in Nuremberg. Chodowiecki was a fanatic draftsman, who pursued an extreme interest in nature studies and reliably portrayed genre. When Menzel created the series on the history of Frederick II of Prussia, he consulted Chodowiecki's work.

4. Quotation in Paul Meyerheim, *Adolph Menzel. Erinnerungen* (Berlin, 1906), p. 129.

5. Meyerheim, ibid., p. 132.

6. Jan Veth, *Streifzüge eines holländischen Malers in Deutschland* (Berlin, 1904), p. 50ff.

7. Julius Haselblatt [Julius Norden], "Bei Adolph Menzel," in *Die Gegenwart* 29, v. 58 (1900), p. 261.

8. Ibid.

9. Letter of 5 March 1836 to Carl Heinrich Arnold, reprinted in Hans Wolff (ed.), *Adolph von Menzels Briefe* (Berlin, 1914), p. 7.
Arnold was a wallpaper manufacturer in Kassel. He was intensively engaged in painting and studied with Jacques-Louis David for two years in Paris.

10. *Deutsches Kunstblatt*, 5 January 1854.

11. *Procession in Hofgastein* is in the Neue Pinakothek in Munich, and *Grinding Shop at the Smithy in Hofgastein* is in the Hamburger Kunsthalle.

12. Quotation in Max Jordan, "Menzel und die Nationalgalerie," in *Moderne Kunst in Meisterholzschnitten*, v. XX (Berlin, n.d.), p. 99.

13. Reprinted in Kirstein, op. cit., p. 97.

14. Ludwig Pietsch, "Persönliche Erinnerungen an Adolf v. Menzel," in *Velhagen & Klasings Monatshefte* 2 (1904–1905), p. 206.

15. Carl Johann Arnold, "Erinnerungen aus meinem Zusammenleben mit Adolph Menzel" (Weimar, 1905), sheet 7 from the unpublished manuscript in the Nationalgalerie Archives.

16. Ottomar Beta, "Gespräche mit Adolph Menzel," in *Deutsche Revue* 23, vol. 2 (April–June 1898), p. 51.

17. Letter of 21 December 1884 to Georg Friedländer, reprinted in *Fontanes Briefe in zwei Bände* 2 (Berlin and Weimar, 1968), p. 134.

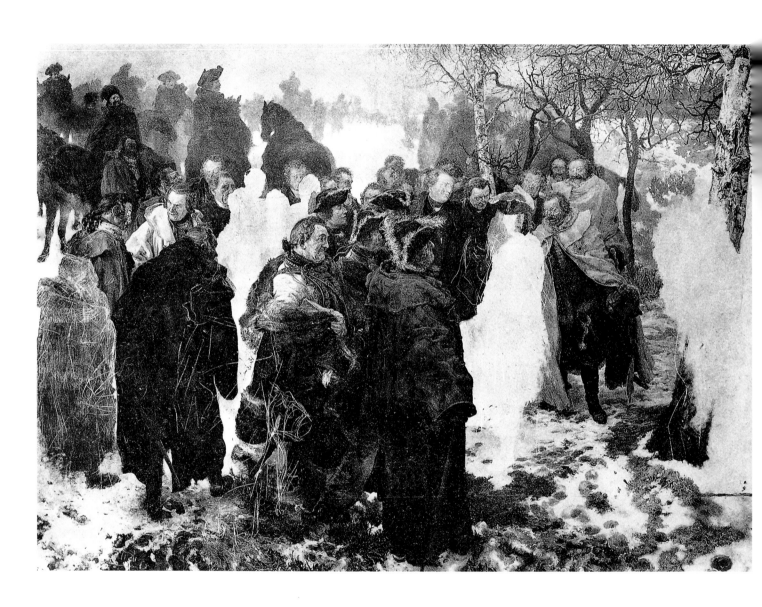

The Nationalgalerie and Menzel

PETER BETTHAUSEN

The honors bestowed on Menzel in the last twenty years of his life surpassed all distinctions that had ever been awarded to a German painter. No other artist had climbed so high in the esteem of the public and those in power. In 1883, he was named vice chancellor and in 1885, chancellor of the Peace Division of the Order Pour le mérite. Also, in 1885, on his seventieth birthday, he was awarded an honorary doctorate from the University of Berlin and honorary citizenship in his hometown of Breslau. Four years later he was appointed an honorary member of the senate of the Academy of Arts in Berlin, and in 1895, on his eightieth birthday, he was made acting privy councillor, with the title "excellency." In the same year he was awarded honorary citizenship in the city of Berlin. Finally, in 1898, he was inducted into the highest Prussian order, the Black Eagle, and elevated to noble standing.

When Menzel died on 9 February 1905, his bier was carried into the rotunda of Schinkel's Altes Museum, the "shrine" of Berlin's Museum Island. Here, the emperor and the empress as well as the knights of the Order of the Black Eagle took part in Menzel's funeral. On 6 March, the Academy of Arts commemorated the artist, again in the presence of the imperial couple, and the Academy's director, Anton von Werner, honored him as Germany's "most loyal son . . . , who was for us the embodiment of inexhaustible diligence and of greatest patriotic sentiment!" [1]

Honoring Menzel as an artist was reserved for the Nationalgalerie, which only a few days later, on 28 March, opened a memorial exhibition the range of which far surpassed all previous standards. The exhibition brought together every obtainable work by Menzel: 129 paintings, 291 watercolors, gouaches, and pastels, 6,405 drawings, and 252 prints. Included in the long

Fig. 6 *Frederick the Great's Address to His Generals before the Battle at Leuthen, 1757,* 1859–61
Oil on canvas, unfinished
318 x 424 cm
Nationalgalerie

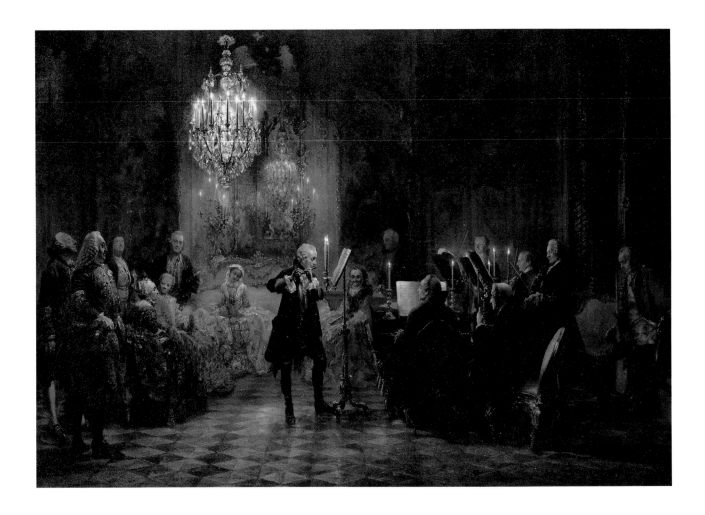

list of lenders were such royalty as the German emperor, the Russian tsar, and the Arch Duke of Sachsen-Weimar; museums in Berlin, Dresden, Hamburg, Munich, Breslau, and Posen; and no less than fifty private individuals, primarily businessmen, bankers, scholars, officials, and art dealers from Berlin. Also shown were several paintings and more than three hundred drawings from Menzel's estate.

The most significant contribution to the exhibition in range and quality was provided by the Nationalgalerie itself, which had already procured the best Menzel collection during the artist's lifetime. Its first acquisition took place in 1874 when the painting *Frederick the Great's Dinner at Sanssouci, 1750* (1850) passed into the museum's possession, more or less by chance, as a component of a painting collection formerly owned by the Society of the Prussian Friends of Art. The date of this acquisition is relatively late when one considers that Menzel not only had become a renowned artist in the 1850s, when he painted his series on the history of Frederick II of Prussia, but that with *The Coronation of William I in Königsberg on 18 October 1861* he had also risen to a status approaching that of court painter.

Fig. 7 *Frederick the Great's Flute Concert at Sanssouci*, 1852
Oil on canvas
142 x 205 cm.
Nationalgalerie, West Berlin

Founded as a state museum of contemporary art by order of King William I in 1861, the Nationalgalerie was initially administered by and housed in the Academy of Arts. In the 1860s, classical aesthetic standards still reigned in the arts academy, and the close relationship between the two institutions undoubtedly hindered the acquisition of Menzel paintings. The so-called *Landeskunstkommission*, which in 1862 began advising the Prussian Ministry of Culture on all art acquisitions, including paintings for the Nationalgalerie, was constrained by these same artistic tenets.

Indicative of the relationship between Menzel and the Nationalgalerie at this time is the following incident. In 1867, when the Nationalgalerie wanted to acquire one of his paintings from the Frederick series, the artist announced that he was prepared to complete *Frederick the Great's Address to His Generals before the Battle at Leuthen, 1757*, which he had begun in 1858 (fig. 6). Apparently, he expected that the purchase would be guaranteed with payment in advance, but the Landeskunstkommission did not wish to become involved. Formally viewed, this was correct, but it demonstrated little good will or empathy towards Menzel. Thus, the painting remained in the studio, unfinished. The Nationalgalerie finally acquired it in that state in 1905.

Max Jordan, who had been appointed director of the newly independent Nationalgalerie in 1874, systematically began to build the museum's Menzel collection. Significantly, one of his first official tasks was to visit Menzel in his studio. Over the years the relationship between the two approached friendship. They often met at social events of various kinds, and one can safely assume that these friendly terms paved the way to the Nationalgalerie for many of the artist's works.

In 1875, shortly before the opening of the museum's newly constructed building on Berlin's Museum Island, Jordan acquired two major works for the Nationalgalerie, *Frederick the Great's Flute Concert at Sanssouci* (fig. 7) and *The Iron Rolling Mill* (fig. 8). The *Flute Concert* came from the private collection of the banker Magnus Hermann for 95,000 marks, approximately ten times the sum the painting had cost its first owner, the financial advisor Jacobs, in Potsdam. *The Iron Rolling Mill*, completed only a few months earlier, belonged to Adolph von Liebermann, also a banker, who found himself in financial difficulties and offered the painting to the Nationalgalerie for 30,000 taler. (He had paid Menzel only 11,000 taler.)

The Nationalgalerie undoubtedly contributed to this wild increase in prices, and this trend in acquiring Menzel's art continued in the years that followed. Despite relatively modest budgetary funds and dependency on financial assistance from other sources, such as the emperor's personal treasury, grants, and donations, the museum's acquisitions activity influenced the art market and sharpened the demand for works by those artists who gained entry into its collection.[2]

Jordan recognized the art historical significance of *The Iron Rolling Mill*, which he also named "Modern Cyclopes." He was the first to describe the painting, both objectively in a Nationalgalerie catalogue, and in excessively

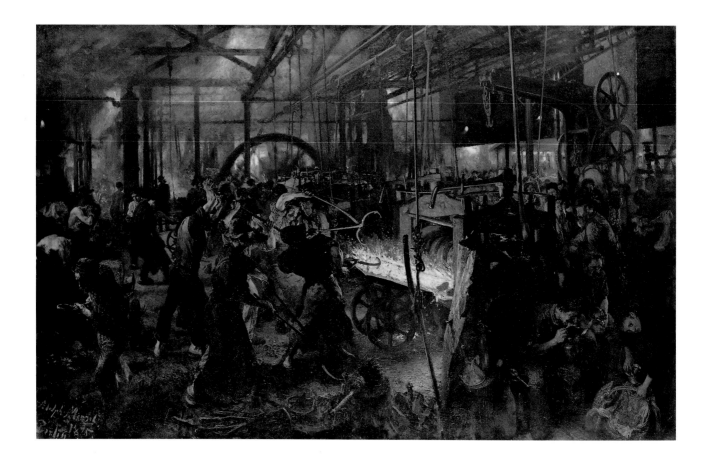

literary language steeped in German idealism in monographs published on the artist in 1890 and 1905. Strikingly, the aesthetic and artistic quality of the work is scarcely praised in these texts. Rather, Jordan addressed the "heroism in the workman's filthy apron," the "people in unwarlike weaponry," the "thousands, who defy Fate in their day to day combat with danger," [3] and the "wrestling of human intelligence and strength with the extremely awkward material forced into serving culture." [4]

Such pathos reflected the spirit of the times in Germany as it emerged from the Franco-German War in 1871. Menzel was inspired by this historic event as well, and in the same year painted *The Departure of His Majesty King William for the Army on 31 July 1870*. In Jordan's eyes it was, above all, a patriotic act, and he bought the painting in 1881 for 30,000 marks. He had it hung next to *The Iron Rolling Mill*, not exclusively for aesthetic or art historical reasons but rather, as he wrote, to bring William I as he departed for battle into close relationship with the "working *Volk*," for as they "returned from war victorious," they became his sole concern.[5]

The acquisitions of the oil sketch *The Coronation of William I* and an immense bundle of works on paper also occurred during Jordan's tenure. Among these pieces were more than 1,000 drawings and oil sketches based on Frederick II and his period (the "Fredericiana") and *The Children's Album*. This collection of works came to the museum under quite dramatic

Fig. 8 *The Iron Rolling Mill*, 1872–75
Oil on canvas
158 x 254 cm
Nationalgalerie

circumstances for Jordan. In 1887, Hermann Pächter, Menzel's dealer, offered *The Children's Album* to the Nationalgalerie for a price that to Jordan seemed too high. Finally, they agreed on a total price of 250,000 marks for the lot, which, however, exceeded the Nationalgalerie's budget. Because the finance minister was not prepared to grant special subsidies, Jordan borrowed the sum himself and paid the interest out of his own pocket. He was relieved of this difficult situation by Frederick III, who ascended the throne in 1888 and consented to the appropriation of the amount from his personal funds.

The works acquired in 1881 and 1889 defined Menzel's image during the period and characterized the artist as the herald of the glory of the fatherland and the Hohenzollerns. Certainly, Menzel functioned in this role, but not to the extent of many of his contemporaries, nor to the degree supposed by those who determined Nationalgalerie purchases, including the director. One more point regarding Jordan's concerns is noteworthy. His view of Menzel's purely artistic qualities was extremely one-sided, for unlike his successors, Hugo von Tschudi and Ludwig Justi, he was foremost a scholar and a writer who understood art primarily as a vehicle for the expression of ideas. Thus, it becomes apparent why, in his enthusiasm for the German Reich unified under the Hohenzollerns (an attitude he shared with most Germans), Jordan emphasized in particular the patriotic side of Menzel's art. Additionally, during his directorship, the Nationalgalerie organized its first exhibitions devoted to Menzel's work. In 1882, the *Album Commemorating the Festival of the White Rose on 13 July 1829*, from the collection of the Russian tsar, was displayed, followed by an exhibition in 1884 celebrating the artist's fiftieth anniversary as a member of the Berlin Artists Society. Menzel's prints were again exhibited on the occasion of his eightieth birthday in 1895. It was also Jordan, along with his colleague Richard Dohme and with the artist's active participation, who published the first catalogue of Menzel's oeuvre through the Bruckmann-Verlag in Munich.

In 1896, Hugo von Tschudi became director of the Nationalgalerie. He had worked on early Netherlandish and Italian paintings as Wilhelm von Bodes' assistant at the Gemaldegalerie in Berlin since 1884, and he had come to admire the impressionists during his visits to Paris. With his tenure began a new era in the history of the Nationalgalerie and the Menzel collection. Von Tschudi opened the doors to modern European *plein-air* painting and its precursors. During his first year as director he acquired two landscapes—one by John Constable, the other by Claude Monet—as well as Edouard Manet's magnificent *In the Winter Garden*. This artistic point of view placed Menzel in a different light, for von Tschudi discovered aspects in his art that had remained hidden to his predecessor.

First, von Tschudi published an essay in the journal *Pan*, a mouthpiece for the modern art movement, that addressed Menzel and the homages paid him on the occasion of his eightieth birthday. Its critical style, however, was considered unseemly for the director of the Nationalgalerie. Anton von

Werner, outraged by von Tschudi's artistic views, stated, "I want the director of the Royal Prussian Nationalgalerie to recognize, that he, as a Swiss citizen, perhaps cannot feel so strongly as we do for that which Adolf Menzel is for us Prussians . . . but I would like to ask Mr. von Tschudi what would happen in Switzerland, should a German in a government post there permit himself to write in the same tone about Arnold Böcklin as Mr. v. Tschudi writes here about A. Menzel." [6] Von Tschudi maintained that Menzel's greatness lie in powers of observation founded on diligence, "which with the sharpness of scientific method seized the tiniest detail." [7] This detracted from the overall painterly effect and the depiction of people: "His eye does not penetrate into the depths of the character." [8] According to von Tschudi's interpretation, these elements became more and more evident in the artist's later work. Although the realism of the Frederick paintings was subdued through the historical distance of the subject and the "greatness of the task," and the painting distinguished itself in its unity and delicacy of tone, Menzel's "pencil that became ever sharper, and his eye that became ever more clever" could no longer give rise to such painterly effects.[9] Nevertheless, *The Iron Rolling Mill* was an exception. Its structural continuity did not permit it to fall apart into "clever details." [10] Furthermore, von Tschudi emphasized that Menzel had created this painting for the sake of painterly effects, that is, for artistic reasons, and not, as Jordan believed, for the sake of its theme, namely, to sing praises of human toil.

Clearly, attitudes toward Menzel had shifted. The criteria upon which von Tschudi based his assessments of contemporary art were oriented in favor of impressionism, which allowed content to recede in favor of form and color. Thus, in his essay, he criticized not only Menzel's inclination for stringing details together, but also his apparently heavy, dull color effects: "A colorist, however, Menzel is not." [11] It was therefore no accident that in Menzel's later work, the gouache technique predominated over other media as it lent itself to rendering local color. Von Tschudi closed with the comment, "More interesting than Menzel's paintings themselves are the preparatory studies in color; here the artist has shown himself at his freest." [12]

When von Tschudi wrote his article for *Pan*, he was largely unfamiliar with Menzel's canvases of the late 1840s and 1850s. Actually no one, including Jordan, who had been in and out of Menzel's studio, knew of their existence. Or at least he did not choose to recognize their significance, for the artist himself did not view the works as valid paintings and kept them hidden in a dark corner of his workshop. Not until the end of the 1890s did they begin to come to light, little by little, through Menzel's dealer Hermann Pächter—to the great astonishment of experts in the field, among others. In one stroke, Menzel became an artist of the avant-garde, a precursor of impressionism. These early works are primarily small in format. *The Balcony Room* (fig. 9), *The Construction Site under the Willows*, and *The Berlin-Potsdam Railway*, to name only a few examples, remain unique in nineteenth-century art history. Although Menzel did not paint

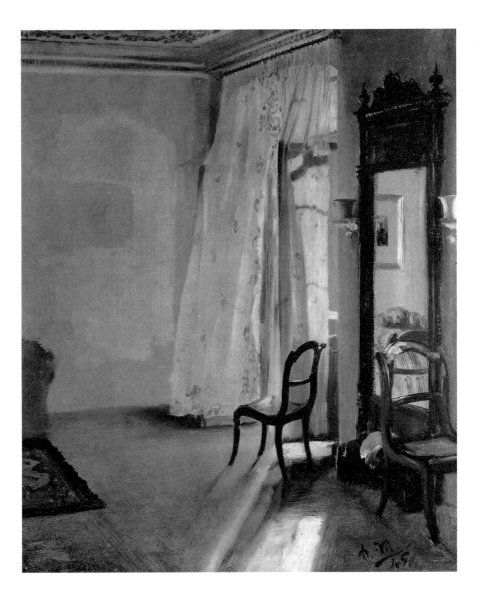

Fig. 9 *The Balcony Room*, 1845
 Oil on paperboard
 58 x 47 cm
 Nationalgalerie, West Berlin

them directly from nature, but rather composed them from pencil sketches in the studio, his use of flooding light and loose brushstrokes give the canvases the appearance of true *plein-air* paintings.

It is not difficult to guess how von Tschudi perceived these newly discovered paintings. For him, they were the strokes of genius of a young painter who felt free from convention and had given full rein to his imagination. Menzel had then brought "painterly values" to the canvas with a "vigor and purity" he could not attain in later works.[15]

Until this time, von Tschudi, like his predecessor Jordan, had been convinced that the extensive purchases of 1889 concluded the acquisition of the essential part of Menzel's oeuvre. Now new circumstances had arisen, and the Nationalgalerie began its second phase in collecting Menzel's work. Although this trend continued until 1905, it peaked in 1899 and 1903 when

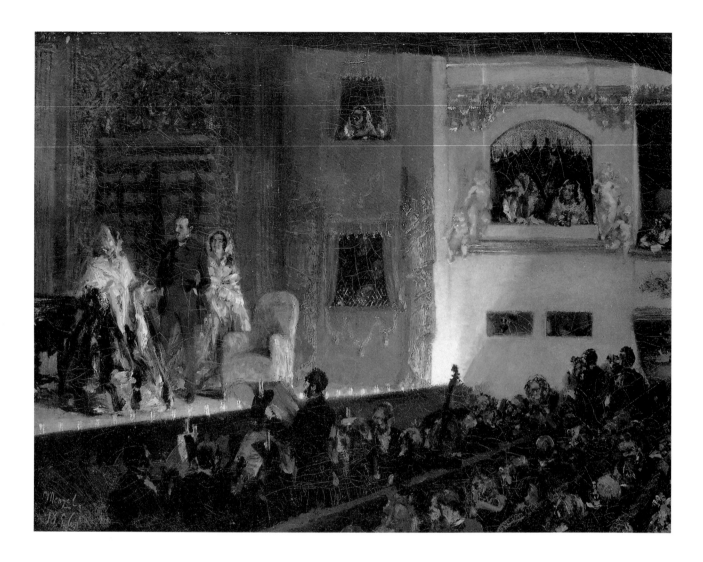

The Berlin-Potsdam Railway was purchased for 27,000 marks and *The Balcony Room* was acquired for 10,000 marks.

After Menzel's death in 1905, von Tschudi organized a memorial exhibition, bringing these early painterly canvases to the public's attention for the first time. Works from the 1840s and 1850s completely dominated the famous centennial exhibition held at the Nationalgalerie in 1906, which was devoted to German art of the nineteenth century. This was one of von Tschudi's most lasting achievements. Only two of the twenty Menzel paintings exhibited there were created after 1860: *The Studio Wall* (1872) and *The Iron Rolling Mill*.

In less than ten years Menzel's image had fundamentally changed. Under Jordan's direction, the Nationalgalerie believed that Menzel's later works best represented the artist on the occasion of his eightieth birthday. After the presentation of the artist's complete oeuvre in the 1905 exhibition, emphasis shifted to his early works. To a certain degree, this was facilitated by von Tschudi, who designated that the dates of the centennial exhibition

Fig. 10 *The Théâtre Gymnase*, 1856
Oil on canvas
46 x 62 cm
Nationalgalerie, West Berlin

extend from 1775 to 1875, which necessarily excluded much of Menzel's later work. It is not clear, however, where von Tschudi's sympathies lie. In the foreword to the catalogue he noted, "Alongside a selection of precious works from his youth, which unveil for us today so many as yet unfulfilled expectations for the artist as well as for German art, emerge the best of the Frederick pictures and his last great creation, *The Iron Rolling Mill*." [14]

Acquisition of Menzel's work peaked once again in the years immediately following his death. The Prussian diet granted the Nationalgalerie a special endowment of 1,500,000 marks to secure the artist's estate and, where possible, many works still in private collections. The museum's last Menzel purchase, a drawing in ink, was acquired with these funds in 1921. At that point in time, the drawing cost approximately 36,000 marks. The majority of the acquisitions, including *The Théâtre Gymnase* (fig. 10) for 90,000 marks and *The Ball Supper* for 160,000 marks, occurred in 1906.

Fig. 11 *Frederick the Great and His Followers at the Battle of Hochkirch, 1758*, 1856
Oil on canvas
295 x 378 cm
Formerly in the Nationalgalerie, lost during World War II

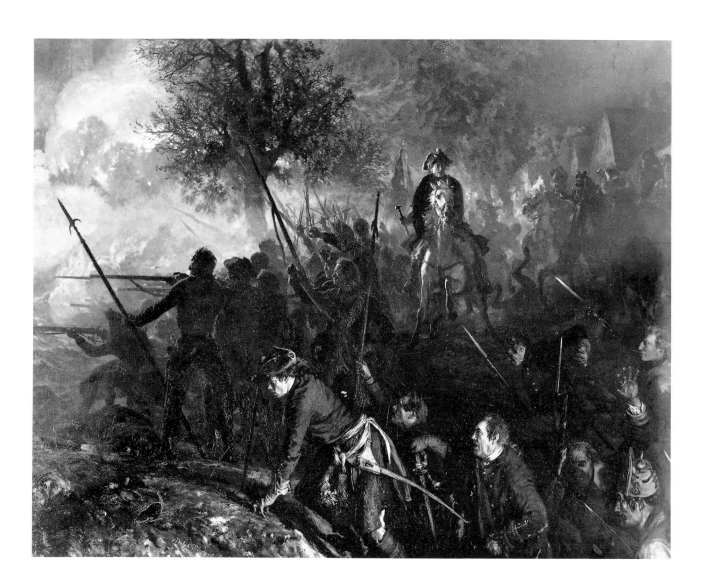

Ludwig Justi succeeded Hugo von Tschudi as director in 1909, and in 1922 brought to the Nationalgalerie the most significant of the Frederick series, *Frederick II and His Followers at the Battle of Hochkirch, 1758* (fig. 11), which had formerly been in the emperor's collection. When *The Coronation of William I* became available upon its release by the emperor, Justi deliberately rejected the opportunity to acquire it. The Nationalgalerie no longer had the ambition of owning the artist's complete oeuvre; enthusiasm for Menzel had subsided by the turn of the century. In addition, *The Coronation* was too large for the museum's galleries, but above all, the painting did not meet Justi's strict standards.

In contrast to his predecessors, Justi dealt with Menzel only marginally. His judgment was more balanced, and he tried to treat both the artist's early and his late work fairly. For Justi, Menzel's art attained the "peak of objectivity in content as well as form." It was an ingenious objectivity infused with the sparkling, lively sense of the rococo.[15] Of all the paintings, Justi valued *The Théâtre Gymnase* most highly.

In conclusion, a word on the location of the Menzel collection in the Nationalgalerie is appropriate. For a time, housing it in a separate building was considered necessary in order to exhibit the paintings permanently and to display a portion of the 6,000 works on paper on a three-year cycle. Anton von Werner, who the emporer originally intended to succeed von Tschudi, was strongly in favor of the idea. After the reconstruction of the Nationalgalerie in 1911–13, Menzel's paintings and a selection of drawings were relocated to the ground floor and later to the second floor. When the building was closed at the outbreak of war on 1 September 1939, the paintings were at first deposited in the museum's cellar and then transferred to the Reichsbank and finally to the anti-aircraft tower at the Zoo. For a few exceptions—including, of course, the *Hochkirch* painting (the loss of which weighs especially heavy)—the entire Menzel collection of the Nationalgalerie survived World War II. Since then, it has been divided: twenty paintings and nearly the complete collection of drawings are now in the Nationalgalerie der Staatlichen Museen in East Berlin and thirty-five paintings are in the Nationalgalerie in West Berlin.

1. Eulogy given by Anton von Werner at Menzel's funeral at the Academy of Arts on 6 March 1905 (Berlin, 1905), p. 4.

2. In the period from 1876 to 1913, approximately 300,000 marks were available to the Nationalgalerie for acquisitions each year.

3. Max Jordan and Robert Dohme, *Das Werk Adolph Menzels*, vol. 1 (Munich, 1890), p. 66.

4. Max Jordan, *Das Werk Adolph Menzels 1815–1905* (Munich, 1905), p. 74.

5. Jordan and Dohme, *op. cit.*, p. 67.

6. Cited from Dominik Bartmann, *Anton von Werner* (West Berlin, 1985), p. 214.

7. Hugo von Tschudi, "Adolf Menzel," in *Gesammelte Schriften zur neueren Kunst* (Munich, 1912), p. 49.

8. *Ibid.*, p. 52.

9. *Ibid.*, p. 50.

10. *Ibid.*

11. *Ibid.*, p. 53.

12. *Ibid.*, p. 55.

13. Hugo von Tschudi, *Aus Menzels jungen Jahren* (Berlin, 1906), p. 16.

14. Hugo von Tschudi, "Ausstellung deutscher Kunst aus der Zeit von 1775–1875 in der Königlichen Nationalgalerie Berlin 1906," in *Gesammelte Schriften zur neueren Kunst*, (Munich, 1912), p. 199.

15. Ludwig Justi, *Deutsche Malkunst im 19. Jahrhundert. Ein Frer durch die Nationalgalerie* (Berlin, 1920), p. 174.

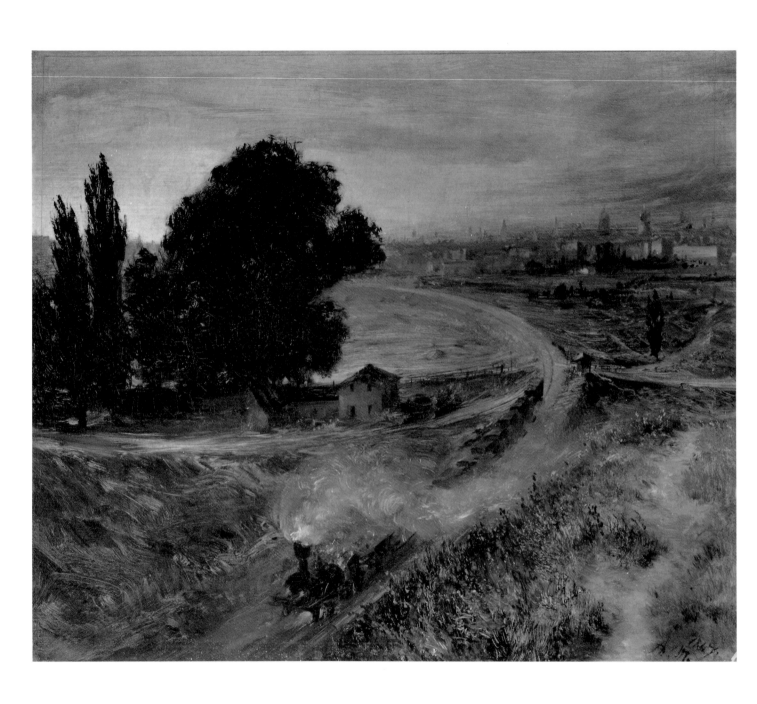

Menzel and America: A Missed Encounter, An Unpainted Picture

CLAUDE KEISCH

Fig. 12 *The Berlin-Potsdam Railway,*
1847
Oil on canvas
43 x 52 cm
Nationalgalerie, West Berlin

The origins of when and how Menzel's fame spread to the United States are difficult to trace from the European standpoint. American collections contain some of his drawings. Under what circumstances were they acquired? How did the art critics react, especially to the body of Menzel's work that was presented at the St. Louis World's Fair in 1904? Which aspects of his multifaceted work were perceived most clearly? Certainly *The Coronation of William I* (1861–65, Potsdam Staatliche Schlößer und Gärten), a painting brimming with figures, was an especially prominent attraction in St. Louis. In any case, it was not the painter's wish to herald the greatness of Prussia there, a role to which he was reduced in Wilhelmian Germany. When he learned of the decision of the German selection committee, the eighty-eight-year-old artist imagined he would confront a country of liberals and wrote skeptically, "And would the Americans have a very open mind towards the subject? Couldn't perhaps a free man with a stone in his pocket visit the exhibition?" This statement presupposed a clearly defined image of the United States. Furthermore, from distant America, how would one orient oneself towards the German controversy over the relationship of Menzel's mature and late works to those of his early period? These questions must remain unanswered here. Rather, the author will give an account of a challenge to the artist that until now has been unknown. It will be conveyed through the myth of adventurous entrepreneurs on an only half-developed continent, through the attraction of its vastness and the raw allure of the absence of tradition. The challenge, although it remained unmet, casts a strong light on Menzel's work and is cause for reflection.

33

In July 1883, Menzel received two letters from Richard Goerdeler, the general agent and manager of the Berlin office of the Northern Pacific Railroad Company. Only the artist's answer to the second letter remains, yet the text fully reveals the previous events. Menzel had already begun his annual summer trip and wrote while en route:

Dresden, Hôtel de Rome.
27 July 1883.
Mr. R. Goerdeler
General Agent, etc. etc:

Most Honorable Sir!
I gather that his Excellency Mr. State Secretary Herzog has informed you of the reasons that hinder me from accepting such an honorable proposal. For if the overload of unfinished commissions and the probability of overwhelming impressions from my travels in the midst of this do not allow me to succeed in my resolve, how much more would the completion of my present projects become an impossibility, here, where it is, therefore, now in question of producing a work of art on a theme that would absorb me for years to come. In this case, I will permit myself to recommend to you a younger colleague, Mr. Anton v. Werner, director of the Royal Academy of Arts, in response to your request. I need not expound on this, for he has repeatedly proven his brilliant reputation by answering assignments precisely of this kind.

Finally, with expressions of sincere regret that I find myself unable to accept this splendid offer, I remain yours truly and faithfully

Adolph Menzel

Menzel was not in the habit of enhancing his refusals with pleasantries; "overwhelming impressions from my travels" and "splendid offer" are substantive and certainly sincere words. The correspondence concerned no more or less than a painting of a great event: the representation of the festive opening of the longest railroad in the world at that time—in the heart of the Rocky Mountains and in the most northwestern corner of the United States, not far from the terminus of its dangerous transcontinental course. And it was about a journey across America.

In 1864, Congress had already granted 57 million acres of national land to the Northern Pacific Railroad Company. The railway extended over almost 11,000 kilometers (6,835 miles), including main and branch lines, across the northern United States, from the upper Mississippi to the Pacific Ocean, and connected Chicago with the Puget Sound. The last three years of almost twenty years of construction were the most intense. Henry Villard (1835–1900), an entrepreneur of German descent (his given name was Heinrich Hilgard) who already controlled the Oregon Railway & Navigation Company, gained command of the Northern Pacific and hired 25,000 workmen—15,000 were Chinese—to complete both lines. In his memoirs, he wrote that the rate of construction had never been equaled in the world. On the average, three miles of track were laid each day.

Villard made the driving of the last railway spike the climax of an almost two-week international celebration "in order to draw Europe's attention to his undertaking." Invited were politicians, diplomats, financiers, scientists,

and journalists from Germany and England. Among the Germans were the law scholar Rudolf Gneist, the chemist August Wilhelm von Hofmann, the Munich geologist Karl Alfred von Zittel, Georg von Bunsen, and Georg Siemens, the director of the Deutsche Bank who was later raised to noble rank for his services in connection with the Bagdad railway, as well as many other prominent individuals.

Five German newspapers were permitted to send representatives on the trip. The versatile writer Paul Lindau (1839–1919), who was associated with the *National-Zeitung*, later assembled his reports into a book, which allows the reader to experience the daily encounter of a representative from Old Europe with the vastness of the New World. Lindau anticipated the excursion with skeptical curiosity and was as critical as he was self-ironic in describing his perceptions.

The writer, as well as the other invited guests, was given as little notice of the journey as was Menzel. The trip began in mid-August and lasted two-and-one-half months, including the ten-day voyage on the Atlantic—they received notice in July. They set sail from Bremerhaven on 15 August, met in New York on the 25th, and traveled three days later by way of Chicago to St. Paul, Minnesota, the first station on the Northern Pacific Railroad. From their departure on 3 September until their arrival in Portland, Oregon, on the 11th, a series of events unfolded, including receptions, parades, processions through triumphal arches, salutes by military bands, and sightseeing. Featured was an "exhibition" of an entire tribe of Crow Indians in full war regalia—folkloric finery as the epilogue to a bloody drama. Immediately following the official program, which ended on 15 September, were optional weeks of more traveling. When Lindau returned to Berlin on 27 October, he calculated that he had traveled 28,219.37 kilometers (over 17,535 miles) on sea and land. Yet, while crowds cheered this victory of technical progress, the stock of the deeply indebted railroad was already falling on the New York Stock Exchange. Even though German bankers, impressed by the grandiose presentations, opened new lines of financial sources, the Northern Pacific Railroad and its sister line, the Oregon & Transcontinental, were on the verge of bankruptcy. The president of the railroad was forced to resign only two months after the inaugural celebrations.

For their transcontinental journey, the travelers were placed on three special trains, the first one being reserved for the Germans. Despite inconvenience, fear, and accident—a mishap occurred in the Rocky Mountains while crossing a dangerous, hastily constructed wooden trestle of an "emergency track" because a tunnel had not been completed—they reached Gold Creek in the Rocky Mountains on 8 September. Here, the "last spike" was to be driven into the last railroad tie. Preliminary events, which included many speeches, claimed an entire day. Lindau described his view of the festivities. "Unfortunately, the light was not very favorable. Although the sun shone in a cloudless sky, the distant view of the majestic craggy peaks of the Rocky Mountains was spoiled by an impenetrable haze, and we saw

only the bare, sparsely covered gray heights of nearby surroundings. . . . If Konrad Dielitz [who ultimately accepted the offer in Menzel's place] wants to paint a very realistic picture of the locale and the crucial events, he will not have inconsiderable difficulties to overcome in order to create an artistically attractive and effective work. . . . The characteristic feature of the landscape of the American West, the overwhelmingly grand proportions, is totally lacking here. It was a landscape like many others. . . . A grandstand had been erected there, which was very practical but nothing more; the only decorations were the usual greens of fir trees, ears of corn, and the railroad workers' tools. On the gables flew the flags of the United States, the German Reich, and England."

Indeed, speeches infused with economic and technical optimism introduced the ceremony celebrating the driving of the last spike. As Lindau noted, this was "not the 'golden spike,' about which the newspapers had fabricated stories, [but instead] Villard drove in a rusty, iron spike of the value of gold—it was the first spike that had been hammered in in February 1870—and now the Indian chief 'Iron Bull' has presented it to the clever builder of the Northern Railroad as a sign of his subservience to the power of civilization." The symbolic meeting of two locomotives draped with flags lent to the spot what it did not possess. "And should not a gifted painter be inspired by this memorable event to create a true work of art?," shouted the man of the quill to his colleague at the easel. "By this great day in celebration of culture in the midst of the formerly inaccessible and virginal wilderness? By this singular gathering of cultural pioneers from eastern shores; of distinguished guests from the Old World; of adventurous fellows who squander their hard-earned pay in the gambling dens; of Mongolians with slanted eyes . . . ; of lazy Negroes . . . ; of colorfully dressed and colorfully painted Indians, who humbly recognize themselves as the vanquished . . . I take it all back . . . and I envy the painter whose mission it is to capture this fleeting, fantastic image and to preserve it for future society." This was precisely the task that had been intended for Menzel.

Henry Villard's German descent, combined with the prestige that German art had enjoyed in America since the sensational success of the Düsseldorf Gallery in New York (a private collection that had been open to the public from 1849 until 1866), led to the notion of entrusting the rendering of that great moment in American history to a German artist. Additionally, the call for a foreign artist emphasized the significance of the undertaking for the European continent as well. This must have been of particular interest to the railroad company, as each day it barely managed to avoid financial and organizational collapse.

It follows from Menzel's letter of refusal that not long before, through his own intervention or on Herzog's recommendation, Goerdeler had invited the artist to take part in the celebratory journey. That this invitation was linked to an assignment did not at first seem clear to the painter. Nevertheless,

he declined, and when the circumstances were explained to him once more, he could only reaffirm his decision.

Few clues exist as to how Menzel envisioned the distant country of America, and later evidence of this has already been cited. That he once illustrated a scene from the American Revolution (see *Washington's Farewell*, cat. no. 15), does not signify much, for it was a commissioned piece. Yet he was a contemporary of the great emigration movement overseas. He could not ignore that any more than he could the reverberations of the Civil War, which had occurred during the years he was working on the coronation painting.

But the railroad! For Menzel, it was more than a symbol of modern life. It had had its place in his imagery since his—and its—beginnings. As a young lithographer, he had copied an illustration of an early English locomotive. One of his famous early landscapes depicts, as a matter of course, the Brandenburg countryside cut in two by the Berlin-Potsdam railway (painting of 1847, Nationalgalerie, West Berlin; fig. 12). And from the 1850s on, when he himself had begun to travel regularly, he drew and painted scenes inside the train compartment: people in haste, in trivial situations, or in grotesque, disfiguring sleeping positions. Critical and expectant, as he quite simply faced everything, he could not have been indifferent to the American proposal.

Yet, other self-imposed commitments confronted him, including his last great painting, the market scene at the Piazza d'Erbe in Verona, which was completed in 1884 and sold to the Dresdener Gallerie a few years later. There were also the preparations for his retrospective exhibition at the Nationalgalerie (also in 1884), for which he added the final touches to *The Children's Album* (see cat. nos. 38–49). This was more than enough work for a man of sixty-eight years. In addition, a painted rendering of the inaugural ceremony would require a composition with many portraits. (Similarly, almost fifty years earlier, in 1835, an unknown watercolor painter had offered the Nuremberg-Fürth Railroad a representation of the members of its board of directors.) Menzel had already experienced the strain of creating that kind of representational piece when he painted the aforementioned *Coronation*, and in 1873, at the last moment, he withdrew from the commission for the painting of the *Parade in the Presence of King Victor Emanuel*, which otherwise could have meant the undoing of the completion of *The Iron Rolling Mill*.

Goerdeler immediately followed Menzel's advice and appealed to Anton von Werner, the forty-year-old director of the Berlin Academy of Arts. In 1877, Werner had painted the *Emperor's Proclamation in Versailles*, and in the weeks prior to Goerdeler's request had completed a panorama of the Battle at Sedan. Time was running short. The entire company of travelers was set to depart from Bremerhaven on 15 August! What is more, Goerdeler had already risked declaring in a newspaper article that "a famous German painter has been convinced, as we hear it, to immortalize in a great historic

painting the moment when Henry Villard, president of the Northern Pacific Railroad Company, lays the last tie with his own hands near the west entrance of the Mullen Tunnel, in one of the most beautiful spots in Montana. . . ."

In his letter to the academy director dated 29 July, Goerdeler tactfully concealed the earlier events. Unversed in German painting, he claimed, he had asked Menzel only to recommend an appropriate artist. (This version of the incident was, of course, easily disproved by Menzel's answer, which Goerdeler, uncleverly enough, let fall into Werner's hands.) It is apparent from Werner's correspondence that he was inclined to accept the offer. Yet, Werner must have suspected that the man who had approached him was acting on his own authority and could not have been certain of his choice of a replacement for Menzel without the consent of the railroad's president. Furthermore, Werner appears to have been contemplating the frequency of bankruptcies in the recent past—the most famous being that of the Berlin "railroad baron" Strousberg—when he requested a payment guarantee for his honorarium. In response, Goerdeler telegraphed from the United States that he could obtain the sum at the Deutsche Vereinsbank in Frankfurt. Despite this, Werner declined. In his memoirs, he briefly mentioned the offer, the "alluring prospect," and the "very high honorarium." In addition, after he had "already half . . . accepted" the invitation, he learned that his panorama of Sedan would be unveiled in the presence of the emperor on 1 September, so he passed the commission on to Konrad Dielitz.

Thus, neither Werner nor Menzel journeyed across the ocean. Making the trip instead was a middling, young history painter, whose work—or that part of it which still exists—does not provide a sense of his impression of the experience. Dielitz also took part in the opening ceremonies, but the collapse of the company, which followed soon afterwards, rendered the execution of the painting superfluous.

A missed opportunity: why remember it? Menzel never saw America. Edgar Degas, to whom Menzel felt a close artistic association in some respects (and Degas shared this view) did not shy away from the *dépaysement*. He spent a few months in New Orleans in 1872–73 capturing details for his painting of the cotton exchange. Still, something more can be gained from the story of a picture that remained unpainted than from an anecdotal contribution to the social history of art. Be it only in passing, this story places Menzel's work and character against a distant, colorful horizon. Beyond the backdrop of imperial and royal Berlin, the New World glowed in magnificent solemnity.

History in the conditional tense—now and then it is worth exploring. Menzel's last great painting was *The Piazza d'Erbe in Verona*, not *The Opening of the Northern Pacific Railroad*. Had he been some years younger (or without the Verona painting), would he have accepted the assignment? And how would the results have been envisioned? Probably as a group portrait, similar to the "coronation painting," but set outdoors with the

Rocky Mountains in the background. With the same faithfulness and ever unconciliatory sharpness of vision, Menzel would have portrayed the American entrepreneurs and their guests as he had the highest members of European society. His tendency to let figural relationships dissolve (a trait that became ever more apparent in Menzel's late work) would have had its effect here, and he would have possibly surpassed the proscribed task in a notable manner, perhaps depicting the event in *plein-air* comparable to *The Piazza d'Erbe*. A painting of the international business world gathered to celebrate the triumph of industrial capitalism in a young country unencumbered by history: only this element was missing in a life of work in which the Frederician period, the urban present, the atmosphere of the Prussian court, and the workman's world of the iron rolling mill made the same claim to representation—for in like manner, all are real.

This text is an altered version of an essay entitled "Ein ungemaltes Bild Adolph Menzels: *Die Einweihung der Nordpazifikbahn* (1883)," which appeared in *Staatliche Museen zu Berlin, Forschungen und Berichte* 28 (1989).

It is based on material from the following sources:

Zentrales Staatsarchiv, Dienststelle Merseburg, Rep. 92, von Werner XI, Lit. M, fol. 112f.; Lit. G, fol. 45–49.

R.G. [Richard Goerdeler], "Berlin, 25. Juli. Die Eröffnungsfeierlichkeiten der Northern-Pacific-Eisenbahn. Die deutschen Ehrengäste," in *Allgemeine Zeitung* (Munich, 27 July 1883).

Heinrich Hilgard-Villard, *Lebenserinnerungen* (Berlin, 1906), especially the chapter on the completion of the Northern Pacific Railroad, pp. 436–56.

Paul Lindau, *Aus der Neuen Welt. Briefe aus dem Osten und Westen der Vereinigten Staaten* (Berlin, 1885), quotations, pp. 145–52.

Anton von Werner, *Erlebnisse und Eindrücke 1870–1890* (Berlin, 1913), quotation, p. 374.

The letter on the exhibition in St. Louis cited near the beginning of the essay is in Friedrich Frecksa, "Die Photosammlung der 'kleinen Exzellenz.' Aus Adolph v. Menzels Nachlaß," in *Die Woche* 34, no. 9 (1932), p. 280.

The group portrait of the board of directors of the Nuremberg-Fürth Railroad is in the private collection of Georg Schäfer, Schweinfurt; see Willi Geismeier, *Biedermeier* (Leipzig, 1979), fig. 23.

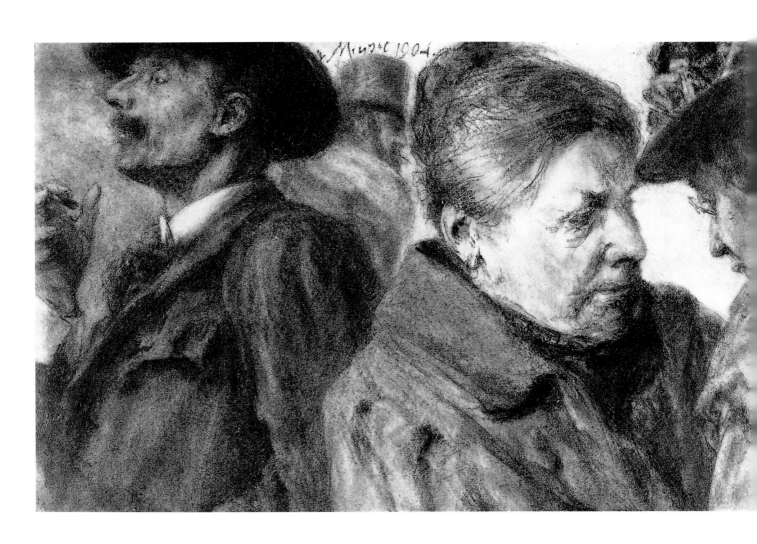

"Courage of Vision"[1]

Traces of Alienation and Loneliness in Menzel's Work

MARIE URSULA RIEMANN

"As an individual he had no enemies; a noble and kind artist's nature brought him the rare triumph that all opposition [he encountered] remained purely in principles." Thus, the writer Theodor Fontane viewed the forty-seven-year-old Menzel. He commented further thirty years later: "Menzel is the master of every branch of his art, but, even more, he is the master of his own passions. The human in him still surpasses the artist. What he is in his greatness, he is, above all, through his human qualities, through his rare incarnation of diligence, responsibility, and courage. This courage is perhaps his most beautiful and greatest side." [2]

Menzel was conspicuously small in stature, which almost seemed to predispose him to isolation from society. Unlike Toulouse-Lautrec, he hailed from narrow, bourgeois circumstances, and this closed fundamental areas of life to him.[3] Despite this, Menzel was sociable and open-minded in his youth, and he approached his fellow men and the events of the period almost eagerly. His self-confidence, which had suffered several setbacks, grew with the responsibility he assumed at an early age for his mother and his two younger siblings. He himself was not yet an adult when his father died suddenly in 1832. These early obligations shaped him and gave him strength which was nourished by the love he felt for his family. After the deaths of his mother and his brother, he continued to live within the circle of his sister's family until his own death.

As his work developed—although his untiring diligence curbed his genius—Menzel's position in society became more secure. The dissonance, inner tension, or even expression of antagonism toward society that is sensed

Fig. 13 *Men and Women*, 1904
Graphite
13.3 x 21.0 cm
N 1733, Nationalgalerie

in many of his works sprang from his early family obligations. It marked the beginning of an alienation that Fontane was the first to recognize and to attempt to describe, as we shall see. Menzel's works enjoyed little success, and in 1860–61, he considered leaving Berlin and moving to Paris. In the summer of 1861, this time of crisis culminated in illness.

Reflecting on this stressful period, Menzel wrote in an autobiographical note: "I never had financial support; neither my professional training, nor my travels, nor my basic necessities have cost either the state or anyone else one cent. This probably lay in [the fact] that, I confess, out of untimely pride and, even more, out of fear of refusal, [and] especially [out of fear] of then probably having to humble myself to protection and outside influences, I never asked for anything whatsoever. Thus, I have relied entirely on my own resources my whole life long." [4]

During this life crisis, a bitterness matured in Menzel's being that remained with him even as honors were heaped upon him in his later years, which only served to veil their contradictions. Two works characterize this difficult period; each is a "child of sorrow" in its own manner. The large painting begun in 1858/59, *Frederick the Great's Address to His Generals before the Battle at Leuthen, 1757* remained an incomplete, final work within his vast theme of the epoch of Frederick II, to which he had devoted almost half his life. He interrupted his work on the *Leuthen* painting to take on the unexpected commission of painting the coronation of King William I in Königsberg in October 1861 (fig. 14). This commission probably arose under the influence of the liberal Crown Prince Frederick, and Menzel's escape to Paris did not take place. The "coronation picture," which engaged him until 1865, established Menzel's reputation at the royal court. While it was his compromise with the Prussian monarchy, it was also his last commission. In a reactionary Prussia that was becoming ever more conservative after the abortive revolution of 1848, Menzel's paintings on the theme of Frederick the Great, in which he concealed his politically liberal and democratic convictions, did not receive the recognition he had anticipated. He had already formulated his "intention" in 1839, namely, "to represent the *prince*, whom the princes *hated*, and the people *revered*, this was the result of that *which he was*, in a word: the old Fritz, who lived through the people. . . ." [5] The monarchy, however, which was in the process of being restored to power, showed little understanding neither for an interpretation of the king that deviated from an idealistic, heroizing representation, nor for Menzel's sharply articulated realism.

Yet the abandonment of Menzel's ambitious plan—to capture in the *Leuthen* painting a psychological moment during the battle when Frederick stood with his generals as an equal before that life-or-death struggle—also had an interior cause. At that time, Menzel refused to oblige his art to meet the extraordinary pretention of expressing such thoughts of Frederick's liberal solidarity with his officers. His hope of finding in William I a patron for such a large design was shattered by the king's conservative opposition. Menzel later sensed that the historic figure of Frederick II was being falsified

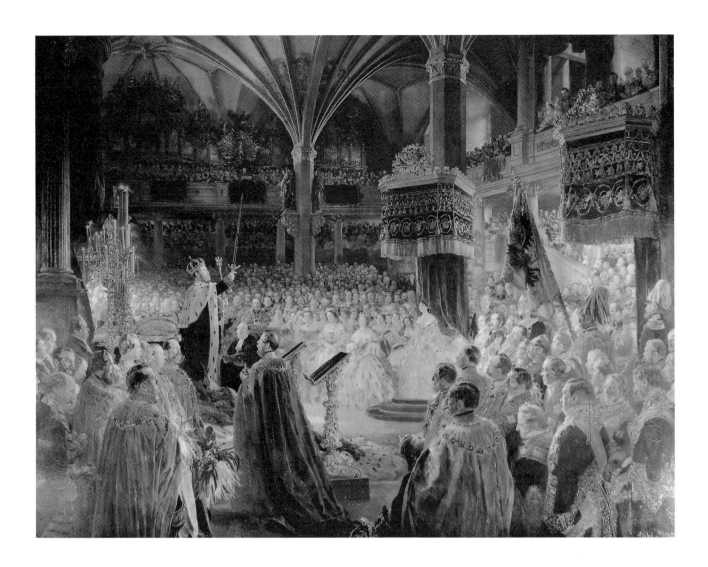

Fig. 14 *The Coronation of King Wil-*
liam I in Königsberg on 18
October 1861, 1861–65
Oil on canvas
345 x 445 cm
Nr. 128, Staatliche Schlös-
ser und Gärten, Potsdam

in the Wilhelmian era to serve personal interests. Disappointed, as he was after the failure of the revolution of 1848, he did not finish his painting *The Honoring of the Insurgents Killed in March 1848*, and he hung the *Leuthen* painting, the last in his Frederick series, in its half-complete state on a wall in his studio. "It will remain so," the writer Ottomar Beta quoted Menzel as saying in 1898. "It was not wanted then; it would have worked against me and spoiled my desire to proceed with the work. And besides that, I was sincerely tired of Berlin. I was already considering moving to Paris. I was not finding here what I was seeking. I had devoted all my strength to tasks that were not very rewarding. My friends had not wondered a little about it and had advised me against giving my lifeblood to projects of such little worth. And the desire to complete such a painting was once again fundamentally taken from me. I was set aside and forgotten. Of course, afterwards I would have returned to it, but I already had other things that absorbed me." [6]

43

Menzel's disappointment must have been extremely great and, towards the end of his life, he may have felt his failure doubled by his lack of success in promoting liberal views through his art. Yet he must have known that with the king's absolute claim to power, the liberal phase of William I's reign had come to an end, even as Menzel was still working on the coronation painting in 1862. Perhaps Menzel gained some small satisfaction in knowing that even after he modified the painting's foreground he was able to represent the liberal ministers of state, who had been dismissed in 1862, in their position within the hierarchical composition of the coronation ceremony.[7]

With the completion of the "coronation picture," Menzel emerged from under his "cloud of disfavor,"[8] but his reputation as "Preußenmaler" (painter of Prussia) was sealed, and it accompanied him even beyond his death. In the end, the numerous honors bestowed upon this "painter of Prussia" further obscured the continual lack of understanding that German critics held for the realism of his later works, which were directed solely towards contemporary life.

The "chronic paroxysms of bitterness," as Beta called them, that took root during these years contributed to Menzel's growing isolation.[9] He characterized the German critics' partiality for idealism, as related here by Max Jordan. "The time had, so said Menzel in his pregnant manner of expression, not yet completely decided to accept that a person not only acts but also has a certain appearance, and the latter is as inconsequential as it is accidental."[10]

In contrast, Menzel's realist style of drawing and painting received considerable recognition in France.[11] He repeatedly exhibited works in Paris beginning in 1855, when his *Frederick the Great's Dinner at Sanssouci* was displayed at the World's Fair there. Menzel made his first trip to Paris in the fall of that year. Although the *Deutsches Kunstblatt* published several notices as well as reviews by the French press (even the artist's intention to travel was announced), Menzel's first direct encounter with Paris and French art went unnoticed for a long time.[12]

Menzel was hesitant to travel. In April he wrote to his friend Fritz Werner in Paris that he was "still not coming this year," only to write to him on 29 September, immediately after the artist returned from the trip that he nevertheless took, to say how meaningful the journey had been for him.[13] Menzel's affinity to French art and culture dates to his artistic beginnings and is evident in many of his works and statements. Friends knew of Menzel's expectations, which surely must have attended him on his first encounter with international art in a location such as Paris. Henriette Merckel, whose husband, Wilhelm von Merckel, was a member of the literary group "Tunnel über der Spree" along with Menzel and his longtime friend Theodor Fontane, wrote to Fontane's wife Emilie on 29 September 1855, "The Menzel siblings should be returning from Paris now—I am already looking forward to their stories."[14]

The artist's interest in France continued into old age and may have been partially due to his awareness that his art was first appreciated there. In 1889, he was among those artists who, in spite of public warnings against their actions in the press, sent works to the World's Fair in Paris for the 100th anniversary celebration of the French Revolution. The degree to which Menzel's isolation and his distance from the realities of society had increased is evident in his powerful reaction to these demands. "The official as well as the private [sectors of] Germany, out of consideration for the national honor and dignity, refused and were forced to refuse their participation in an exhibition, ... which with its glorification of the philosophy of the Revolution constitutes a challenge to the monarchical consciousness. . . ." [15]

In the later half of Menzel's creative period, a conflict in his art became increasingly apparent, which his friend Fontane first noticed and described as follows. "And thus we then became accustomed to regarding Menzel, more or less exclusively, as a glorifier of our Prussian history, of the past as well as of the present. But beside this Menzel of conventional views is always a second Menzel, who proceeds in an entirely different manner in many respects, and who turns away from the exterior, material world that confronts him as a desire, a commission, or a challenge and finds his ideal in purely artistic endeavors that he initiates himself—in the continual discovery of new techniques as well as in the continual solution of new problems. . . ." [16]

French critics such as Edmond Duranty or later Jules Laforgue and Louis Gonse, with their unbiased and clear manner of observation, praised the modern elements in Menzel's realism manifested in the everyday themes of his paintings and drawings. One may surmise from this that the self-taught Menzel was open to all innovations and was plainly compelled to participate in as many important events of the period as possible. In 1855, his conceptions of a realist interpretation of art were realized in Paris, and he at least saw his inner struggle validated. Courbet, at his own pavilion in the Palace of Industry at the World's Fair, announced his "Realism Manifesto" and aroused the tempers of artists in his discussion of the subject. It is convincing, as Françoise Forster-Hahn has supposed, that contrary to Duranty's opinion, Menzel was well familiar with the program of realism formulated by Courbet. [17] Likewise, he praised the spectacular, large industrial paintings by Francois Bonhommé (called "le Forgeron") that were then exhibited at the Palace of Industry. They may be considered the French inspiration for his later painting *The Iron Rolling Mill*.

Menzel could find stimulating elements for all his later works within the program of French realism. It did not escape his attention that the writer Duranty, who edited the journal *Le Réalisme* (1856–57) and the book *La Peinture réaliste* (1876), cited Menzel's works as being an outstanding example of the new direction in realist art. That Menzel's art was absolutely current with the times eluded German critics. His first painting of urban life, a theme to which he became increasingly devoted, originated in Parisian

motifs. In 1856, with his interior view of *The Théâtre Gymnase*, he painted not only his first urban image from life but also one of the most modern paintings of German origin. Similarly innovative works are *The Berlin-Potsdam Railway* of 1847, the first painting of a railroad in Germany, which also depicts the destruction of the obliging landscape outside the cities by the cutting arc of railroad embankments, and *The Iron Rolling Mill* of 1875, the first representation of industry in German painting to portray the workers' dependency on machines. Suspecting that German art critics were not ready for an unconventional composition such as *The Théâtre Gymnase*, Menzel kept it and his early paintings of the 1840s, primarily interior scenes and landscapes from nature, in his studio until 1903.[18] While Duranty unfolded the continuous development of Menzel's work in a sensitive analysis[19] (and thus Menzel gained admiration from painters as diverse as Ernest Meissonier and Edgar Degas), German critics such as Julius Meier-Graefe and Hugo von Tschudi had nothing more fortunate to do than to play the work of the young Menzel off that of the old.

Menzel saw the signs of alienation and misunderstanding intensify during his lifetime so that by age eighty-three he felt "cast aside and buried while still alive."[20] The isolation he felt as an artist deepened in his later years and extended into his private life. Fontane felt close to Menzel in the critical realism of his own literary works,[21] and passages from his letters provide insight. In the summer of 1881, when Menzel was sixty-six years old, Fontane wrote: "Menzel has his good time; in winter, when he is often at the court, sometimes daily, he becomes barely manageable, but now he is once again a man among men."[22] Shortly thereafter, another observation made by Fontane touched upon the general human superficiality and the spiritual atrophy that an artist must confront in a city of millions. In 1884, the author replied to a friend: "You wrote, 'in lesser careers we would have more truth in the world.' Certainly. And not merely more truth, also more simplicity and naturalness, more honor, more human compassion, indeed, more thoroughness, knowledge, [and] competence in general. And what is a career, other than to live in Berlin; and what is living in Berlin other than the pursuit of a career? Some individuals need the big city because of their occupations, that is granted, but they are *indeed* lost, particularly lost in regards to their occupations, if they do not understand the difficult art of living in a large city and, on the other hand, of also *not* living. Ad. Menzel is, for example, a master in *this* as well as in his true art. Certainly, Berlin was a necessity for him (Menzel in Filehne for 50 years would no longer be Menzel), but how also did he live in Berlin? From 9 to 9 a recluse in his studio, and then not until others go to bed, does he go, wearing his ribbon of honor to the court, or with his opera hat to 'Huth.' He was a lifelong master of the art of *concentration* and thus pursued a career in art, without ever being a careerist. . . ."[23]

Fontane also expressed his thoughts on disturbances in the familiar context of Menzel. "Krigar's melancholy! A famous European personality

now lives in such an atmosphere, day in and day out. In the end, he must not suffer from it too greatly, otherwise he will not be able to endure it." [24]

Several years later, in 1889, Fontane wrote the following after meeting Menzel in Bad Kissingen, a spa the artist visited on several occasions as a companion to his sister, who needed the treatments. "Comparatively speaking, the visit with the Menzel family was distinguished by its prominent amiability, and it would be shameful if I wanted to carp and grumble here. If a pleasant memory of him came to me of which I was worthy: giving myself airs for half an hour or longer on a stroll with the small man and the great celebrity. Nevertheless, it continues: it is a house that excludes all cheer, for they—without regard for the dangers to which each one is subject—live . . . with a constantly defensive attitude, so that one enters the house only as one would a freshly frozen stream that can support one but perhaps can also engulf one." [25] Fontane, who was nearly the same age as Menzel, observed the path of his friend's art and life from both a close and a distant vantage point until his own death in 1898. Like Menzel, who joined in 1850, he belonged for many years to the literary and scholarly circle of friends who together established the literary club "Tunnel über der Spree." Fontane felt an intimate association with the artistic viewpoints of Menzel's critical realism. His literary path also offers comparisons in his inclination away from historical themes and towards modern subjects. Thus, the author's judgments carry more weight than the flood of anecdotes and questionable statements of many contemporaries.

"When our Menzel dies," wrote Fontane two years before his own death, "thus the homages on the part of the court and those by the people will become similar, or what concerns the court [will become] perhaps greater. But our aristocracy is not free in its sentiment or expressive enough to pay homage to an artist like the English aristocracy did for Sir John Millais." [26]

After 1875, shortly after the completion of *The Iron Rolling Mill*, Menzel's compositions, most of which included many figures, increasingly lost harmony. As the quiet of the garden in his painting *Prince Albert's Palace Garden* (Nationalgalerie, West Berlin) was disturbed thirty years later when he added a group of construction workers, contrasts in his works sharpened to shrill dissonance. One need only to consider the gouache *Trip through Beautiful Nature* of 1892 or *Visit to the Rolling Mill* of 1900. His eye had long been trained to perceive the reality of objects and psychologically penetrate surfaces. This transformed his paintings into mirrors of the displacement of humanity caused by the turning wheel of the progressively industrial society of the German empire. In his painting *Piazza d'Erbe in Verona* (1884; fig. 15), the last high point of his painting career, Menzel portrayed the loss of individuality in the masses of people who rush beside each other like a surging ocean enclosed by the walls of buildings, between which only a small vestige of sky remains. F.-G. Dumas enthusiastically praised Menzel's urban paintings and found reflected in them the typical character of the urban scene and its social milieu, in which people are

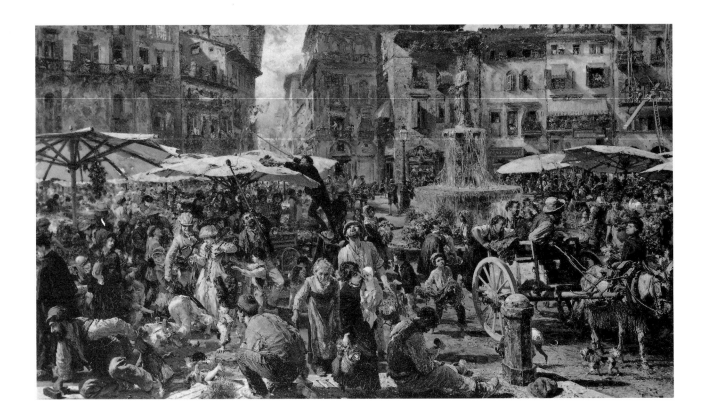

characterized as belonging to a certain level in society. Yet in Germany, one praised the painterly detail captured in the images without comprehending the critical realism of the social dimension.[27]

Menzel's late compositions, which were rich with figures, were often rendered in surprisingly dissonant tonalities that bordered on true colorfulness. (Beginning in the early 1890s, Menzel used only gouache.) Such color dissonance, however, corresponds with the discord and contradictions within the work's motifs. Man's alienation from his environment is reflected in many forms, and it was portrayed in varying degrees of intensity as a growing characteristic of the late nineteenth century. The individual is depicted in his relationship to nature, to animals, to his fellow man—travelling, at church, in a café in a beer garden, or at a spa resort. Like images in a kaleidoscope, Menzel's imagery falls apart into co-existing but separate realities. Unusual visual angles or the absence of a focal point of interest convey distress and bewilderment. He sought neither unity within the composition nor color harmony to reconcile these discordant elements. As Menzel fixed the essentials of visible reality in such a manner in his late works, contrary to all academicism, these images approach the height of a critical realism that perhaps is only beginning to be perceived and understood today.

Fig. 15 *Piazza d'Erbe in Verona,* 1884
Oil on canvas
740 x 127 cm
Galerie Neue Meister,
State Museum, Dresden

Towards the end of 1895, Menzel experienced a bad fall. He recovered, but from that time on, he concentrated almost exclusively on drawing with pencil. In these last years before his death, when he left his studio less and less, a group of pencil drawings emerged that once again present a quality particular to Menzel's work. These sheets reveal a great calm, almost an enraptured state, in their focus on the human countenance. Heads, or at most, busts of figures, are arranged into scenes on relatively small sheets of paper, which lends a monumentality to the figures similar to the full framing technique seen in film. The artist's desire to create a realistic representation once again coalesced in an exemplary and provocative manner in these last works. Here, Menzel's struggle for authenticity is realized in masterful drawings that are "true to nature" without "being copied from nature with fearful exactitude...." [28] The incorruptible honesty of his vision, combined with gestures that are extremely expressive, even when they are reduced to a minimum, dominates his efforts. Fragmentary images recall the work of Degas, who admired Menzel's art.

The snapshot quality of many of his compositions suggests a comparison with photography. This medium interested Menzel throughout his life, even though he denied using it as an aid in his creative processes.[29]

In these very last drawings that portray only people, the theme of alienation is approached in novel variations. Genre elements as well as true studies from models give way to the representation of the diversely shifting relationships between men and women (fig. 13). Menzel ponders not only social differences but also emotions such as uneasiness, sadness, skepticism, seriousness, and indifference. His drawings of old bearded men who resemble baroque saints recall the studies of Jewish men that he had painted in the 1850s in connection with the mezzotint *Christ among the Scholars at the Temple*. Another theme that Menzel had formerly presented in a different manner is seen afresh in a sheet in which a painter is confronted with the head of a yawning old woman—as if to indicate the disillusioning relationship between the artist and the public.[30]

The rigorousness with which Menzel wielded the pencil in these works recalls his earlier "vigorous drawing," as he characterized his sketches for the "coronation picture." In some areas, it is almost as if he were desperately pushing himself, prodding and scratching at the paper. And yet with a delicate touch, he softly applies his shading stump to the medium.

These sheets also demonstrate a bold compositional style in which the foreground and the background draw tightly together. Figures in the background are not always rendered in an atmospherically light manner, but are instead drawn disproportionately small and with strong contours. This last technique may be observed in the splendid gouache *End of the Day of Atonement* (1900), the only sheet in color that belongs to this group, as well as in a drawing of four heads of 1904.

In their grasp of the characteristic quality of the individual psyche and of the social milieu, as well as in their ingenious drawing technique, these sheets are exceptional examples of their kind. Nothing in the foreground

blurs the artist's intentions. One might almost believe that in these images his ideas are realized in the sense of Schopenhauer's *Urdenken in Bildern* (original thinking in pictures).

Dream-like unreality and visionary qualities, which seem to spring from the eye's delight in what is represented, are varied with great immediacy. Perhaps this immediacy came from the direct presence of his models, one of the most fundamental human contacts experienced by the aging Menzel. "There he lived, visited only by a few close friends, on the fourth floor; his studio was on the fifth. On the landing, one could encounter old, ugly models, 'character heads,' which he preferred for practice in these late years," wrote Gustav Kirstein.[31]

Alfred Lichtwark, who succeeded in visiting the increasingly reclusive Menzel in December 1902, wrote: "Soon thereafter, the door was flung open and the old man, fading in the twilight, looked at me with old eyes. He is quite unchanged; only the circles under his eyes had grown somewhat larger. Perhaps his eyes had become smaller. But they see as . . . sharp as ever." [32]

50

1. For more on Menzel's phrase *Courage des Sehens*, see Agatha Hermann, "Wie ich Menzel kannte," in *Moderne Kunst* (Berlin: Verlag Richard Bong, 1905), p. 100.

2. *Männer der Zeit, Biographisches Lexikon der Gegenwart* (Leipzig, 1862). Theodor Fontane, "Zu Adolph Menzels 80. Geburtstag," *Die Zukunft* 4 (7 December 1895), vol. 13, no. 10, pp. 441–44.

3. See, for example, Menzel's will, in which his renounced relationship with women is documented. The original copy is in the Nationalgalerie Archives. Reprinted in in Gustav Kirstein, *Das Leben Adolph Menzels* (Leipzig, 1919), p. 97.

4. *Kunstchronik*, n.s. 21, 1910, p. 77. See also Kirstein, *op. cit.*, p. 108.

5. Letter of 17 July 1839 to the publisher J. J. Weber regarding the title page illustration for Kugler's *Geschichte Friedrichs des Großen*, in Hans Wolff, *Briefe Adolph Menzels* (Berlin, 1914), p. 32. For his political views, see also his letters on the revolution; Wolff, *ibid.*, pp. 126ff., p. 132.

6. Ottomar Beta, "Gespräche mit Menzel," *Deutsche Revue* 23, vol. 2, 1898, p. 50ff. See also Claude Keisch, "Adolph Menzels *Ansprache Friedrichs des Grossen an seine Generale bei Leuthen*," *Forschungen und Berichte* 26 (Berlin, 1987), pp. 259–82 and n.48.

7. Letter to FriedrichPecht dated 1 July 1878; reprinted in Kirstein, *op. cit.*, p. 113.

8. Beta, *op. cit.*, vol. 3, 1898, p. 111. Beta was one of the few German critics who recognized and understood the innovation of Menzel's realist works and the bold aspects of his vision and thought.

9. Beta, *ibid.*, p. 110.

10. Max Jordan, *Das Werk Adolph Menzels* (Munich, 1905), p. 8. Jordan, Menzel's first biographer, began to study the artist's work when he became director of the Nationalgalerie in Berlin. The comment was directed toward the public's alenation from the series of lithographs *Events from the History of Brandenburg-Prussia*. Cf. the negative criticism of Menzel's composition and the financial failure of his exhibition at the Art Society in 1861, in *Dioskuren* 6, 1861, p. 375. Over the years Max Schasler made numerous negative remarks in *Dioskuren* regarding Menzel's realism. For example, he criticized the painting *Frederick II's Meeting with Joseph II in Nice*.

11. Françoise Forster-Hahn, "Menzels Realismus im Spiegel der französischen Kritik," in *Adolph Menzel* (exhibition catalogue; East Berlin: Staatliche Museen Nationalgalerie, 1980), pp. 27–47.

12. *Deutsches Kunstblatt* 6, no. 30, 26 July 1855, p. 266; and 16 August 1855, p. 289.

13. Letter of 4 April 1855, Wolff, *op. cit.*, p. 166, and an unpublished letter of 29 September 1855, Nationalgalerie Archives. See also Menzel's letter to Dr. Puhlmann of 29 September 1855, Wolff, *op. cit.*, p. 168.

14. Menzel had been in Paris with his sister for two weeks. See Gotthard Erler, ed., *Die Fontanes und die Merckels. Ein Familienbriefwechsel 1850–1870*, vol. 1, (East Berlin, 1987), p. 13.

15. *Kunstchronik* 24, 1888–89. Also vol. 32, 16 May 1889, p. 506. It seems especially surprising that Menzel did not offer an explanation.

16. Fontane, *op. cit.*

17. Edmond Duranty, "Adolphe Menzel," *Gazette des Beaux-Arts* 22, 1880, p. 123. See also Forster-Hahn, *op. cit.*

18. See Menzel's notes on the creation of his painting *Prince Albert's Palace Garden* (1846–76) in an unpublished manuscript in the Nationalgalerie Archives. It contains a description of Menzel's working processes for the painting of his balcony from nature in 1846 and of his subsequent pentimenti thirty years later.

20. Beta, *op. cit.*, vol. 2, 1898, p. 54.

21. Letter to Ludwig Pietsch dated 9 January 1886, in *Fontanes Briefe*, vol. 2 (Berlin and Weimar: Nationale Forschungs und Gedenkstätion, 1980), p. 139. With gratitude for Pietsch's friendly criticism of his novella *Unterem Birnbaum*, which includes a comparison of Menzel and Turgenjew, Fontane wrote, "I look to both of them as I do to my masters and examples."

22. Letter to Mathilde von Rohr dated 6 June 1881, in *Fontanes Briefe, op. cit.*, p. 38. After *The Ball Supper* (1878, Nationalgalerie, West Berlin), Menzel painted more ball scenes in the 1880s, the last one being *After the Card Party* (1889, Muzeum Narodowe Pozhan).

23. Letter to Georg Friedlaender dated 21 December 1884, in *Fontanes Briefe, op. cit.*, p. 130. Filehne probably refers to a village in Mark Brandenburg. In his later years, Menzel frequented Frederich's tavern and the cafJosty more often than the Huth restaurant.

24. Letter to Emilie Fontane dated 27 June 1883, in *Fontanes Briefe, op. cit.*, p. 109. Menzel's brother-in-law, the music director Hermann Krigar, had died in 1880.

25. Letter to Karl Zöllner dated 19 August 1889, in *Fontanes Briefe, op. cit.*, p. 230.

26. Karl Scheffler, *Adolph Menzel* (Berlin, 1938), p. 129.

27. Foreword by F.-G. Dumas, in *Exposition des Oeuvres de Adolphe Menzel* (exhibition catalogue, Paris, 1885). Alfred Lichtwark, "Menzels *Piazza d'Erbe*," in *Die Gegenwart* 25, 1884, p. 398. *Deutsches Kunstblatt* 3, no. 18 (June 1884), p. 143. See also Emilie Fontane's letter to her husband dated 11 June 1884, in which she compares "the medly . . . of precious, interesting details" in the painting *Piazza d'Erbe in Verona* with Theodor Fontane's production. In Hans-Heinrich Reuter, *Fontane*, vol. 1 (East Berlin, 1968), p. 252.

28. Letter to Dr. Puhlmann dated 5 November 1836, Wolff, *op. cit.*, p. 15.

29. Menzel encouraged his younger brother to become a photographer and to acquire the Fotografische Kunst—und Verlagsinstitut Gustav Schauer on Potsdamer Straße in Berlin. After his brother's early death, his widow continued the endeavor for a time with Menzel's financial support.

30. See Werner Hofmann, "Entfremdungen," *Bruchlinien, Aufsätze zur Kunst des 19. Jahrhunderts* (Munich, 1979), p. 231.

31. Kirstein, *op. cit.*, p. 84.

32. Alfred Lichtwark, *Briefe an die Kommission zur Verwaltung der Hamburger Kunsthalle*, Gustav Pauli, ed., vol. 2 (Hamburg, 1924), p. 29.

Catalogue of Works

CLAUDE KEISCH

MARIE URSULA RIEMAN

Notes to the Entries

All the drawings represented in this catalogue are from the Sammlung der Zeichnungen (Drawing Collection) of the Nationalgalerie, Staatliche Museen, East Berlin, in the German Democratic Republic. Statements that concern the National-galerie in West Berlin are clearly indicated. Otherwise, all references to the Nationalgalerie are to the museum in East Berlin.

Measurements are indicated in centimeters, height before width. In cases of irregular edges, the widest measurements are given.

The number assigned to each drawing (the so-called Menzel number) is prefaced by "Kat.," "N," or "Nr." "Kat." numbers follow the ordering system in Lionel von Donop's *Katalog der Handzeichungen, Aquarelle und Ölstudien in der Königlichen Nationalgalerie* (Berlin, 1902), which cites 1,702 sheets by Menzel. The first of these was purchased in 1880.

Sheets with the prefix "N" were acquired in 1906 with Menzel's estate. In 1905, a few months after the artist's death, an extensive exhibition of 6,925 of his works was mounted. The Nationalgalerie acquired 4,598 sheets, the majority of the drawings in the estate.

"Nr." numbers indicate those drawings added to the collection after 1906. The numbering system encompasses the Kat. numbers; therefore, Nr. numbers begin at 1703.

In bibliographical references, abbreviated publication information refers to the following titles. They are the most important publications and exhibition catalogues on Menzel and his work in the Nationalgalerie.

Berlin, 1905	*Austellung von Werken Adolph von Menzels.* Königliche National-Galerie, Berlin, 1905.
Berlin, 1980	*Adolph Menzel. Gemälde und Zeichnungen.* Staatliche Museen zu Berlin, Nationalgalerie, East Berlin, 1980.
Bock	Elfried Bock. *Adolph Menzel. Verzeichnis seines graphischen Werkes.* Berlin, 1923.
Schmidt	Werner Schmidt. *Adolph Menzel. Zeichnungen.* Staatliche Museen zu Berlin, Nationalgalerie, East Berlin, 1955.
Tschudi	Hugo von Tschudi, ed. *Adolph Menzel. Abbildungen seiner Gemälde und Studien. Auf Grund der von der Kgl. National-Galerie im Frühjahr 1905 veranstalteten Ausstellung.* Munich, 1905. (This work treats only paintings, gouaches, and drawings in colored chalks. In many areas it is obsolete, especially in indications of current ownership. For the present, however, it remains the only catalog of Menzel's oeuvre.)
Vienna	*Adolph von Menzel. Zeichnungen, Aquarelle, Gouachen.* Staatliche Museen zu Berlin, Nationalgalerie, Vienna, 1985.
Wolff	Hans Wolff, ed. *Adolph von Menzels Briefe.* Berlin, 1914.

Complete information on other authors and titles included in bibliographical references can be found in the text or at the end of this book.

Individual entries were written by Marie Ursula Riemann or Claude Keisch, and are initialed accordingly, that is, with M.U.R. or C. K.

Sketchbooks and comparative sheets mentioned in the entries are from the Sammlung der Zeichnungen of the Nationalgalerie. They are cited by number only, with no location given. Comparisons made with works not in the Nationalgalerie's collection include the current location of the piece in parentheses.

I. The World of His Early Years: Landscapes, People, and Animals

(1–14)

1. *The Former Schafgraben,* 1843

Graphite

13.0 x 20.9 cm

Inscribed at lower left: *Schafgraben von* [illegible] *jetzt Carlsbad 1843 A. Menzel.*

Provenance: purchased 28 February 1908 from Councellor of Justice Ivers, Berlin Nr. 1756

Bibliography: Berlin, 1905, no. 5405; Schmidt, no. 133; Berlin, 1980, no. 146, illus.

Carefully placed areas of hatching and the sharp, delicate line of the at times powerfully wielded pencil characterize a group of Menzel's early landscape drawings. Until his later years, landscape themes yielded almost completely to figural representations.

This sheet served as a preparatory drawing for sheet 3 (Bock, no. 1140) of his *Radir-Versuche* (Essays in Etching; title page and six sheets, L. Sachse & Cie, Berlin, 1844; Bock, nos. 1137–43). It depicts a small wooden bridge over the Schafgraben, a stream that was modified into the *Landwehrkanal* in 1848. The road to Carlsbad was located in the vicinity of the Potsdam Bridge. The etching, of which there are four states, differs from the drawing in several respects, most notably in the buildings. A gothic chapel appears in the etching instead of the half-timbered houses. Menzel repeatedly drew scenes along the Schafgraben (see the painting *Schafgraben* [Tschudi, no. 38]; the etching [Bock, no. 1145]; and its preparatory sketches [N 412 and Skb. 8]).

For his *Radir-Versuche*, Menzel primarily studied works by Jean-Jeaques Boissieu (1736–1810) and Rembrandt (1606–1669), in addition to making drawings from nature. He wrote to his fatherly friend Carl Arnold, "In the meantime, I am familiarizing myself with the etching process; I would very much like to be able to accomplish something with it. It is quite a different matter in every respect . . ." (22 July 1843; Wolff, p. 78). Somewhat later, delighted by the gift of some Boissieu prints—he considered Boissieu to be one of "the greatest fellows in drawing and etching"—he wrote: "I am generally often at the Kupferstichkabinett, browsing around, enjoying the etchings of the Dutch, especially Rembrandt, who is the genius in this medium and will remain so; the more one studies him, the more one is awed by him. Not only because of his lighting effects, but also because of his composition, his knowledge of nature, his sense of form!" (23 April 1844; Wolff, p. 79).

Atmospheric effects of soft light and chiaroscuro are recurring themes in Menzel's own etchings of unpretentious landscapes in the environs of Berlin.

M.U.R.

Holzgraben jetzt Carlsbad 1843. A. Menzel.

1

2

3

2. *Flooded Field with Tree Stump*, ca. 1843

Graphite

21.0 x 13.0 cm

Unsigned

Provenance: acquired in 1906 with the estate of Adolph Menzel

N 310

Bibliography: Berlin, 1905, no. 3202a

3. *Landscape with Wooden Fence*, ca. 1843

Graphite

12.4 x 20.8 cm

Unsigned

Provenance: acquired in 1906 with the estate of Adolph Menzel

N 411

Bibliography: Berlin, 1905, no. 3224d

Stylistically, these landscapes are among several studies created for the *Radir-Versuche* (1844; cf. cat. no. 1), which primarily represent landscapes. In both of these landscapes, the delicate certainty of Menzel's drawing technique reflects his strong desire to express his own sense of the mood inspired by nature. His intent becomes even more apparent in the interplay of graphite tones, which range from light gray in the flat areas and in the hatching to deep black in the vigorous, almost passionately drawn lines of the fallen willow. Such lines further indicate the spontaneity of the drawing. It is perhaps not only the simple, small images of a landscape in early spring that make these drawings so engaging, but also their gentle, melancholic mood and loneliness, which combine with the anticipation of spring that breathes in them. Young Menzel was not afraid to extend the emptiness of the flat, flooded field across the whole sheet. Indeed, he left a second willow in the foreground incomplete so the view of the empty space would remain unobstructed. This characteristic found in Menzel's early drawings was completely lost in his later work, as his compositions increasingly succumbed to a *horror vacui*.

M.U.R.

4. *View from the Roof of the Picture Gallery at Sanssouci,*
between 1840 and 1847

Graphite

21.0 x 26.8 cm

Unsigned

Provenance: acquired in 1889 in an extensive purchase from Menzel's art dealer
 Hermann Pächter

Kat. 1582

Bibliography: Berlin, 1905, no. 1852; Drescher-Kroll, 1981, no. 320, illus.; Vi-
 enna, no. 1, illus.; Riemann and Robinson, *The Romantic Spirit*, no. 121, illus.

While working on the illustrations for *Geschichte Friedrichs des Grossen*, a book by
Franz Kugler (1839–1942), Menzel frequently sketched in the palaces and in the
park at Sanssouci in Postdam. In 1842, he drew a frontal view of the Picture
Gallery (Kat. 1584). For Kugler's second edition, Menzel drew seven of Frederick
II's ornate buildings in addition to the six statues of Frederick's generals on the
Wilhelmplatz in Berlin. The architectural images, including the Picture Gallery,
were not published until after Menzel's death (see Bock, nos. 815, 816–21).
Menzel also drew views apparently from the stairway and the balustrade of the
Picture Gallery for an illustration for Kugler (Bock, no. 806).

 Due to its view from the upper terrace of the Sanssouci palace onto the roof
and cupola of the Picture Gallery (built by J.G. Bing in 1755–63) and of the
Dutch garden below, this drawing may have originated at a later date. At the
right is the rear wall of the grotto of Neptune, and in the background are the
outlying areas of the town of Jäger. Menzel's drawing must have originated
between 1840 and 1847, after P.J. Lenné began to redesign the garden in 1840
but before the renovation of the upper terrace in 1847–50. Comparable is a view
dated 1844 of the same size and with a similar perspective that was also drawn
from the upper terraces of the palace, but looking towards the west onto the Neue
Kammern (Kat. 1572). The trees in the drawing are in full, summer leaf. Thus,
Menzel's pencil did not capture the transparency of the springtime foliage in the
sharp, delicate manner seen here. Instead, the park's full, shady foliage is darkly
rendered with soft stumping.

 M.U.R.

4

5. *Portrait of Frau Meyerheim*, 1847

Watercolor and gouache over graphite, partially scratched with the end of a
paintbrush handle, on yellowish English cardboard

verso: rapid graphite sketches

35.7 x 22.6 cm

Inscribed at upper right: *den 12 März 1847 A.M.*

Provenance: acquired in 1915 through the estate of Paul Meyerheim

Nr. 1778

Bibliography: Berlin, 1905, no. 302; Tschudi, no. 200; Berlin, 1980, no. 7; Vienna,
no. 18.

The unreal monumentality of this portrait results from the illogical foreshortening
caused by the slightly upward view of the figure (demonstrated in the prominence
of the throat and shoulders) and the notably low horizon. The landscape is simply
indicated through the atmospheric effects of a dusky mist, which creates a melan-
choly backdrop. (The lighter portion of the sky above is actually the untouched
paper support.) The figure, with her direct, expressive gaze, looms up in the
foreground in a self-evident manner.

In the years around 1850, Menzel painted several portraits in oils as well as in
watercolors and in chalk that far surpassed the conventions of the Biedermeier
style. At first, this group of works remained incidental, until the preparation for
the "coronation picture" (*The Coronation of William I in Königsberg on 18 Octo-
ber 1861*, 1861–65, Nationalgalerie) brought forth a new series of portraits. They
would be enough to challenge Hugo von Tschudi's judgment (see *Pan 1*, 1896,
p. 43) that Menzel refused to perceive portrait painting as the "test of the greatest
artistic genius" and that the artist had succeeded in capturing the physical but not
the psychological qualities of the sitter.

Karoline Drake, the sister of the sculptor Friedrich Drake, had married the
painter Eduard Meyerheim in 1836. By the time this portrait was painted, Meyer-
heim was already Menzel's good friend, as his son Paul also later came to be. A
portrait of Menzel by Paul Meyerheim is in the Nationalgalerie in West Berlin.

<div align="right">C.K.</div>

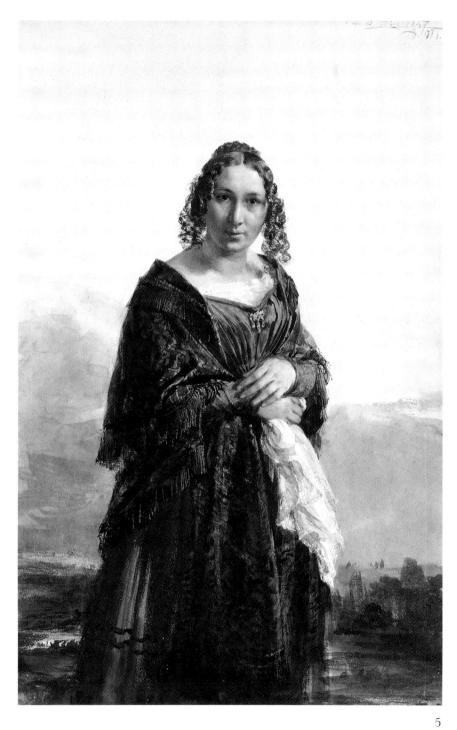

5

6

6. *Horse's Head and Dog*, 1848

Oil on gray paper

20.1 x 39.1 cm

Signed at lower left: *A.M. 48*

Provenance: acquired in 1906 with the estate of Adolph Menzel

N 4587

Bibliography: Berlin, 1905, no. 107d; Tschudi, no. 47, illus.

Menzel held a special preference for horses; he drew and painted them repeatedly in a great variety of situations. From the summer of 1847 until the spring of 1848, he stayed in Kassel to paint the "Kassel cartoon," a large mural of a historical subject. When not at work on this strenuous project, the artist often found opportunities to draw in the nearby stable. (Many of the resultant drawings are now in the Nationalgalerie.) "Of what has been the most interesting and most educational for me here is the horse farm and the riding stable; the stable master is very kind; there are splendid animals to observe there; I am often there . . . ," he wrote to his siblings on 15 September 1847 (Wolff, p. 111).

Back home in April, in the midst of the aftermath of the 1848 revolution, Menzel continued his studies of horses. Several were executed in oil on paper and also on canvas (see Tschudi, nos. 39–43, 50; the latter is in the Nationalgalerie, West Berlin). Belonging to this group is the sheet shown here of a brown horse's bridled head (cf. *Carriage Horse*, Tschudi, no. 23, now in the Nationalgalerie, West Berlin). A sense of the horse's magnificent sculptural qualities is emphasized through the placement of the small dog next to the larger animal.

Characteristic of Menzel's rigorous working processes was that he also drew from the heads of dead horses. On 3 May 1848 he wrote to his friend Arnold in Kassel, "Last week in the midst of 'Sang und Stank' [literally, song and stench], I painted from nature, in life-size form, a pair of horses' heads [see Tschudi, nos. 42 and 43; the latter is in the Reinhart Winterthur Collection] that I had brought to me from a butcher's shop. This was very educational. Presently, I am working on a sketch in color, what or whether something will come out of it, I do not yet know . . . " (Wolff, p. 134). Menzel mentioned that he had begun the painting *Honoring the Insurgents Killed in March 1848* (Tschudi, no. 52; now in the Hamburger Kunsthalle) with enthusiasm for the revolutionary movement but had left it unfinished out of disappointment in the revolution's outcome. It remains questionable whether an intellectual connection exists—and such "double meanings" often occur in Menzel's art—between the massacred citizens and the heads of the butchered horses. In a photograph taken ca. 1895, Menzel sits at his desk, with one of the almost life-size representations of horses' heads (including the one shown here) hanging next to the unfinished painting *Honoring of the Insurgents Killed in March 1848*.

<div align="right">M.U.R.</div>

7. *At the Concert*, 1848

Black chalk and colored chalks

26.6.2 x 36.7 cm

Inscribed at lower right: *3 Dec: 1848 / Erinnerung aus / musikal: Soir*

Provenance: acquired in 1906 with the estate of Adolph Menzel

N 4464

Bibliography: Tschudi, no. 214, illus.; Scheffler, *Adolph Menzel. Der Mensch, das Werk*, p. 164, fig. 139; Berlin, 1980, no. 11; Riemann and Robinson, *The Romantic Spirit*, no. 123, color pl.

Many of Menzel's letters document his interest in and understanding of music (see Wolff, *Briefe*, 1914). As it was common practice in bourgeois circles to hold musical evenings, Menzel did so in his home and within his group of friends. In addition to theatrical performances, concerts and visits to the opera formed part of the young artist's educational and cultural experiences. Not until old age did he fully lose his inclination to attend such events. Even in his early letters of the 1830s he had begun to write both enthusiastic and critical commentary on his musical experiences. His sketchbooks contain many small pencil studies that parallel his written impressions of the theater or the concert hall. We know, for example, that he heard Graun's *Tod Jesu* and Haydn's *Creation* as well as attended concerts of Mozart's works, including the operas *Don Giovanni, La Clemenza di Tito*, and the "divine music" of the *Zauberflöte*. In 1877, he described himself as one of the oldest regular guests who attended the symphony evenings held at the Opera House (see letter of 27 January 1877 in Wolff, p. 218). Menzel not only enjoyed music; he was also capable of judging it, which he did in his serious, or at times, characteristically scurrilous manner. For example, he reported from Kassel to his siblings that "the orchestra is good, but what has significantly astounded and shocked me is that Spohr [Louis Spohr, 1784–1859] appears to have no feeling for tempo—just one more example of the many—the tearful aria went at a trot!" (Wolff, p. 113).

In the 1840s and 1850s, Menzel often drew scenes from operas and concerts in a very painterly manner. Like the sheet reproduced here, Menzel rendered many studies from memory, relying on what he had conscientiously noted. Although he often observed the audience, he also sketched famous performers, such as Clara Schumann at the piano in 1854 with violinist Joseph Joachim (pastel drawing, private collection, New York; not in Tschudi). Menzel was friends with Joachim, and he did not enjoy missing the violinist's concerts.

In 1859, Menzel's sister Emilie married a family friend, the composer and director Hermann Krigar. The artist lived in the same household with them and their two children until his death. It was only natural that his love for music received further stimulus there. The Krigar-Menzel family owned Menzel's drawings (present location unknown) of the room in which Beethoven died in the Schwarzpanierhaus in Vienna, in addition to his drawings of the graves of Beethoven and Schubert. Menzel revered Brahms and left behind a note to him when he was absent: "I only wanted to have breathed in the air around you" (see Kirstein, *Das Leben Adolph Menzels*, Leipzig, 1919, p. 81). Menzel even came to accept Wagner's latest compositions. In 1876, he drew the maestro at the podium in Bayreuth during the premier performance of *Ring of the Nibelungen*. When Menzel's brother-in-law, the royal music director Krigar, died in 1880, it was Menzel who wrote his obituary.

<div align="right">M.U.R.</div>

7

8. *Menzel's Brother Richard with a Toothache*, ca. 1850

Black chalk and colored chalks, stumped, on brown paper.

A narrow section has been cut off the upper left edge of the sheet.

23.4 x 33.3 cm

Provenance: acquired in 1889 from Menzel's art dealer Hermann Pächter of the
firm R. Wagner, Berlin

Kat. 1369

Bibliography: Berlin, 1905, no. 1639; Tschudi, no. 251; Vienna, no. 28.

The figure at the left is a second study that is spatially unrelated to the main
figure.

<div align="right">C. K.</div>

8

9. *An Officer and a Gentleman in a Frock Coat Conversing,*
ca. 1850–55

Gouache over black chalk, partially stumped, on greenish brown paper
20.6 x 28.5 cm
Signed at lower right: *A.M.*
Provenance: acquired in 1905 from the estate of Adolph Menzel
N 316
Bibliography: Berlin, 1905, no. 4613; Tschudi, no. 249; Schmidt, no. 62; Berlin, 1980, no. 41.

The composition was executed in gouache over a sketchy chalk drawing. The men's heads and the uniform of the officer are rendered more solidly and with greater detail than other areas, which are more freely and summarily expressed. The washes do not extend to the lower edge of the sheet, thus allowing the untouched, tinted paper to provide the background. This drawing's theme corresponds to Menzel's delight in entering into the midst of everyday situations and capturing a moment of instability. Two different tempos are represented through the spatially dominant animation of the gesturing officer, his nervous hand shielded from view by the broad expanse of the chair, and the idle body of his companion. Menzel always presented his subjects within the context of such fleeting moments.

<div style="text-align:right">C. K.</div>

9

10

10. *Portrait of Dr. Puhlmann*, 1850

Watercolors and gouache

24.1 x 18.4 cm

Signed at lower left: *Menzel / 1850.*

Provenance: purchased from Menzel in 1903

Nr. 1713

Bibliography: Berlin, 1905, no. 200; Tschudi, no. 226; Berlin, 1980, no. 18, color pl.

The smiling gaze directed towards the viewer reveals the affection that the sitter, medical officer Wilhelm Puhlmann (1797–1882) of Potsdam, felt for the artist. Even though Menzel never wanted to be a portraitist, and his portraits were primarily created for special occasions or as favors, he succeeded brilliantly in this area. In addition to artistic ability, his watercolors, pastels, and pencil drawings attest to his grasp of the psychological aspects of portrait painting, which were bolstered by his extraordinary empathy and his knowledge of human nature.

The friendship between Menzel and Puhlmann began in the 1830s. At the latest, they first became acquainted in 1836 when Dr. Puhlmann, whose father was director of the Royal Picture Gallery in Potsdam, commissioned the young Menzel to lithograph a membership card for the local art society that he had co-founded two years earlier (see Bock, no. 146). Their relationship developed into a close, lifelong friendship that included both their families. Aside from his letters to his friend Carl Heinrich Arnold in Kassel, Menzel's correspondence with Puhlmann most freely expresses his character and life style in an engaging form.

M.U.R.

11. *Menzel and His Family at the Piano,* 1851

Graphite, stumped

22.5 x 28.5 cm

Inscribed at lower center: *A.M. 22. December 1851.*

Provenance: acquired in 1906 from Fritz Martini in Berlin, along with other portrait drawings of family members

Nr. 1744

Bibliography: Berlin, 1905, no. 5369; Berlin, 1980, no. 406; Vienna, no. 31.

At the piano sit Menzel's younger siblings Emilie and Richard, while in the foreground appears Constanze Martini, a young relative visiting from Silesia. Constanze was the daughter of his cousin Karl Martini of Jauer (Silesia), and Menzel had drawn her once as a child in 1844 (N 1748). Standing in the background to the right is the artist himself. The many intimate interior scenes that Menzel created in the 1840s are echoed in this drawing, which belongs to the few that, if only without consideration, could be called "Biedermeier." The pencil gently models the forms, and a soft light shimmers across the figures.

This compositionally complete sheet—a formally structured group portrait in which the artist represents himself in a frontal and inactive pose—was intended as a gift for the Martini family. Menzel kept for himself a more informal moment (N 4519). Its date of "52" indicated that it must have been created just before his niece's departure.

In 1906, the Nationalgalerie acquired from Fritz Martini, a descendant of the family, a complete group of portraits that Menzel had drawn largely in 1844 during his visit to Jauer.

<div align="right">C. K.</div>

11

12. *Two Guests at the Spa*, 1851

Colored chalks on light brown paper

37.4 x 30.6 cm

Signed at lower right in graphite: *A. Menzel.*

Inscribed at lower left: *Erinn: Arkona, August 1851.*

Provenance: transferred from the Kupferstichkabinett in 1878

Kat. 642

Bibliography: Tschudi, no. 300; Berlin, 1980, no. 24; Vienna, no. 30.

In August 1851, Menzel managed to include an eight-day excursion to Rügen with his sister Emilie as a restful interval from his intensive preparations for *Frederick the Great's Flute Concert at Sanssouci.* He gave an account of his journey in a letter to Carl Heinrich Arnold dated 26 December. "I had not imagined Rügen to be so; its splendid forest vegetation in such close association with the sea creates quite a wonderful ensemble" (Wolff, p. 154). The island landscape, which Menzel had discovered long before in the works of the Romantic painters C. D. Friedrich and in Berlin, Karl Blechen, was depicted in a multitude of drawings in Sketchbook No. 11 at the Nationalgalerie. (He had purchased this modest notebook en route in Stettin.) His observations of the people were equally sharp. "I could see the first individuals afflicted with seasickness on the short trip over; it did not affect me, though, and so there were the most wonderful sights to see." Towards the end of the visit, he drew (on pages 82 and 84 of the sketchbook) two separate figures that appeared soon afterwards in this gouache. Furthermore, the sheet's inscription does not indicate the date of its creation but rather the date of the remembered experience. We can only guess at the drawing's date, as we do not know how much time the artist allowed to elapse before he referred to his earlier sketches.

Gentleman and Lady, a drawing in colored chalks (Tschudi, no. 299, present location unknown), is a recollection from the same trip. The figure of the man in the cape was employed once more in the background of a chalcotype entitled *Les Voyageurs* (Bock, no. 1157).

<div align="right">C. K.</div>

12

13. *Tourists at the Rheinfels Ruins*, 1855

Watercolor and gouache over graphite

37.0 x 26.0 cm

Signed at lower left: *Menzel 55*

Provenance: purchased in 1906 from the art dealer Ed. Schulte in Berlin

Nr. 1722

Bibliography: Berlin, 1905, no. 5743; Tschudi, no. 334; Schmidt, no. 243; Berlin, 1980, no. 40

Menzel made his first lengthy journey in 1852, when he was nearly thirty-seven years old. The ten-week trip led him to Franconia and Bavaria, and then to Austria. Later, he traveled every summer, and southern Germany remained his favorite destination. With a mind open to all the innovations of his time, Menzel was fascinated with traveling by rail. He spoke in retrospect about his "little, later traveling" with a notable trace of regret that work, obligations, and concern for providing a livelihood for his mother and siblings had long kept him from this pleasure.

In 1855, on his return from his first trip to Paris to see the World's Fair, he journeyed up the Rhine via Cologne to the Rheinfels ruin near St. Goar. His baggage consisted of a voluminous suitcase that included an extra, well-used compartment. He packed it according to an outline drawing that was accompanied by the following description found in Sketchbook No. 14 (1855), his sketchbook for this trip. "Additional compartment: coats frockcoat sketchbooks and, where there is room, boots; below in the suitcase: undershirts nightshirts stockings handkerchiefs vests neckties shirts and trousers 5 pair . . . boots."

Menzel subjected himself to all the usual hardships of a journey at that time. The long train rides, his hotel accommodations, and even the destinations of his summer trips were scarcely different from those of his fellow bourgeois travelers. Once he returned to Berlin, he would work up the newly acquired motifs. "En route," he wrote, "I find little quiet and little time for actually painting or drawing studies; the material crowds itself too densely" (letter to C. H. Arnold, 27 October 1852; Wolff, p. 158). Many of his works, especially those from the second half of his life, document impressions gathered on his journeys. His perceptive eye did not shun banalities. In his recurring depictions of his rail journeys, he portrayed in an unrelenting manner his fellow travelers as they revealed themselves to him—in their public displays of intimacy or, as here, during a somewhat indifferent visit to a place of interest, the Rheinfels fortress, which dates from the Middle Ages and the Renaissance and which was greatly destroyed in the eighteenth century. Menzel's drawings often give unembellished information about human behavior, for his sense of realism did not omit trivialities. He became a chronicler of his time, but the innovative and rich rendering of his sheets distinguishes them from the popular art of the period.

A comparable sheet in color created around the same time also shows *Visitors at Ruins* (N 4449; Tschudi, no. 276), and the artist took up the theme once more in 1884 in the gouache *Visit to the Aura Ruins near Kissingen* (location unknown; Tschudi, no. 644). These sheets are united by the unsentimental relationship with nature that characterizes the world-traveling tourists they represent. This attitude is greatly removed from the sense of emotional connection with nature felt by their Romantic predecessors. It is Menzel's untiring eye, as manifested in such works, that links him to younger French colleagues such as Degas or Manet, whom his fellow German artists largely criticized.

M.U.R.

13

14

14. *Burning Building*, 1863

Gouache on dark prepared paper

29.9 x 39.3 cm

Signed at lower right: *Menzel 4 Juni 1863*

Provenance: acquired in 1906 with the estate of Adolph Menzel

N 232

Bibliography: Berlin, 1905, no. 4640; Tschudi, no. 415; Berlin, 1980, no. 47;
 Vienna, no. 37.

Like candlelight, lamplight, and moonlight, the effects of fire light was one of
Menzel's preferred subjects of study, especially in the late 1840s and 1850s. He
often intensified lighting effects by combining different light sources. For a time,
a policeman was commissioned to wake him as soon as a fire broke out in the
city. In the large painting *Frederick the Great and His Followers at the Battle of
Hochkirch, 1758* (1850–56; lost by the Nationalgalerie during World War II), these
studies brought especially striking results. The grisaille-like gouache here repre-
sents further pursuit of this area of study. On the dark, wax-like surface of the
slightly water-repellent ground, the paint gathered into tiny droplets. Only reflec-
tions of light were painted on this surface in layers of color that range from
brilliant white to light or rich ocher. Here and there a wide, bristle paintbrush
was employed. The artist even used his finger, traces of which can be observed
near the upper left corner. Focusing on the spontaneous rendering of space did
not hinder the artist from adding as a detail a group of firemen embedded in
darkness at the right center. They prefigure Menzel's later practices: thirty years
after he created *Prince Albert's Palace Garden* (1846; Nationalgalerie, West Ber-
lin), he added a group of resting workers to the painting.

<div align="right">C. K.</div>

II. The Period of Frederick II: Historical Works

(15–26)

The significance of history in Menzel's work is an expression of the development and emancipation of the German bourgeoisie in the nineteenth century. In their struggle for a German nation since the Wars of Liberation in 1814, German citizens repeatedly looked to the past.

As the movement toward restoration advanced after the failure of the 1848 revolution, the innovations in Menzel's history paintings were perceived to reflect his liberal bourgeois status and nothing more. Other painters filled the demand for representational works of the German empire that was established in 1871 better than he did. Menzel's art was directed towards the portrayal of the everyday life of this new society and the new ideals that the bourgeoisie attached to industrial progress. Menzel's experience with historical events began before the 1848 revolution, which had inspired him to create images with novel contemporary themes, such as *Honoring of the Insurgents Killed in March 1848* (Hamburger Kunsthalle).

In his series of lithographs for the book *Denkwürdigkeiten aus der Brandenburgisch-Preußischen Geschichte* (Memoirs from the History of Brandenburg-Prussia; 1834–36), his first exercise in historical representation, Menzel implemented an artistic method based on an exacting thirst for knowledge, which included the study of historical source material in documents, original images, and archives. In 1840, the publisher J.J. Weber in Leipzig commissioned him to illustrate Franz Kugler's *Geschichte Friedrichs des Großen* on the occasion of the centenary of Frederick II's accession to the throne. There, Menzel found not only a theme that would captivate him for decades, but in the process he also revived the wood-engraving technique in Germany.

Through his studies, Menzel became a specialist in the period of Frederick the Great, which he intellectually incorporated into the context of the bourgeois enlightenment. In 1842, he began the laborious task of creating lithographs for the three-volume opus *Die Armee Friedrichs des Großen in ihrer Uniformierung* (The Army of Frederick the Great in its Uniforms), which had been commissioned by the Berlin publisher L. Sachse. He came

to regret this work and, in retrospect, viewed the illustrations for Kugler with equal criticism. In 1902, he wrote as a dedication in one copy, "The work at hand, a first edition,—not seen in a long time—was not a happy reunion!!!" (H. Vollmar, "Menzeliana," in *Moderne Kunst in Meister-holzschnitten* 19 [1905], p. 182). In 1843, when he was commissioned by Frederick William IV to illustrate *Werke Friedrichs des Großen* (Works of Frederick the Great), Menzel documented his own artistic interpretation of the intellectual philosophy of the eighteenth century. His immense knowledge of that recent past, which he must have acquired through his own efforts, brought about his own "phantasmagoria," as Theodor Fontane called them. Occasionally, in his studies of the baroque and rococo periods, Menzel would bring to light works of art and artists long before art historians took notice of them.

Disappointment over the outcome of the revolution of 1848 strengthened his resolve to pursue the path he had once followed with great intensity and enthusiasm. "Once again too much has been entrusted to Humanity; added to the (just) indignation regarding those above is the indignation regarding those below. It is nothing but a jump from one school bench to the next . . ." (letter to C.H. Arnold, 15 September 1848; Wolff, p. 136). Instead of creating conceptual images far removed from actuality, Menzel tried to infuse his representation of Frederick with idealistic historical realism. To him, an enlightened monarchy appeared to be the best guarantee of progress during his own time as well. In his history paintings, Menzel strove to present Frederick's tragic conflict: his greatness of intellect (the artist no doubt had in mind the supremacy plan as Frederick had unfolded it in his letter to Voltaire) and his weakness in military concerns. Menzel also wanted to portray a ruler who would represent the national identity "that princes hated, and the people revered . . . : the old Fritz, who lived through the people . . ." (letter to Weber, 17 July 1838; Wolff, p. 32). And even if Frederick never truly equalled this description, in retrospect Menzel's images helped to create this idealistic aura. While Bismarck strove for Prussian supremacy before the founding of the Reich, the ruling aristocrats and their historians supported Menzel's interpretations in that they plainly saw Frederick as a symbol of the Prussian identity. Yet, in comparison with the tendency of history paintings to idolize, Menzel did not glorify or idealize his subjects, and thus at the time they were created, his works did not succeed as expected.

The director of the Royal Museums in Berlin, Ignaz Franz von Olfers, hoped to arrange the purchase of *Frederick the Great's Dinner at Sanssouci* (lost during World War II; Tschudi, no. 67), the second of Menzel's nine large paintings of Frederick, but in 1850 the king rejected the proposal. Because of this prospective sale, Menzel had interrupted his work on *Frederick the Great's Flute Concert at Sanssouci* (Nationalgalerie, West Berlin; Tschudi, no. 79), which he did not resume until 1851. Menzel, who claimed that he never approached his subjects casually, devoted himself to solving the complicated problem of conveying the effects of candlelight

from all sides as well as from above (see letter to Arnold, 16 December 1851; Wolff, p. 154).

In 1854, Menzel completed the fourth painting in the series, *Frederick the Great on a Journey* (Nationalgalerie, West Berlin; Tschudi, no. 94), for the renowned Berlin industrialist and art collector Louis Ravené. The *Battle at Hochkirch* (1851–56, lost during World War II; Tschudi, no. 106) succeeded as Menzel's most significant portrayal of a historic event. Here, in a manner similar to that of the unfinished painting *Bon Soir, Messieurs! Frederick the Great after the Battle at Leuthen at the Castle in Lissa, the Austrian Military Headquarters* (1857–58, Hamburger Kunsthalle; Tschudi, no. 117), he penetrated the subject afresh, surpassing the documentary detail and theatrical poses of the history painters of the Düsseldorf and Belgian schools. From genre painting he introduced the element of surprise into history painting and further invigorated the scene. Theodor Fontane described in his memoirs the sensational effect of Menzel's paintings on his friends and those in artistic circles. When writing from Paris to his wife Emilie on 21 October 1856, Fontane referred to the *Battle of Hochkirch* and added, "Let him . . . know that in Versailles, it first became clear to me how good and how significant his painting is."

After discontinuing his painting of the incident at Lissa, Menzel intended to commemorate in a second painting the centennial of the Battle at Leuthen of 1757, a battle that was won at the last moment. Once again, however, Menzel was frustrated by a self-imposed task, this one to represent convincingly the psychological impact of Frederick's inflammatory speech to his generals. This ninth and last painting of the cycle, *Frederick the Great's Address to His Generals before the Battle at Leuthen, 1757* (Nationalgalerie; Tschudi, no. 121), remained unfinished in the master's studio. Out of frustration with his own lack of ability, Menzel increasingly altered its surface by scratching out areas.

The Society for Historical Art, founded in 1855, wanted to prevent the decline of the highest order of art, i.e., history painting, and commissioned Menzel to paint *The Meeting of Emperor Joseph II and Frederick II in Nice* (Nationalgalerie; Tschudi, no. 112). Menzel completed the work in 1857, but the depressing fate of this painting and the negative criticism it received from the ranks of the adherents to idealistic history painting contributed to his complete withdrawal from this class of painting in 1860, after a span of ten years. The new element of genre in his Frederick pictures, which was based on traditional realism practiced in Berlin, remained unnoticed. After this artistic turning point, brought about by the commission for the "coronation picture" in 1861 (Staatliche Schlösser und Gärten, Potsdam; Tschudi, no. 128), the Frederician theme reappeared in the early 1860s in the form of six genre-style gouaches of scenes from Frederick's period as Crown Prince. It reappeared again at the end of the 1870s in a few sporadic wood engravings.

The development and significance of such historicizing genre painting, its popularity at the time, and above all, how it relates to Menzel's later

work has never been examined more closely. In this field, Menzel succeeded not only in creating noteworthy and original works of art, but also in extending the influence of seventeenth-century Dutch artists as well as Hogarth and Chodowiecki through critically ironic and psychologically interpretive elements.

M.U.R.

15. *Washington's Farewell*, 1836

Brush and gray wash

19.8 x 11.0 cm

Signed at lower left: *Menzel inv. & fec. 1836*

Inscribed below: *Mit einem Herzen voll Liebe und Dankbarkeit neh / me ich jetzt Abschied von Ihnen. Mein aufrichtigster Wunsch / ist, daß Ihre künftigen Tage so glücklich sein mögen, wie Ihre / vergangenen ruhmwürdig und ehrenvoll gewesen sind! —*

Provenance: acquired in 1891 with a companion piece, *Copernicus*, through the estate of the chemist Dr. Theodor Wagener, Berlin

Kat. 51

Bibliography: Berlin, 1905, no. 401

Menzel drew this small but polished composition probably towards the end of his work on the lithographs for *Denkwürdigkeiten aus der Brandenburgisch-Preußischen Geschichte* (1834-36) as he became involved in "a great many in-between projects" (see letter to Arnold, 23 February 1836; Wolff, p. 4). Together with a portrait of Copernicus, its companion piece of approximately the same size, this drawing was possibly intended as an illustration for a book on important personalities in world history. Menzel's composition portrays George Washington in a scene towards the end of the president's glorious career, when he delivered his now famous farewell address in 1796 as he departed from his loyal comrades-in-arms. In this manner, he relinquished a third re-election as president of the United States and retired to privacy for the last few years of his life. His departing message, which is indicated in Menzel's inscription, was essentially composed by Washington's aide-de-camp, the statesman Alexander Hamilton, who contributed to the draft of the first Constitution in 1787. A small pencil sketch, which certainly emerged in the context of this composition, represents the figure of Washington with a scroll and his hat in his hands (Kat. 1294). Also related is a study for a portrait (Kat. 1295).

M.U.R.

Menzel inv. & fec: 1836.

Mit einem Herzen voll Liebe und Dankbarkeit neh-
me ich jezt Abschied von Ihnen. Mein aufrichtigster Wunsch
ist, daß Ihre künftigen Tage so glücklich sein mögen wie Ihre
vergangenen rühmwürdig und ehrenvoll gewesen sind! —

15

16

16. *Frederick II's Room at the City Palace in Potsdam*, 1840

Graphite

20.8 x 13.0 cm

Signed at lower right: *A.M. 40*

Provenance: acquired in 1889 in a collection of Menzel's Frederkiana from the
art dealer Hermann Pächter of the firm R. Wagner, Berlin

Kat. 74

Bibliography: Berlin, 1905, no. 424; Schmidt, no. 182

The artist drew this representation of the king's study at the City Palace in
Potsdam as one of the 400 planned wood engravings (398 were executed) for
Franz Kugler's book *Geschichte Friedrichs des Großen*, which was published in
twenty parts from 1840 to 1842. The wood engraving (Kugler, p. 262; Bock, no.
599) portrays the king sitting on the sofa at his worktable. These illustrations
composed the young Menzel's first important, large commission, for which he
further refined the art of wood engraving after the example of Horace Vernet (see
Vernet's illustrations in Laurent de l'Ardeche, *Histoire Napoléon*, Paris, 1839).
Despite negative criticism by the old master Gottfried Schadow, who called them
"scrawls or scribbles" (*Spenersche und Vossische Zeitung*, 26 March 1840, Berlin),
the drawings established Menzel's fame. Menzel strove to achieve "the greatest
authenticity possible" in his work, as he told his publisher J.J. Weber in a letter
dated 23 April 1839 (Wolff, p. 27).

This drawing of the king's room was no doubt executed during one of Menzel's
study trips to Potsdam in November or December (see letter to Puhlmann dated
22 October 1840, Wolff, p. 52; and letter to J.J. Weber dated 31 October 1840,
Nationalgalerie Archives). Menzel had executed a graphite study of the writing
table and sofa in 1839 (Kat. 1690), which reveals that the angle of the table top is
somewhat exaggerated in the wood engraving and in the drawing shown here.
Such alterations in reality, which were intended to intensify spatial relationships
within a composition, can frequently be observed in Menzel's works and are
characteristic of his critical realism.

On 20 November 1840 he wrote to Weber regarding the wood engravings. "In
the one where Frederick writes in his study, I would like the figure of Fritz, the
floor inside the study, and the dark area in the background up to the wall clock to
be cut by Georgy. The little thing must be handled *very delicately*. For the
background, the same dark atmosphere over the battle at Mollwitz (which he cut)
should serve as a model for the rendering, of course, maintaining respect for all
the drawn-in details!" (Nationalgalerie Archives). By shortening the sharp vertical
lines in the upper and lower areas and by slightly modifying the visual angle, the
wood engraving appears wider than the preparatory study. Regarding this wood
engraving, Menzel noted in the book, "The room, still preserved in its original
state, was drawn on the spot." (The City Palace in Potsdam was destroyed in
1945 and its ruins were later removed.)

<div style="text-align: right">M.U.R.</div>

17. *The Marquise de Pompadour,* ca. 1841

Graphite

12.8 x 21.0 cm

Unsigned

Inscribed at upper center: *Iadem.*; at upper right: *Marqu: Pompadour.*

Provenance: acquired in 1889 in a collection of Menzel's Fredericiana from the art dealer Hermann Pächter of the firm R. Wagner, Berlin

Kat. 138

Bibliography: Jordan, *Das Werk Adolph Menzels 1815–1905,* p. 21, illus. on p. 15; Berlin, 1905, no. 488; Schmidt, no. 209

Here Menzel portrayed the mistress of Louis XV in a frontal, three-quarter view and in a profile study of her head. As he noted regarding the wood engraving in Kugler's *Geschichte Friedrichs des Großen,* both are "after contemporary portraits." It is presumable that this sheet was created as a study for that print. The wood engraving presents Mme de Pompadour in the same costume walking through a colonnade (Kugler, p. 435; Bock, no. 699). Precisely the same pose and presentation seen in this study were then employed in one of two hundred vignettes designed for the deluxe edition of *Werke Friedrichs des Großen* (Nr. 144; Bock, no. 968), which King Frederick William IV had commissioned Menzel to create (1843-49).

Menzel's wood engraving is alive with the lightness and magic of the rococo. Having studied the epoch of Frederick II, he felt an extraordinary affinity towards the period, as clearly demonstrated by many of his drawings after paintings, architecture, and the applied arts of the eighteenth century. The fictitious likeness of Mme de Pompadour sparkles with Menzel's clever interpretation of the text it illustrates, especially within the decorative frame that surrounds her. It alludes charmingly but unmistakably to the sensual pleasures of the French court and especially to the licentious orgies in the deer park.

M.U.R.

17

18

18. *Wilhelm, Count zu Schaumburg-Lippe,* 1850

Graphite and watercolor

20.2 x 12.8 cm

Unsigned

Inscribed at upper right: *Wilhelm regierend Graf / v Schaumburg Lippe / Portug. u. Engl: Feldmarschall / (M. d. Acad 1749) / die Farbe des Gesichts / ist recht. Das Gesicht / an sich aber taugt / nichts, das andere / ist besser.*

Provenance: acquired in 1889 from Menzel's art dealer Hermann Pächter of the firm R. Wagner, Berlin, in a collection of "Fredericiana"

Kat. 1202

Bibliography: Liebermann and Kern, *50 Zeichnungen,* no. 23, p. 7, color pl.; Riemann and Robinson, *The Romantic Spirit,* no. 125, illus.

In 1839, Menzel began to focus intensively on the period of Frederick II. Three years later, after completing the 398 wood engravings that illustrate Franz Kugler's *Geschichte Friedrichs des Große,* he began work in the same year (1842) on 436 pen lithographs for the so-called *Armeewerk* (three volumes, completed in 1857, published by Sachse & Co., Berlin). Since 1843, he had also been working on 200 wood engravings that were intended as final vignettes for the deluxe edition of the works and letters of Frederick II. These were completed in 1849.

In his attempt to achieve the greatest authenticity possible, Menzel quickly became a specialist of the Frederician period. Thus, he received the commission from King Frederick William IV, who had also suggested the production of the thirty-volume edition, which appeared between 1846 and 1857. Menzel studied the Frederician rococo period extensively in sources still accessible in the palace collections and the armory, in depositories of military uniforms and artworks, as well as in galleries, archives, and print rooms. In the course of his studies, it was necessary for him to create numerous sketches and drawings based on portraits, architecture, and art objects that did not appear in his final designs. This drawing of Count Schaumburg-Lippe no doubt belonged to that group of sheets, which Menzel classified as "chance subjects for possible use." Only the wood engraving after the portrait of Count Albert (Menzel erroneously wrote "Albrecht" on the preparatory drawing, Kat. 144) Wolfgang von Schaumburg-Lippe und Sternberg was permitted to appear in the edition on *Werke Friedrichs des Großen* (see Bock, no. 977). Menzel's inscription "n. Vanloo" and the color notations refer to the painting by Charles Amédée Philippe van Loo (1719–1795) from which he had drawn the likeness.

The location of the painting is not known, but on 30 May 1850 Menzel wrote to Dr. Puhlmann: "In addition to all this, yesterday Olfers [Ignaz Franz von Olfers (1793–1871), director of the Royal Museums] sent me 2 big, old, square [paintings] that he had shipped from Bückeburg so that they could be inserted into the sixteenth volume, which will now begin to be printed. One is of the Count Albrecht Wolfgang v.d. Lippe (the Freemason, whom Frederick, then the Crown Prince, persuaded to correspond with him). They must be drawn as quickly as possible so that the engravings are there in time" (Wolff, p. 147ff.). In the published edition, the wood engraving appeared after two letters from Crown Prince Frederick to Count Albert zu Schaumburg-Lippe, whose intervention had gained Frederick entry into the Order of the Freemasons in 1738.

It is conceivable that Menzel intended to include a portrait of Count Wilhelm von Schaumburg-Lippe (1724–1777) in his extensive, illustrated work because, in addition to the sheet discussed here, two other representations of him exist. The Count, who had governed since 1748 and was a prominent and influential figure, had proven his success as a general in the British army while still a young man. An early advocate of general military service, he founded a military school that Scharnhorst also attended from 1773 to 1777. He fought with distinction in the Seven Years' War, especially as an artillery commander in the allied Prussian and

English army, and in 1762 he led an English and Portuguese army against French and Spanish troops. The Count returned to Bückeburg in 1765 and married.

The masterpieces by the artist Johann Georg Ziesenis (1716–1776) were the nearly life-size portraits of the Count and his wife Marie von Lippe-Biesterfeld painted ca. 1770 (destroyed by fire in Berlin in 1945; see Börsch-Supan, exhib. cat., *Höfische Bildnisse des Spätbarock*, Schloß Charlottenburg, West Berlin, 1966, p. 208). Ziesenis made several copies of this portrait of the Count, and Menzel executed two drawings based upon them. In the second study, a half-length portrait of the Count in pencil (Kat. 1203), the inscription clearly indicates that Menzel must have seen two of the paintings. "Face color[:] earthy yellow. This face is from the large picture that was sent later, and [is] the more accurate one [See also the letter cited above. The "large picture" was therefore the one from the museum.]; all of the rest is exactly as it is in the smaller one." It may be supposed that the "smaller picture," as Menzel called it, came from the estate of Herder, who had been the Count's court chaplain in Bückeburg from 1771 to 1776. In 1807, Herder's widow gave a Ziesenis portrait of the Count to Gottfried Schadow while he was working on a bust of General Schaumburg-Lippe for the Valhalla in Munich. Menzel had probably seen the portrait (Staatliche Schlösser und Gärten, Potsdam-Sanssouci) in the palace of Prince August of Prussia when it arrived there ca. 1817–18 to supplement a collection of portraits of generals (see Joh. G. Schadow, *Kunstwerke und Kunstansichten*, edited by Götz Eckardt, Berlin, 1987, vol. 2 and notes to vol. 1, p. 81).

Menzel concentrated on the Count's face in the drawing of the head, and particularly on expressing the sitter's firmness and masculine strength. In this sheet the posture of the entire figure comes to the fore, as it did in Ziesenis' painting.

The Count's coat is colored red with yellow lapels, and on his head rests a black tricornered hat. He wears on his chest a medallion with a portrait of King Joseph I of Portugal set in diamonds and, to the left, the Order of the Black Eagle of Prussia.

Menzel drew a third image of the Count, a bust in civilian clothes, on a sheet beside a likeness of Gustav Adolph Baron von Gotter "after a painting of 1767 by Joshua Reynolds," as Menzel noted on the sheet (Kat. 1777). His notations on color again indicate that he sketched it from an original work (location unknown). In this stylistically altered drawing, Menzel once more captured with the eloquent virtuosity of his pencil the determined, noble features and the distinguished character of this man's countenance.

M.U.R.

19. *Rococo Chair*, ca. 1849–50

Black chalk, heightened with white, and stumping
30.7 x 20.2 cm
Unsigned
Provenance: acquired in 1889 in a collection of Menzel's Fredericiana from the
 art dealer Hermann Pächter of the firm R. Wagner, Berlin
Kat. 165
Bibliography: Berlin, 1905, no. 515; Schmidt, no. 270

This drawing of a rococo chair well exemplifies Menzel's habitual practice of
rendering studies from nature that were intended for the settings of his works on
the period of Frederick II. To find appropriate objects such as furniture, costumes,
or artworks, he exhausted all available resources and visited museums, palaces,
fine art repositories, and libraries. Menzel employed the image of this chair in his
painting *Frederick the Great's Dinner at Sanssouci* (begun in 1849, completed in
1850; lost during World War II). This chair, like others Menzel drew for *The
Flute Concert*, was located at the Berlin Kunstkammer during his lifetime. Cre-
ated by M. Hoppenhaupt the Elder, it most likely was originally placed in
Frederick's apartments at the palace in Berlin. The same chair, shown here in a
lateral view, is represented from behind in another study (Kat. 164).

<div align="right">M.U.R.</div>

20. *Menzel's Brother Richard at the Piano*
 Study for the Figure of Philipp Emanuel Bach at the
 Harpsichord, ca. 1851–52

Black chalks and colored chalks on yellowish brown paper
32.1 x 26.1 cm
Unsigned
Inscribed with notes regarding light effects
Provenance: purchased from Menzel's art dealer Hermann Pächter of the firm R.
 Wagner, Berlin, on 23 April 1889 in a collection of 1,314 works by Menzel
Kat. 679
Bibliography: Berlin, 1905, no. 1005; Berlin, 1980, no. 214; Hermand, *Das Flö-
 tenkonzert*, p. 42, fig. 28

Of all the preparatory studies for the *Flute Concert*, this is an especially masterful
drawing of the view from the back of the court harpsichordist Philipp Emanuel
Bach. One of Johann Sebastian Bach's sons, he was engaged by the court of
Frederick II from 1740 to 1767. Menzel's brother Richard posed for the figure in
this study.

<div align="right">M.U.R.</div>

19

20

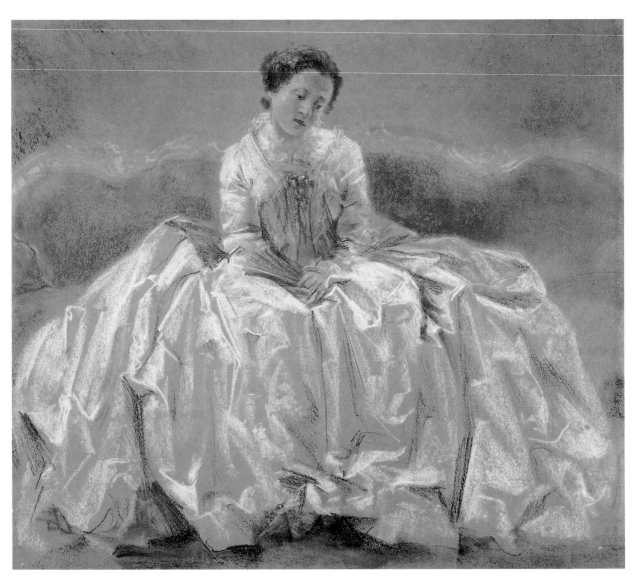

21

21. *Study for the Figure of the Margravine Wilhelmine von Bayreuth*, ca. 1851–52

Colored chalks on brown paper

38.6 x 44.1 cm

Unsigned

Provenance: purchased from Menzel's art dealer Hermann Pächter of the firm R. Wagner, Berlin, on 23 April 1889 in a collection of 1,314 works by Menzel

Kat. 673

Bibliography: Berlin, 1905, no. 999; Berlin, 1980, no. 218, illus.; Vienna, no. 6, illus.; Hermand, *Das Flötenkonzert*, p. 47, fig. 31

While creating studies for his illustrations for the Kugler project and for *Werke Friedrichs des Großen*, Menzel drew from a miniature portrait (Kat. 1125) Frederick's favorite sister, Wilhelmine, the Margravine von Bayreuth, seated on a sofa. This drawing, however, is not related to that delicate pencil drawing.

On the occasion of the Margravine's visit to Potsdam, a concert was held in Sanssouci at which the king, who was also a composer, played the flute. Wilhelmine was seated in an open area, her figure lit by a brilliantly shining chandelier.

M.U.R.

22. *Study for the Figure of Frederick II in an Armchair*, 1852

Black chalk, stumping, white heightening, on brown paper

34.2 x 28.4 cm

Unsigned

Provenance: purchased from Menzel's art dealer Hermann Pächter of the firm R.
Wagner, Berlin, on 23 April 1889 in a collection of 1,314 works by Menzel

Kat. 155

Bibliography: Berlin, 1905, no. 505; Schmidt, no. 264; Berlin, 1980, no. 220,
illus.; Vienna, no. 8, illus.; Lammel, *Frideriziana und Wilhelmiana*, p. 47, fig.
36

In addition to the nine large Frederick paintings, Menzel executed in the 1850s
six small genre-like scenes on the theme of "Frederick." In 1852, two of these
gouaches emerged from a commission by the Parisian art dealer Goupil. As
Menzel wrote in June 1852 to his friend Arnold in Kassel, Goupil had already
contracted the artist for the work in December of the preceding year (Wolff, p.
156). Menzel drew this study for the painting *Frederick the Great with the Dancer
Barbarina Campanini* (location unknown; Tschudi, no. 81, illus.). Studies also
exist of Barbarina Campanini (Kat. 1122, 1123, 553). In the painting, Frederick
jests with the renowned ballerina of his opera house, surrounded by his confidants
Chazot, Rothenburg, and Algarotti. Its companion piece pays homage to the old
king, who appears with the wheelchair-ridden General Fouquon on the terrace at
Sanssouci (Muzeum Narodowe Poznan, Warsaw; Tschudi, no. 80, illus.).

M.U.R.

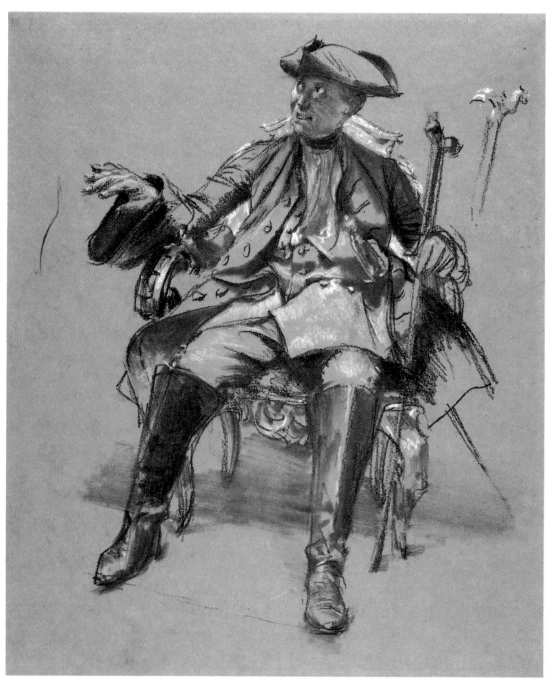

22

23. *Four Studies for the Figure of a Soldier*, ca. 1850–56

Black chalk, heightened with white, and stumping

22.5 x 29.3 cm

Unsigned

Provenance: acquired in 1889 in a collection of Menzel's Fredericiana from the
art dealer Hermann Pächter of the firm R. Wagner, Berlin

Kat. 468

Bibliography: Berlin, 1905, no. 818

This is a preparatory study for the figure of a soldier in the foreground of
Frederick the Great and His Followers at the Battle of Hochkirch, a painting that
represents the bloody night battle of 13 and 14 October 1758, which Frederick II
lost to the Austrians. Menzel worked on this image of defeat from 1850 to 1856.
The painting was lost during World War II, but Menzel's contemporaries viewed
its horror of impending defeat as one of his most prodigious and impressive
achievements. The king himself appeared on horseback amidst the smoke of gun
powder and fire, urging his surprised and hastily assembling soldiers into the
unholy tumult. A study in colored chalks (Kat. 471) is also in the Nationalgalerie,
as are numerous pencil sketches of the soldier who crawls up the rise in the
foreground of the painting.

Paul Meyerheim related in his recollections (*Erinnerungen*, p. 24ff.) how, as he
and his father, the painter Eduard Meyerheim, were taking a walk, they suddenly
saw a peculiarly dressed soldier on the Kreuzberg near Berlin attempting to climb
a steep, sandy incline. He repeatedly slid down, but although he was covered with
dirt, he renewed his efforts. They later recounted the scene to Menzel, who had
already drawn many studies of the man. Meyerheim also reported here that
Menzel had arranged for the night watchman of his district to wake him in the
event of an early morning fire in the city. In this manner, Menzel could study
firsthand the appearance of a great fire like that represented in his *Hochkirch*
painting.

M.U.R.

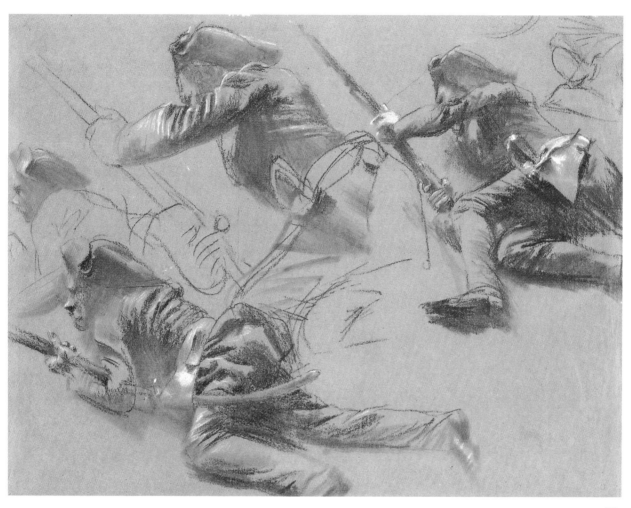

23

24. *Two Studies for the Figure of an Officer with a Candle,* ca. 1856–58

Black chalk, heightened with white, and stumping

28.7 x 21.9 cm

Unsigned

Provenance: acquired in 1906 with the estate of Adolph Menzel

N 4431

Bibliography: Riemann and Keisch, *Adolph Menzel*, no. 9, illus.

Derived from a model, this preparatory study was intended for the figure of an officer in the unfinished painting *Bon Soir, Messieurs! Frederick the Great at the Castle in Lissa* (1857–58, Kunsthalle, Hamburg; Tschudi, no. 117). The figure appears at the upper right on the steps, below the Austrians who rush by in surprise as Frederick II enters the military quarters of the Austrians after the Battle at Leuthen with the greeting, "Bon Soir, Messieurs!" Menzel repeatedly made such studies from life to master a particular pose, without slavishly copying them in his paintings.

As in the *Hochkirch* painting, Menzel again chose a scene of surprise and pursued similar compositional devices to explore potential lighting effects, as seen in this interior view. The painting remained unfinished, since its patron, Baron von Ratibor, disapproved of the unusual interpretation of the event.

M.U.R.

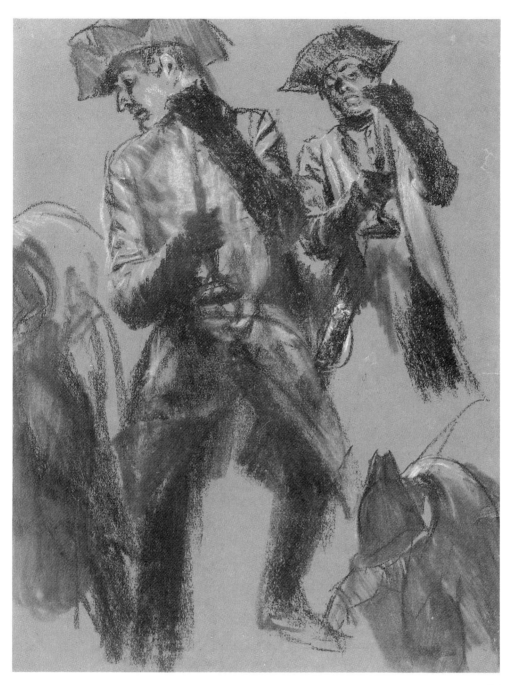

24

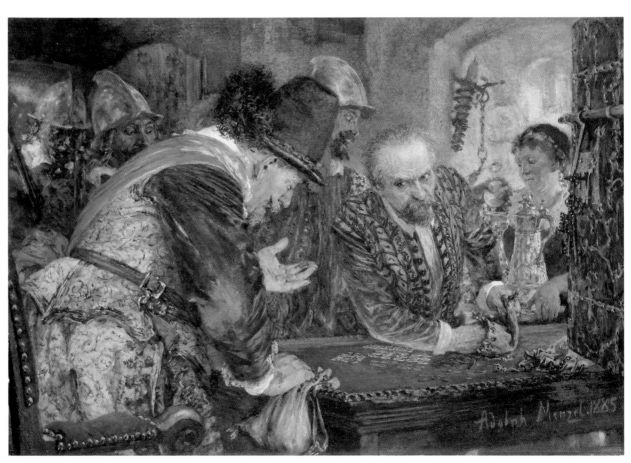

25

25. *Contribution*, 1885

Gouache

17.4 x 24.7 cm

Signed at lower right: *Adolph Menzel. 1885*

Provenance: formerly in the Staatliche Graphische Sammlung, Munich, sold in 1940; entered the Sammlung der Zeichnungen, Nationalgalerie, East Berlin, after 1945

Nr. 1802

Bibliography: Berlin, 1905, no. 205; Tschudi, no. 651, illus.; Berlin, 1980, no. 109, illus.; Vienna, no. 14, illus.

During his life, Menzel established the significance of what previously had been only a subject within the range of genre painting—the historicizing genre scene. The German Renaissance, the world of the Dutch bourgeoisie in the seventeenth century, and the French rococo proved rich in subject matter. In contrast to the sentimental transformation of reality that took place in most genre scenes of that period (and re-emerged after 1848 as the populace became more disillusioned with current conditions), Menzel's smaller works often have an ironic, comic, or slightly remote quality. His precise knowledge of historic details—a vast number of studies of costumes, armor, and art objects accompany his larger works— allowed him to select themes at will.

In the *Illustrierte Zeitung* (Leipzig, vol. 85 [1885], p. 586), this image in gouache was entitled *Collecting Contributions from Fellow Party Members*. Ludwig Pietsch gave the following description. "In the office of a businessman, an officer at the head of a commando of riflemen ('Flintlocks') arrives to gather contributions for party armaments. The scene takes place during the period before the outbreak of the Thirty Years' War."

<div align="right">M.U.R.</div>

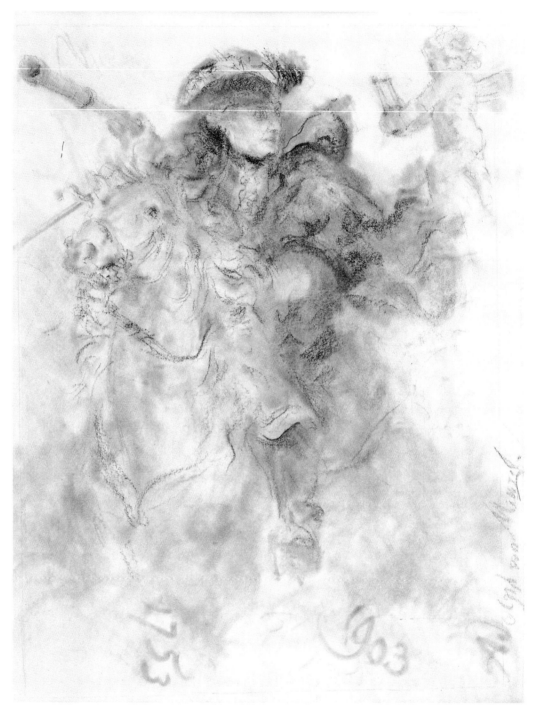

26

26. *Frederick II on Horseback*, 1903

Carpenter's pencil, stumping
32.0 x 25.0 cm
Signed at lower right: *Adolph von Menzel*
Inscribed near lower center: *1753 / 1903*
Provenance: acquired in 1911 from Oberleutnant C. v. Burgsdorff
Nr. 1776
Bibliography: Berlin, 1905, no. 6925

This drawing of Frederick riding his white horse Condéis a preliminary sketch for the music program for the jubilee celebration in Döberitz (Stichting Huis, Doorn; Tschudi, no. 686, illus.). There, on 25 May 1903, an obelisk was unveiled in commemoration of the dedication of the military training field, which had occurred one hundred fifty years earlier in 1753.

 This late sheet, on which a small putto with an hourglass in his hands represents the artist's thoughts, concludes Menzel's work with his great theme of "Frederick," which had engaged so many years of his life. Like an apparition, the figure of the king appears, evoked by the master's ingenious drawing technique.

<div align="right">M.U.R.</div>

III. Prussian Events and Armory Fantasies

(27-37)

After returning home from a restful sojourn at the Spa Freienwalde, Menzel was surprised on 12 October 1861 by a visit from the Minister of Culture von Bethmann-Hollweg. He presented Menzel with a commission from King William I to paint the monarch's coronation ceremony, which was to take place in Königsberg (the site of the coronation of the first Prussian king) in six days, on 18 October. It may be concluded from the short notice of the request that the selection of Menzel was debated until the last moment.

Indeed, it was not the first royal commission he had received. From 1843 to 1849 he had designed the wood engravings for the deluxe edition of *Werke Friedrichs des Großen*, which King Frederick William IV had ordered. For Tsarina Alexandra, a sister of Frederick William IV and William I, he executed ten gouaches in commemoration of the "Festival of the White Rose" (1854, Drawings Collection, Hermitage, Leningrad; Tschudi, nos. 319–28). Yet Menzel's interpretation of Frederick II as an enlightened monarch, which corresponded to the views of democratic liberals, was not agreeable in light of the advancing restoration, and the king's planned purchase of *Frederick the Great's Dinner at Sanssouci* did not ensue. The *Hochkirch* painting, which was acquired by Frederick William IV in 1856, never enjoyed a worthy location in the palace. (Both paintings were lost during World War II). Max Schasler, who had long criticized Menzel's realism, and particularly his painting of Frederick and Joseph II meeting in Nice (Nationalgalerie), expressed the same sentiments regarding the "coronation picture."

With this significant new commission, Menzel's social position improved considerably. He strove, however, to maintain his artistic independence, even when he appeared to exemplify the "compromise of the bourgeoisie with the nobility." In a letter to Dr. Puhlman dated 7 April 1848, he referred to himself as having "thoroughly plebian" sympathies (Wolff, p. 132).

The revival of the coronation ritual, in the place of the heir's simple acceptance of society's oath of allegiance, must be recognized as an

expression of a program of restoration. The date of the coronation, the anniversary of the Battle of Leipzig, was also carefully chosen. From this trend arose the desire to document the historic event of the emergence of a renewed dynastic claim to power.

Menzel accepted the commission, but it remained his last of that kind. On the same day he received the news, he wrote to his painter friend Friedrich Werner (1827–1908) to ask if he might assist him in rendering "local studies." Werner accompanied him to Königsberg. (He had already worked with Menzel towards the end of his laborious *Armeewerk* by producing studies of costumes in Paris [F. Werner, no. 68, Sammlung der Zeichnungen, Nationalgalerie].) Regarding two other drawings (Nrs. 74, 75), Menzel noted that they were "drawn for me by my Werner in Dec. 1858." Menzel later wrote in the foreword to the documentation on the commission, "This is the only assistance I have received for the duration of the work. Every portrait study as well as the painting, from the [first] sketch to the last brushstroke, are works by my own hand. . . ."

A great number of pencil studies, with some studies in color among them, were created on the spot. These depicted the late gothic palace church in Königsberg decorated in baroque fashion. In 1880, together with most of his portrait studies, the Nationalgalerie acquired a folio album designed by Menzel. It includes a two-page report on his work and several photographs of the painting in progress in his studio, which was the converted Garde-du-Corps Hall of the palace in Berlin. (Combined with the studies from the palace church, 166 sheets from this series are today in the Sammlung der Zeichnungen.)

It took Menzel four years to complete the large format painting *The Coronation of William I in Königsberg on 18 October 1861* (Nationalgalerie). On 6 April 1862 he moved into the studio "after a collection of arms and armor stored there until then was partly cleared out, partly pushed to the side." The first study to establish the overall painterly effect of the canvas is a gouache (see cat. no. 27). Two months of "sketching with black ink and a bristle paintbrush" followed. The complexity of the painting required Menzel to render on canvas the portraits of many individuals immediately after their respective sittings and as randomly as they appeared: "Today for the background, tomorrow for the foreground, etc. . . ." For the queen, who refused to sit for her portrait, he relied on his "memory of observations offered by court festivities." For nine figures in the background who had died or did not come to Berlin, he was instructed to use photographs. All the remaining individuals, including the king, sat for him in his hall studio "clad in their respective gowns, regalia, uniforms. . . ." A total of 152 portraits are included in the painting.

Menzel vigorously protected himself against the suspicion that he had worked from photographs. His credibility is beyond doubt, even though such a legitimate procedure would have been kept confidential by most artists during Menzel's time. On 10 October 1866 Menzel wrote to a journalist who had reported on the "coronation picture" in the *Fremdenblatt*

and assumed that the artist had received significant aid from photographs. Menzel maintained that he had refused all offers from photographers, and continued, "Regarding the above, it will become sufficiently clear how I feel about the application and use of photography in painting; that the same [photography], as much as I am convinced of the excellence of the discovery as such, is diametrically opposed to my belief in the responsibility of the artist to art and his self-confidence; and even the continuation of such a method must necessarily lead to the loss of tone in certain important powers of the eyes, the hand, the memory, and the imagination concerning animated nature . . ." (Nationalgalerie Archives).

Sittings for the portraits began on 19 March 1865; on 16 December 1865 the painting was completed. The phenomenon of the singularly unidealized, disillusioning, almost soulless rendering of the many different and so brilliantly drawn physiognomies has always been noted and admired.

M.U.R.

27. *First Sketch for the "Coronation of William I,"* 1861

Gouache

22.6 x 28.9 cm

Unsigned

Inscribed at lower left: *Geistlichkeit*

Provenance: acquired in 1880 from the art dealer Hermann Pächter of the firm R. Wagner, Berlin

Kat. 841

Bibliography: Berlin, 1905, no. 112; Tschudi, no. 420; Hans Werner Grohn, "Menzel. Die Krönung König Wilhelms I. zu Königsberg," in *Blickpunkt* 1, Hannover: Niedersächsische Landesgalerie, 1976; Berlin, 1980, p. 49ff. and no. 249, illus.; Lammel, *Frideriziana und Wilhelmiana*, p. 121ff., col. illus.

Of the four existing sketches in color for the complete composition of the "coronation picture," this is apparently the first. With a light touch, Menzel captured the color tonalities and the lighting effects of the interior of the palace church in Königsberg. The foreground remained free of figures. In a similarly executed sheet of this scene, the figure of the king was added (formerly in the collection of the emperor; Tschudi, no. 421). The somewhat larger gouache on paperboard (40 x 55 cm) may be considered a third sketch (Niedersächsische Landesgalerie, Hannover; Tschudi, no. 422). Like the first version shown here, it represents the complete composition, but in a rather precise manner in wash over pen and ink. Menzel later modified the figure of the king and the position of the crown prince, and divided the row of figures standing in the foreground into two halves. (For a more detailed discussion of these modifications see Lammel, *Frideriziana und Wilhelmiana*, p. 142ff.). The oil study on canvas (74.5 x 100 cm; Nationalgalerie; Tschudi, no. 127) emerged as the last sketch of the scene before Menzel changed the composition. In its looser application of paint suited to capturing lighting effects and in its incomplete portrayal of the foreground figures, it closely resembles the gouache study shown here. The aforementioned alteration in the composition not only lends greater dynamism to the finished painting, which is over four meters wide (Staatliche Schlösser und Gärten, Potsdam; Tschudi, no. 128), but it also created an appropriate position for the representation of the liberal ministers,

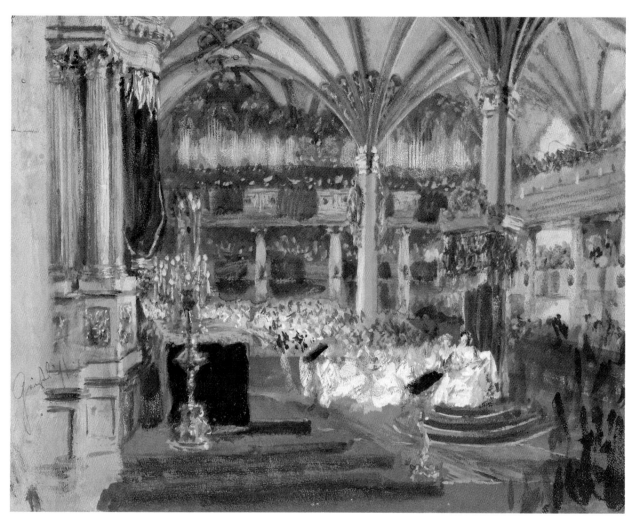

27

who had already been discharged in 1862. Menzel then undertook rendering the figures directly onto the canvas with only the aid of individual figure studies.

In a letter dated 1 July 1879 to the writer Friederich Pecht (Kirstein, *Das Leben Menzels*, p. 113), Menzel wrote: "The painting and certainly the version about which I am enthusiastic [in reference to the modified version] was a great effort for me; but [I am] from the first to the last stroke no martyr. On the contrary, [it provides] a continuous range of interesting [and] educational assignments and exercises. In this manner, four years have passed. I could have had a less expensive [task] and (above all) probably also reaped more thanks. Further: no objections or intrigues and what goes along with them have taken place. No attempts at preferential treatment have given me trouble. I have been allowed to exercise complete control."

<div align="right">M.U.R.</div>

28. *Friedrich Karl, Prince of Prussia*, 1863

Gouache over graphite, heightened with white, on reddish paper

29.6 x 23.1 cm

Inscribed at upper left: *Pr: Friedrich Carl K.H. / 14 Dec: 63 / Größe circa 7 "Kopf 9"*

Provenance: acquired in 1880 from the art dealer Hermann Pächter of the firm R. Wagner, Berlin

Kat. 961

Bibliography: Berlin, 1905, no. 1282; Tschudi, no. 437; Schmidt, no. 289; Berlin, 1980, no. 256

Menzel himself designated the day on which he drew this bust portrait of the prince, who faces left in a quarter-profile view. In the painting of the coronation, however, the prince appears in profile facing right, as Menzel drew him on 9 December 1864 (Kat. 962; Tschudi, no. 436). The reason for this modification resides in the composition. In a large, magnificent volume that includes photographs (Nationalgalerie), Menzel described the process of his work on the "coronation picture," which engaged him from 1861 until 1865. He noted: "Some poetic license has become unavoidable: the modification of the foreground. The princes of the royal family, the ministers, and the Knights of the Order of the Black Eagle stood as indicated in the sketch [Nationalgalerie; Tschudi, no. 127], in three rows in front of the royal platform. Thus, little else, other than the backs and backs of heads of all of these important individuals, would be required. For this reason, I had to divide this area and organize it differently." In the painting, the princes all appear at the left and the group of ministers of state at the right.

Friedrich Karl (1828–1885) was the only son of Prince Karl, the brother of Emperor William I and a follower of the later Minister of War von Roon. He was the first Prussian prince to study in Bonn, and he distinguished himself as an officer during many war campaigns. As an opponent of "parade and march service" in 1858, he fell out of favor for some time. In 1866 and in 1870–71, he commanded the First and then the Second Army, became field marshal, and after the conclusion of the peace, general inspector of the cavalry. He was a general without genius—decisions weighed heavily on him—but he was firm in his resolve.

<div align="right">M.U.R.</div>

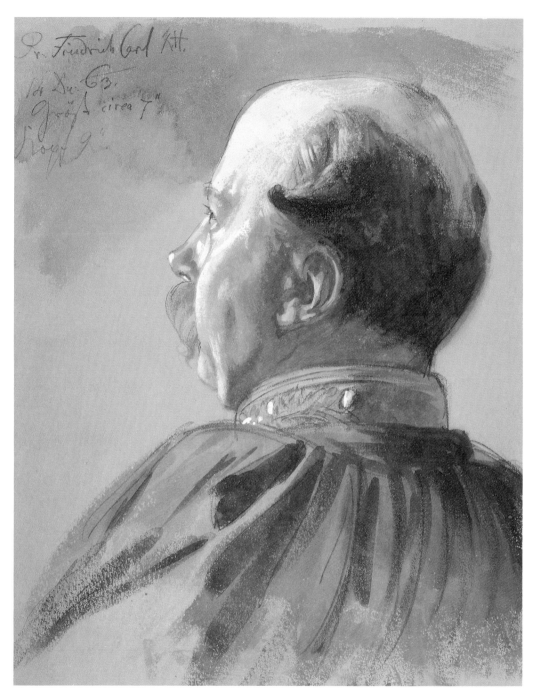

28

29. *Minister of State Robert Count von Patow*, 1864

Graphite, watercolor, and gouache on gray paper

29.2 x 22.2 cm

Unsigned

Inscribed at lower right: *Staatsminister von Patow. / 2 Febr: 64*

Provenance: acquired in 1880 from Menzel's art dealer Hermann Pächter of the firm R. Wagner, Berlin, together with the oil sketch and most of the studies for the "coronation picture"

Kat. 938

Bibliography: Berlin, 1905, no. 1259; Tschudi, no. 501, illus.; Schmidt, no. 291; Berlin, 1980, no. 263, illus.; Vienna, no. 44, illus.; Lammel, *Frideriziana und Wilhelmiana*, p. 137, illus.

Erasmus Robert Count von Patow (1804–1890) was a prominent liberal politician during the revolution of 1848. In 1859, he became the minister of finance but was forced to withdraw to parlimentary activity at the end of the "New Era" (the liberal period that lasted from the assumption of power by Crown Prince William until the first year of his reign as king, that is, from 1859 to 1862). Not without good reason was he valued as the most liberal member of the ministry.

Patow's head is seen among the ministers of state in the right foreground of the painting, just as it is portrayed in the drawing. The addition of the profile view demonstrates that Menzel's interest in the study of his model exceeded his immediate purpose. Additional views, especially profiles, can be found on many of the study sheets for the coronation scene. A full-length drawing of Patow was rendered in pencil (Kat. 937).

M.U.R.

29

30

30. *Otto von Bismarck*, 1865

Graphite, watercolor, and gouache, on ocher-colored paper

29.4 x 22.7 cm

Unsigned

Inscribed at the top edge: *Minist. Präs: v. Bismarck-Sch. 4.Mai 65*

Provenance: acquired in 1880 from Menzel's art dealer Herman Pächter of the firm R. Wagner, Berlin

Kat. 877

Bibliography: Berlin, 1905, no. 1198; Tschudi, no. 452, illus.; Berlin, 1980, no. 264, illus.; Vienna, no. 46, illus.; Lammel, *Frideriziana und Wilhelmiana*, 1988, p. 137, illus.

In 1861, Otto von Bismarck (1815–1898) was still an ambassador in St. Petersburg, where he had been sent during the short liberal period of the rule of the Crown Prince. He did not attend the coronation ceremony. But with his rise in status after he was appointed prime minister of Prussia and minister of foreign affairs in September 1862, he could not be absent from the painting, even if he only appeared in the background. The king, who had fallen into a crisis due to his military and constitutional politics, was considering abdication, but he saw an alternative in Bismarck's appointment. It was also Minister of War von Roon and Bismarck who resolutely pushed the king in the direction of a forced unification of Germany through "blood and iron."

Menzel later painted larger than life-size likenesses of both Bismarck and Helmuth von Moltke. In 1871, the paintings (Staatliche Schlösser und Gärten, Potsdam) served as decorations for the Academy of Arts building when the victorious troops entered Berlin. There is also a preparatory study in the National-galerie (N 199). In a letter dated 16 October 1894, Menzel wrote that his contact with Bismarck "scarcely [went beyond] a conventional handshake . . ." (Wolff, p. 230).

M.U.R.

31. *Three Standing Suits of Armor and Two Helmets*, 1866

Watercolor and gouache over soft graphite on light brown paper

41.1 x 31.7 cm

Signed at lower left: *Ad Menzel 66*

Provenance: acquired in 1907 with four other Menzel drawings from the collection of the painter Max Liebermann, who acquired them before 1895

Nr. 1753

Bibliography: Berlin, 1905, no. 277; Tschudi, no. 554; Berlin, 1980, no. 52; Vienna, no. 112

32. *Several Views of Two Suits of Armor*, 1866

Watercolor and gouache, gray on gray, and graphite on yellowish paper

29.3 x 51.2 cm

Signed at lower left: *A. Menzel 66*

Provenance: acquired in 1905 from the estate of Adolph Menzel

N 4473

Bibliography: Berlin, 1905, no. 4597; Tschudi, no. 550; Schmidt, no. 298; Vienna, no. 112

These two large sheets belong to a series that was exhibited at the Berlin Academy of Arts in 1866, the same year the drawings were created. The works were grouped in the exhibition catalogue under the collective title *Rüstkammerphantasien* (armory fantasies).

A studio had to be prepared in the royal palace in Berlin so Menzel could work on the immense "coronation picture" (1861–65). The so-called Garde-du-Corps Hall was rearranged, and the Renaissance armor stored there was simply moved to the side. After completing the painting, Menzel retained the workshop for a time, primarily to house another painting of ungainly size, the unfinished *Frederick the Great's Address to His Generals before the Battle of Leuthen*. There, at the beginning of 1866, he painted a small series of consecutive sheets in color of different views of armor.

Indeed, in this manner he continued earlier, basic studies of historically significant costumes and weaponry, which had emerged, among many other studies, in preparation for the extensive project of creating 436 lithographs for *Die Armee Friedrichs des Großen in ihrer Uniformierung* (1851–57). As his choice to employ a watercolor technique demonstrates, Menzel's interest in realistic documentation had diminished as much as he could allow. Although several small sheets (see Tschudi, nos. 541–43, 547–49, 551–52) were still executed in a familiar style, they initiated what became essential in later compositions, namely, the painterly effects of highlights on gleaming iron glowing out of deep shadows, and ghostly, marionette-like semblances of life in emptied shells that appear to be animated. Menzel seems to allude ironically to the revived cult of glorified chivalrous splendor just at the time of Germany's discovery of a national identity. In several small genre scenes from the sixteenth and seventeenth centuries, he contrasted this idealized gallantry with everyday reality to a grotesque degree.

That same year he created the lithograph *Guess, Who is it?* (Bock, no. 86), which incorporates an armored knight with a closed visor—no longer an empty panoply—into an anecdotal scene. Similar figures can be found among his small gouaches of historic genre scenes, such as *Blind Cow* (1867; Tschudi, no. 558) and *Knight with a Great Thirst* (1875; Tschudi, no. 615). A year before the creation of the Armory Fantasies, a small oil painting of *The Knight at the Smithy* (Kunsthalle, Hamburg; Tschudi, no. 125) emerged. To a certain extent, it antici-

pated Menzel's large watercolors in its dramatic light effects and mysterious mood.

The painting *Studio Wall* (1872, Kunsthalle, Hamburg) is also conceptually related to the Armory Fantasies in its depiction of death masks lit from below. Here, Menzel revived the forms magically and suggestively, far surpassing the simple atmospheric "painterliness" of stagings in a studio. Artists of this period frequently portrayed their splendid accumulations of historical sets in their studios (e.g., Alexander Couder, 1850, Troyes; Antoine Vollon, 1868, Lunéville; Vaclav Brozik, 1878, Prague), yet this is not the subject of Menzel's work.

An influential Berlin publisher reacted to the exhibition of some of these sheets in this manner. "First of all, they are in no way 'paintings,' but studies, with a great nonchalance; indeed, [they are] dashed off with extraordinary skill . . ., therefore, they largely make such a subjective, capricious impression that one must well admire the specific 'genius' of the artist, but otherwise, objectively one would have no interest in the work" (Max Schasler, in *Die Dioskuren* 11 [1866], p. 378).

The Nationalgalerie possesses the essential body of works of the Armory Fantasies. Menzel sold at least two of these major works during his lifetime. One composition (Tschudi, no. 553) entered the collection of the Kunsthalle in Hamburg in 1892. Another did not resurface until 1932 in the Galerie Caspari in Munich (present location unknown; see the comparative illustration for cat. no. 92 in *Menzel der Beobachter*, Werner Hofmann, ed.).

<div align="right">C. K.</div>

31

32

33. *Moltke's Binoculars,* 1871

Graphite and gouache

26.0 x 40.0 cm

Signed at upper right: *Ad. Menzel*

Inscribed at upper edge: *Feldmarschall G: v. Moltkes' Fernglas (und: Futteral) dessen er sich im Kriege von 1870–71 bediente*; various measurements

Provenance: acquired in 1906 with the estate of Adolph Menzel

N 1022

Bibliography: Berlin, 1905, no. 3999; Tschudi, no. 592, illus.; Berlin, 1980, no. 279, illus.; Vienna, no. 98, illus.; L. Griesebach, *Zeichnungen, Druckgraphik und illustrierte Bher*, West Berlin, 1984, p. 18ff., illus.

The study of Moltke's binoculars and their leather case is a small outgrowth of the preparations for the larger than life-size, full-length portrait of Helmuth von Moltke that Menzel painted to decorate the Academy of Arts building on the occasion of the entry of victorious Prussian troops into Berlin on 16 June 1871 after the Franco-German War. The portrait of Moltke and an equally large one of Bismarck (both in the Staatliche Schlösser und Gärten, Potsdam; not in Tschudi), along with three other portraits of successful generals, dressed the windows of the building. They contributed only a tiny detail to the artistic decorations of the "via triumphalis," which led across the Belle-Alliance-Platz, through the Brandenburg Gate, and past the linden trees.

The famous general in uniform with his coat and spiked helmet holds the binoculars in his left hand. Whatever subject he chose—whether armor, shoes, oyster shells, or old books—Menzel brought the lifeless object under his spell and masterfully filled it with mysterious life. The visibly worn leather case with the violet lining turns, flips around, and opens itself up. Black and worn, the metal binoculars are viewed at close range, frontally, and at an angle. Once again in Menzel's drawing, simple documentation is elevated to the effective, silent eloquence of the still life. Suits of armor, a fur, or a turning lathe not only attest to their own existence, but they also become reflections of the individuals they represent.

<div align="right">M.U.R.</div>

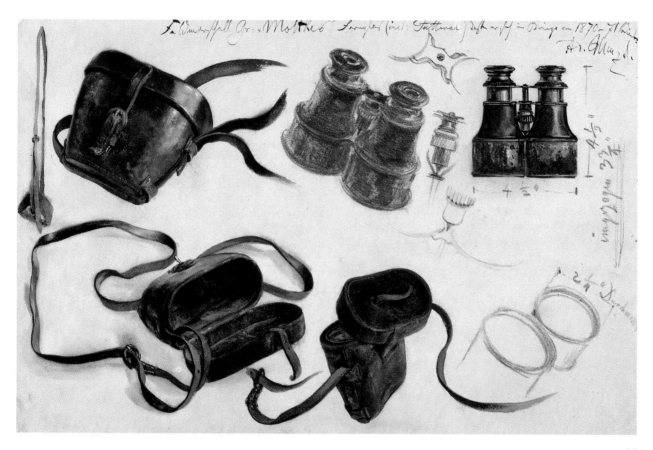

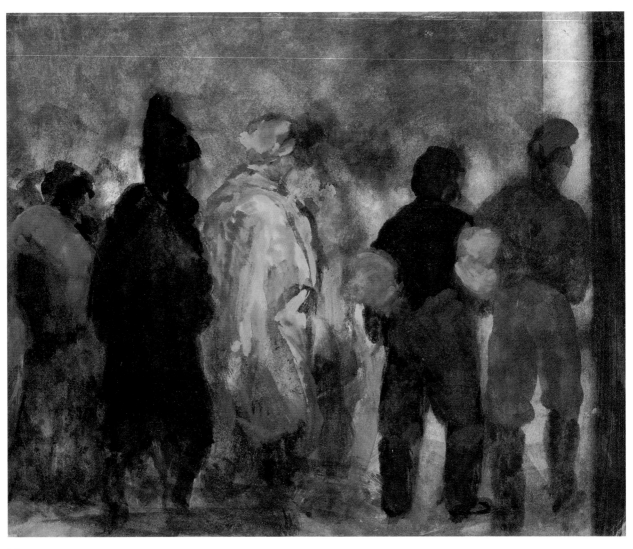

34

34. *French Prisoners of War on the March,* 1871

Gouache

23.4 x 28.2 cm

Unsigned

Provenance: acquired in 1906 with the estate of Adolph Menzel

N 1023

Bibliography: Berlin, 1905, no. 4033; Tschudi, no. 590; Schmidt, no. 309; Berlin, 1980, no. 97; Vienna, no. 52

This composition remains in an intermediate state. Its evocative richness may well strike viewers as more immediate than Menzel's planned result. This, however, was not the artist's intent.

<div align="right">C. K.</div>

35. *Prisoner Transport (Prussian Soldiers and French Prisoners of War)*, 1871

Gouache

21.0 x 19.7 cm

Unsigned

Provenance: acquired in 1906 with the estate of Adolph Menzel

N 598

Bibliography: Berlin, 1905, no. 4032; Tschudi, no. 591; Schmidt, no. 54; Berlin, 1980, no. 98; Vienna, no. 51

In January 1871, the German army was successful in the battle at LeMans, near Saint-Quentin, and on the Lisaine. On 28 January, two weeks after the battle at Mont Valérian, Paris was forced to surrender under heavy siege. Ten days earlier, on 18 January, William I had been crowned the German emperor in Versailles. A letter dated 25 January to Paul Meyerheim gives an account of Menzel's eager, and at first futile, attempts to witness the arrival of the French prisoners of war. Although he apparently shared pride in the victory with his countrymen, he did not manifest it in a biased assessment of the figures. In a painting of the same year, *The Departure of King William I for War*, the genre-like representation of the patriotic subjects borders on satire. This small painting (Tschudi, no. 140; acquired by the Nationalgalerie in 1881, now in West Berlin) is Menzel's most well-known response to the events of 1870–71. In addition, the city of Berlin commissioned two allegorical "diplomas" in gouache on the occasion of the award of honorary citizenship to Bismarck (1871, Aumühle-Friedrichsruh, Bismarck Museum; Tschudi, no. 595) and to Moltke (1872; Tschudi, no. 596).

A former officer at the Spandau citadel, where the prisoners were being held, reported on the sensation that the arrival of the French prisoners of war created ("Menzel-Erinnerungen," *Vossische Zeitung*, no. 83, Berlin, 18 February 1905). He also noted Menzel's artistic presence at the citadel after he finally received permission to draw there. "The colorful gypsies and Turks in their foreign costumes" and their peculiar habits fascinated Menzel as well as the other citizens of Berlin. The retired officer reported that the artist became especially friendly with the "darkest one" among them, Mohamed-ben-Abdallah.

Although Menzel did not include names, his Sketchbook No. 34 of 1869–71 contains (on pages 3–14) a series of drawings from the arrival of the war prisoners, the distribution of food at the East Railroad Station, a military hospital, etc. Among the men disembarking from the train is a Moroccan, and the small sketch of a railroad car that extends across pages 7 and 8 is reminiscent of this gouache.

The unusual effect of the sheet shown here is due to the contrast between the half that is precisely rendered and the incomplete half, that is to say, where the gouache was laid down and then washed away again. Of course, this effect is unintentional. Nevertheless, this unfinished state provides insight into Menzel's working methods. When using oils, he fully painted each area, piece by piece, directly onto the white canvas. In his work with watercolors, he required the suggestive approximation of loosely brushed on or partially washed away tones as a base. From there, he built up the image in layers in small areas. The unfinished state in gouaches is not indicated by remaining white areas, as it is in incomplete oil paintings (e.g., the large painting *Frederick's Address at Leuthen*).

C. K.

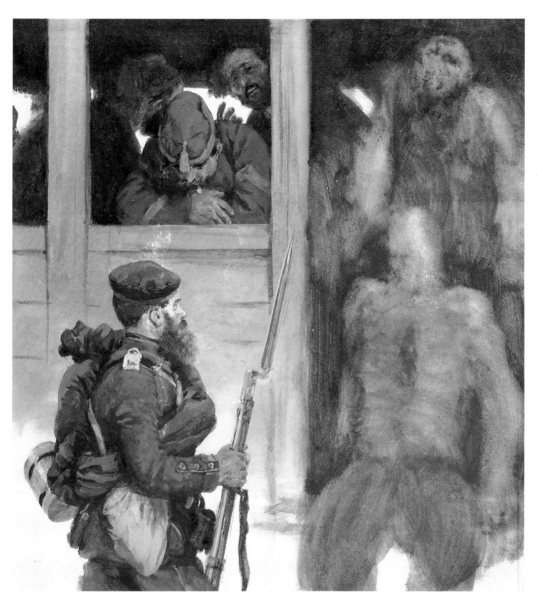

35

36. *View of the Crypt under the Garrison Church in Berlin,*
1873

Soft graphite

23.8 x 33.2 cm

Unsigned

Inscribed at upper left: *Gruft unter der Garnison-Kirche zu Berlin. 1873*

Provenance: acquired in 1906 with the estate of Adolph Menzel

N 4441

Bibliography: Berlin, 1905, no. 5234; Schmidt, no. 388; Vienna, no. 99

When Menzel came upon it, the church of Berlin's military community was in the same form as when it was constructed in 1720–22 after Philipp Gerlach's design in the so-called Spandauer Vorstadt. It was destroyed by fire in 1908, and the subsequent building was destroyed in World War II.

The huge crypt under the church continued to be used for burials until it was closed in 1830. In 1806, during the occupation of Berlin by Napoleon's troops, precious old trophies of victory, including the flags captured in the Seven Years' War, were hidden there. The search for these treasures was the main reason for the re-opening of the crypt in April 1873. Partition walls were removed, clearing passageways between the coffins, and bodies of a number of high Prussian officers were re-buried in the Hohenzollern vault under the cathedral. Hundreds of others were re-interred in a cemetery.

"The coffins lay this way and that, over and under each other," recorded Major von Siefart, "in good condition and in severe decay, truly a spectacle. . . . The lids were removed from a few of the coffins; the dust and cobwebs at first obscured the view of those who lay within. . . . Some of the bodies were fully preserved, and the eighteenth-century costumes, especially the uniforms from the Frederician period, are clearly recognizable . . ." (*Mitteilungen des Vereins für die Geschichte Berlins*, vol. 25, Berlin, 1908, pp. 134–36). Menzel was present, as he was considered an especially reliable connoisseur of the period due to his long years of extremely detailed study of objects, particularly of uniforms, from the period of Frederick the Great. This was not the first time he had such an opportunity. In 1852, he witnessed the opening of the coffins in the crypt of the Frauenkirche in Halberstadt (see graphite drawing N 1181, which he varied in a gouache of 1853), and in 1857, he experienced the opening of the coffin of General von Winterfeld, who had fallen one hundred years earlier. In the words of Menzel's friend Friedrich Eggers (in the *Deutsches Kunstblatt*), "one of his heroes lay in person for him to paint his portrait."

In 1873, Menzel's interest in historic documentation stood first and foremost. Paul Meyerheim interpreted it in this manner (*Erinnerungen*, 1906, p. 47ff.). "His knowledge of the uniforms of Frederick the Great's soldiers was unbelievable. One evening, the coffins in the crypt of the Garrison Church were being opened in the presence of the king, and if there were no names on the coffins, the historians, scholars, and military personnel present had no clue as to whose remains they had before them. Menzel alone recognized with great certainty each prince and general by the portions of the uniforms that remained, and only when the body wore simply a plain shroud did his knowledge fail. Of course, he soon made some drawings and came from the scene late that night to visit me and relate many interesting details, after he had washed his hands."

In addition to this drawing and a further representation of the coffins under the ribs of the vault (N 4440), there is a view at close range of a coffin at an angle, which appears in a sketchbook that Menzel began in 1872 (Skb. 38, p. 17). Many drawings of partially clothed corpses remain in which Menzel heightened the realism to a visionary level, transforming the documentary with unsettling expressiveness. The decaying stacks of coffins also gain a ghostly life of their own in the

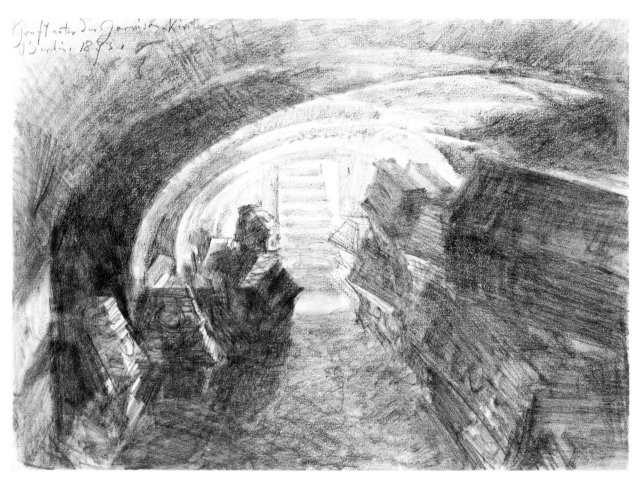

36

glow of the gaslight. This impression often occurs in Menzel's representations that almost resemble still lifes. Bedding, books in a bookcase, armor, and death masks on the wall fall into disarray or are estranged through unusual lighting effects. Thus, they lose their tangibility and familiarity to become "horrible" and unearthly in the truly Romantic sense, as found, for example, in the works of E.T.A. Hoffmann.

This drawing imparts the immediate sense of excitement of a harried encounter with death and the chaos within this underworld. It also bears traces of features characteristic of Menzel's late work. In the 1880s and 1890s, his inclination to exhaust the blackness of the soft pencil, laying it on in broad strokes across the surface of the paper, became ever more apparent, as did his preference for low-lit nocturnal spaces.

<div align="right">C. K.</div>

37. *Corpse of a General from the Period of the Wars of Liberation*, 1873

Graphite

23.7 x 33.1 cm

Unsigned

Inscribed at lower center: *Aus der Frühzeit / Fr:Wilh. III.*; at lower right: *Garnison-gruft / Generals-Leiche. Wer / war nicht aufzufinden gewesen. Jedenfalls / aus der Zeit Friedrich Wilh: III dem Lorbeer / nach aus den Befreiungskriegen.*

Provenance: acquired in 1906 with the estate of Adolph Menzel

N 247

Bibliography: Berlin, 1905, no. 5234a; Schmidt, no. 389; Berlin, 1980, no. 280

Menzel drew this bust portrait of an officer in uniform lying in his coffin, his skull still bearing a laurel wreath and, on his breast, the medallion of the Order of the Black Eagle. A smaller skull and the upper body of a somewhat older corpse were drawn at the left. Above both corpses lie a pair of boots from which bones protrude. The touching sensibility of the representation of these dead men is evoked through Menzel's simultaneously ingenious and objective rendering of the subject.

<div align="right">M.U.R.</div>

IV. From *The Children's Album*

(38–49)

Menzel's use of gouache, which began in the 1850s, soon superceded his technique in colored chalks. He adopted it to such an extent that his representations in color became denser and more detailed; he left the generous summarization of forms to his pencil drawings. In presentation, many of these gouaches are actually paintings. In his later years, Menzel believed that oil painting was not well suited to the rendering of certain subjects: it made no sense to paint a sandy road or a woolly sheep as though they were dipped in oil and varnish (Meyerheim, *Erinnerungen*, 1906, p. 11).

The so-called *Children's Album* is dedicated to Gretel and Otto, the two children of Menzel's sister Emilie, who were born in 1860 and 1861. Emilie had married the composer Hermann Krigar, and the artist was included as one of the family. The multitude of drawings of the children (in Sketchbooks No. 22 of 1860–62 and No. 24 of 1862–64) attests to his interest in them.

The images relate Menzel's impressions from Sunday strolls in Albrechtshof, the nearby garden colony, and above all, in the Zoologischer Garten. Although the drawings correspond to the objective interests of the children— but not to their early perceptive capabilities—these drawings were never actually owned by the children. Menzel kept them to himself, completing the series over the next twenty years and reworking the older compositions. He then sold the collection for the benefit of the then grown children, whose father had died in 1880.

Of the fourty-four sheets (including the title page), three are dated 1863, one 1864, one 1868, and three 1883. It is questionable whether the rest were executed throughout the intervening years. The majority more likely emerged in the 1860s. (Menzel entered many studies of animals into his sketchbooks during those years, and he may have renewed his efforts not long before 1883.) That most of these sheets originated at an earlier date and were then reworked much later is supported through comparable examples.

It is possible that Menzel gradually abandoned a preconceived, uniform design for the album pages. The four earlier sheets and even those datable

to 1868 or 1869 are in an imposing horizontal format. Quite conceivably, the miniatures or the narrow vertical format did not originate until later. Moreover, when he concluded the album in view of its approaching sale, it is not known if the artist randomly completed the series with unrelated sheets. In any case, the number of pieces corresponds exactly to the number of birthdays the two children celebrated until the middle of 1883. Their uncle may have viewed their birthdays as dates on which to add another finished sheet. Although the work was essentially concluded when the children became adults, the exhibition of the drawings may well have offered a more immediate incentive for completion. In the spring of 1884, in celebration of Menzel's fiftieth anniversary as an artist represented in the Nationalgalerie, *The Children's Album* was exhibited for the first time.

In selection and presentation, the themes are discerned through the eyes of a city dweller. Nature is a destination for an outing, not an environment and a fundamental part of life. Animals are the inhabitants of zoos; the tamest among them are preferred, and at times their behavior is given an anecdotal edge. The animals are not prescribed a hierarchy. The artist's interest jumps from noble and magnificently exotic creatures to less likeable animals. For him, even a rat is worthy of painting. Occasionally, the focus becomes extremely narrow and reveals "small worlds."

Menzel's *plein-air* realism reached its first high point in the mid-1840s, and yet in a clearly revised form, it is revitalized in many of these images. At times, parallels with early French impressionism are recognizable, but the two styles deviate in their development. For Menzel, representations of reality became increasingly fragmented, both in terms of theme and form. His brilliant painterly expression is accomplished with old, wide, bristly paintbrushes that must also have been used to dab on small touches of color and highlights.

After he visited the World's Fair in Paris in 1867, the artist wrote to his family on 3 June, "Had I known what I know now, there is much I would not shy away from seeing here. Even something from the 'Albogen'?" This term refers to *The Children's Album*, which must have already taken shape by that time. In 1885, it was included in the Menzel exhibition held at the Pavillon de la Ville in Paris.

Provenance: *The Children's Album* was acquired in 1889, at first without its title (or dedication) page, from Menzel's art dealer Hermann Pächter of the firm R. Wagner, Berlin, to whom it was consigned by Emilie Krigar in 1883. Five sheets have been missing since 1945 (Tschudi, nos. 365, 369, 373, 383, 396). Two gouaches that Tschudi included in *The Children's Album* (nos. 397, 398) were not part of the collection acquired by the Nationalgalerie.

C. K.

135

38

38. *Drying Yard*, 1863

Watercolor and gouache
13.4 x 28.1 cm
Signed at lower right: *A.M.1863*
Kat. 1055
Bibliography: Berlin, 1905, no. 188; Tschudi, no. 360; Berlin, 1980, no. 94;
 Vienna, no. 79

Across the elongated area presented in this sheet one vigorous movement follows
another: children play and tussle, a dog rolls on its back, laundry is tugged by the
wind. All contrasts sharply with the quiet smoothness of the lawn, the house, and
the row of poplars in the background. Each element functions independently
without a unifying coherence. Both the format of the sheet and the sense of harsh
light are reminiscent of *Walkers*, an oil on panel by Max Klinger (1878, National-
galerie). Like many other sheets from *The Children's Album*, this work resembles
a painting in its composition and density, and it is presentable as such despite its
size.

C. K.

39

39. *Sweet Freedom*, no earlier than 1867–68

Watercolor and gouache
24.3 x 14.1 cm
Signed at lower center: *Ad. Menzel*
Kat. 1030
Bibliography: Berlin, 1905, no. 163; Tschudi, no. 382; Berlin, 1980, no. 73

The profile of a macaw's head looking towards the right was drawn four times across facing pages 121 and 122 in Sketchbook No. 30 (Nationalgalerie), which Menzel used in 1867–68. Additionally, the long tail feathers have been hastily sketched in the corner of the sheet. Another sheet from *The Children's Album* (Kat. 1032) depicts a red macaw in a different pose.

<div align="right">C. K.</div>

40

40. *Thatched Roof with Storks' Nest*, no earlier than 1866–67

Watercolor and gouache

23.3 x 19.1 cm

Signed at lower right: *A.M.*

Kat. 1015

Bibliography: Berlin, 1905, no. 148; Tschudi, no. 394; Berlin, 1980, no. 63; Vienna, no. 88

Here, the artist referred to a drawing on page 73 of Sketchbook No. 28 (1866–67). The undated pencil drawing *House Between Trees at Dusk* (N 2292; see Vienna, no. 128, illus.), possibly from the 1880s, provides a further comparison.

C. K.

41. *Chinese Women Feeding Pheasants*, 1868

Watercolor and gouache

19.9 x 25.4 cm

Signed at lower right: *Ad. Menzel 68.*

Kat. 1029

Bibliography: Berlin, 1905, no. 172; Tschudi, no. 363; Berlin, 1980, no. 72;
 Vienna, no. 83

At the earliest, Menzel could have discovered the theme for this image the previous year, during his visit to the Paris World's Fair in 1867. Such living examples of exotic life were popularly presented in appropriately designed pavilions. Drawing from his impressions gathered on a trip to Munich, Menzel painted themes similar to this in the 1880s, such as *At the Japanese Exhibition* (1885; Tschudi, no. 662; sold at auction in 1980 by Hauswedell & Nolte, Hamburg) and *Japanese Seamstress—In the Japanese Exhibit* (1887; Tschudi, no. 654; Schäfer Collection, Schweinfurt).

In both of those paintings, the continuity of the foreign environment is noticeably disturbed by the appearance of the public, which transforms the exotic dream into banality. (Here, the small figure of the boy appears at the foot of the steps.) The same holds true for *Confort Chinois* (1868; Tschudi, no. 571; in the collection of Walter Andreas Hofer, Munich, in 1955). Alfred Lichtwark documented Menzel's attraction to the art of the Far East. In two letters to his family from March 1881 and October 1884, Lichtwark gave accounts of Menzel's extended and enthusiastic examination of East Asian prints (Carl Schellenberg, ed., *Lichtwark: Letters to His Family*, Hamburg, 1972, pp. 140, 561). Apparently, the artist's animal and plant studies so impressed Lichtwark that he could only compare them to works by Dürer. Menzel's art dealer, Hermann Pächter, was also Berlin's most prominent dealer in Oriental art at the time.

In a broader sense, these exotica also call to mind the gouache *The Zulus* (after 1855, Hamburger Kunsthalle) that Tschudi erroneously counted (under no. 398) among the sheets for *The Children's Album*. Here, Menzel referred to sketches he executed in 1855.

A drawing of pheasants is included in Sketchbook No. 30 (1867–68). It did not, however, serve directly as a model for this sheet.

<div align="right">C.K.</div>

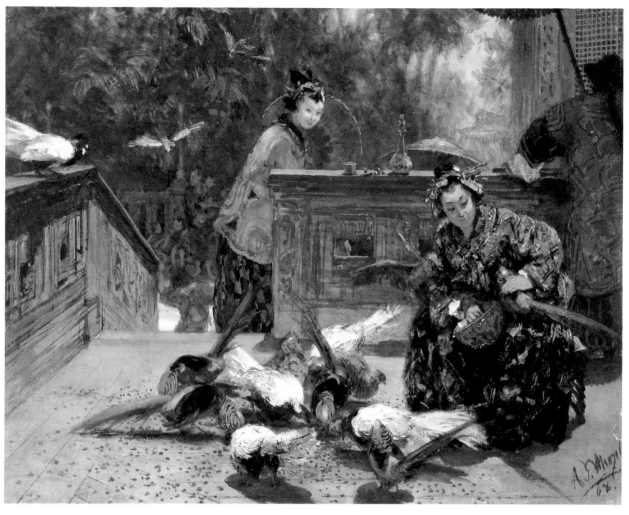

41

42. *Two Swans*, no earlier than 1868

Watercolor and gouache

12.0 x 17.1 cm

Signed at lower left: *A.M.*

Kat. 1038

Bibliography: Berlin, 1905, no. 171; Tschudi, no. 404; Berlin, 1980, no. 80;
 Vienna, no. 84

A drawing dated 1868 from Sketchbook No. 31 (p. 202) in the Nationalgalerie
served as a model for the swan at the right.

<div align="right">C.K.</div>

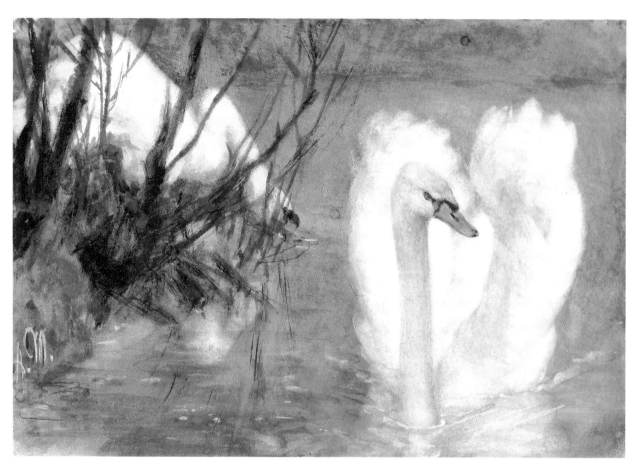

42

43. *Three European Goldfinches and a Canary in a Bird Cage*

Watercolor and gouache

14.1 x 10.9 cm

Signed at lower right: *A.M.*

Kat. 1034

Bibliography: Berlin, 1905, no. 167; Tschudi, no. 379; Schmidt, no. 360; Berlin, 1980, no. 77

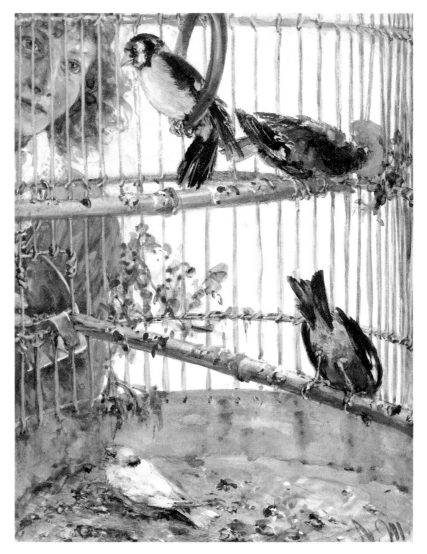

43

44. *White Peacock with Female Turkey and Roosters,* no earlier than 1881

Watercolor and gouache

14.4 x 24.5 cm

Signed at lower left: *Ad. Menzel*

Kat. 1040

Bibliography: Berlin, 1905, no. 173; Tschudi, no. 390; Berlin, 1980, no. 82; Vienna, no. 85

"Consider his range," Fontane wrote to Maximilian Harden on 13 December 1895, "to the left Hochkirch and Leuthen (this one, [still] unfinished in the studio, [is] especially wonderful), to the right hens, roosters, and white peacocks, the latter—more so than his female companions—[an image] of sheer, arresting beauty."

Two sketches of a rooster in profile that may have been employed in this gouache are found in Sketchbook No. 58 (Nationalgalerie), which the artist used in 1881. It includes additional drawings of animals.

<div align="right">C. K.</div>

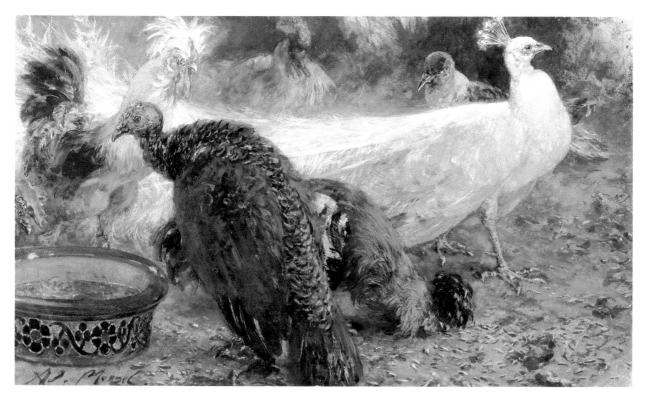

44

45. *Three Bears in a Cage*, no earlier than 1867–68

Watercolor and gouache
21.6 x 23.9 cm
Signed vertically at the lower left edge: *Ad. Menzel*
Kat. 1025
Bibliography: Berlin, 1905, no. 158; Tschudi, no. 386; Berlin, 1980, no. 69

A drawing of bears behind the bars of their enclosure on facing pages 47 and 48
in Sketchbook No. 30 (1867–68) at the Nationalgalerie is similar to this sheet and
is often used by the zoo.

C. K.

45

46. *Street Corner in Moonlight*

Watercolor and gouache

27.7 x 20.8 cm

Signed at lower left: *Ad.Menzel*

Kat. 1016

Bibliography: Berlin, 1905, no. 149; Tschudi, no. 393; Berlin, 1980, no. 64;
 Vienna, no. 87

Like many other images from *The Children's Album* (cf. cat. nos. 38 and 40), this sheet resembles Menzel's early city landscapes but with a different approach, as demonstrated by a comparison with the oil painting *Moonlight on the Frederick Canal in Old Berlin*, which dates from the 1850s (Nationalgalerie; not in Tschudi). Simplicity and tranquility yield to contrast and visual impact: nature and the metropolis, moonlight and modern artificial light, and atmospheric effects and disquieting disturbances collide with one another. By emphasizing the strict geometrical division of the picture plane as well as the separation and isolation of its components, sections of the image appear to be detachable from the whole, like a "picture within a picture."

The gouache *Street at Night*, which was auctioned in 1939 at Hans W. Lange, Berlin (no. 24 in the auction catalog *Eine Berliner Privatsammlung*; not in Tschudi) can be placed chronologically and developmentally between this work and the painting.

<div align="right">C. K.</div>

152

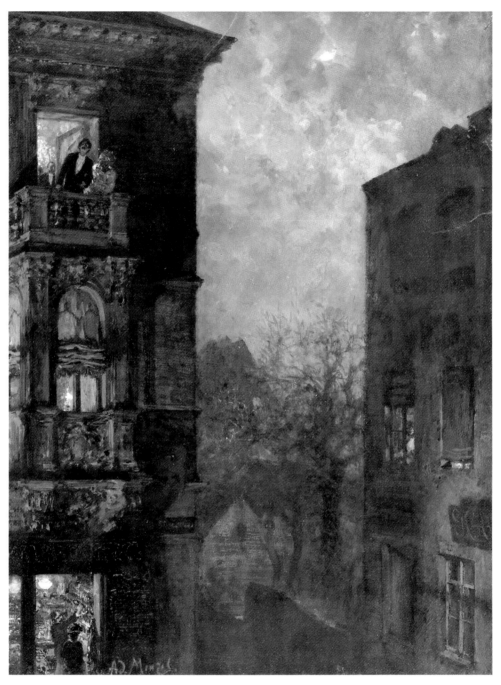

46

47. *Old Man and Boy at a Door*

Watercolor and gouache

22.3 x 10.9 cm

Signed at lower left: *A.M.*

Kat. 1013

Bibliography: Berlin, 1905, no. 146; Tschudi, no. 364; Schmidt, no. 371; Berlin, 1980, no. 61

At first glance this image is somewhat reminiscent of genre scenes by Ludwig Knaus. Indeed, the scene is pointedly anecdotal, yet it is not sentimental, and it wittily refers to what Germans since the mid-nineteenth century have called the *Tücke des Objekts*, literally, the "trick of the object," signifying the apparent resistance of an inanimate object. Because the door opens outwardly, it threatens to topple the child backwards down the steps, which calls to mind the artist's ever recurring theme of "disturbance." All the action in the picture was shifted to the left half of the composition, while the right side allows the viewer's eye to fall into the depths without a focal point. Not only is the transience of the event emphasized by the composition of the image, but it is also suggested by Menzel's hasty, fragmentary observations, which are stylistically similar to the pencil drawings from the last years of his life. This sheet can thus be included among his later creations for *The Children's Album*.

<div align="right">C. K.</div>

47

48

48. *Goat with a Wooden Horse*

Watercolor and gouache
20.8 x 16.0 cm
Signed at lower center: *A.M.*
Kat. 1021
Bibliography: Berlin, 1905, no. 154; Tschudi, no. 368; Berlin, 1980, no. 67

The composition is divided in half by the continuation of the diagonal line created by the goat's tether. The goat is attracted to the toy horse much like a child is to a doll. Here, the artist clearly entered the world of a child through his depiction of the barnyard, a toy, and flowers.

C. K.

49. *Sweetened Servitude*, 1883

Watercolor and gouache
23.8 x 13.8 cm
Signed at lower right: *Ad. Menzel 1883*
Kat. 1031
Bibliography: Berlin, 1905, no. 164; Tschudi, no. 403; Schmidt, no. 363; Berlin, 1980, no. 74; Vienna, no. 92

"A small garden adjoined the old house on Marienstraße, and, to the delight of his sister's children, on its blue-gray whitewashed walls next to the summerhouse, he had painted in oils life-size parrot stands from which various gaudily plumed macaws and cockatoos squawked. The interior of the summerhouse was decorated with a Swiss landscape. One morning, I visited my friend and found him sitting in front of the glacial landscape, already soaped up and ready to be shaved" (Meyerheim, *Erinnerungen*, 1906, p. 33ff.).

This composition brings the heavy ornamentation of the new baroque into a discordant relationship with the natural elements its depicts. The paint and its application also contribute to this contrast. At times the paint is dense and saturated, even plastic; at other times it appears thinner, lighter, and looser. The inclusion of the abbreviated arm of a woman could not be more astonishing in the context of the work's title, which was symbolically given (by Menzel?) to the picture. The image is somewhat similar to the wood engraving in *Werke Friedrichs des Großen* in which two hands appear holding a crown (Bock, no. 922). In a representation with such deceptive closeness in meaning, this radical fragmentation has a surprising effect. The sheet looks as if it were cut from a larger composition, which is not the case. As with numerous sheets in *The Children's Album*, the artist retained in this finished work the "extracted," fragmentary character that the entries in his sketchbooks possess. This device suggests a sudden focus that isolates the object of his interest.

For the cockatoo, Menzel referred to a life drawing in Sketchbook No. 30 (1867–68; pp. 93–94), which he had used fifteen years earlier. He frequently drew this species of bird, as seen in his early Sketchbook No. 6 (1838; p. 23) and with the excited cockatoos in Sketchbook No. 25 (1863–64; pp. 29, 31).

C. K.

49

V. *The Iron Rolling Mill*

(50–57)

The theme of human toil may be traced nearly throughout Menzel's oeuvre. It achieved a high point with the painting *The Iron Rolling Mill*, which engaged the artist for three years, from 1872 until 1875. He completed the picture on 22 February 1875, and in October, Max Jordan acquired the work for the Nationalgalerie from the banker Adolph von Liebermann. In the first descriptive catalogue on the work, Jordan called the painting *Modern Cyclopes*.

The Iron Rolling Mill is the most significant large-format painting created at the peak of Menzel's figurally rich work of his late period. Stimulated by the perpetual dualism of an artistic understanding of self and the challenges of the society that supported him, his later works exhibit novel, dynamic, and even inconsistent achievements. Theodor Fontane pointed out this conflict in Menzel's art. In an essay in honor of the artist's eightieth birthday, Fontane began his praise of *The Iron Rolling Mill*: "Beside this Menzel of conventional views is always a second Menzel, who proceeds in an entirely different manner in many respects, and who turns away from the exterior, material world that confronts him as desire, a commission, or a challenge, and finds his ideal in purely artistic endeavors that he initiates himself—in the continual discovery of new techniques as well as in the continual solution of new problems. . . ."

Perhaps the provocative nature of the discovery of the image of *The Iron Rolling Mill* is explained in that since its appearance, interest has been aroused, be it positive or negative, by the successful lifting of the tense relationship already mentioned. Here, Menzel's own will, which required the constant experimental gauging of his artistic ability, could coincide with the public's wishes for current, temporal themes. Menzel's *Iron Rolling Mill* became a symbol for the industrial explosion during the *Gründerzeit*, in which the development of entrepreneurs and production workers were intertwined. It is the first work of art in Germany to portray the environment of machine workers at a progressive production site. The apparent chaos of the various machines at the rolling mill, which dictate the rapid, rigorous process that the men must perpetuate, vividly points to the dependency of

160

the workers on the machines: they must subordinate their most basic needs to mechanical operations.

Numerous studies and sketches for the painting attest to its authenticity. (About 150 such works are known to exist, most of which were acquired by the Nationalgalerie from Menzel's estate.) In addition to working individuals, the studies depict laborers washing up before going home and others taking a break for a quick meal. Menzel even drew workers sleeping next to the iron rails.

In his painting, the phenomenon of industrial production was represented for the first time and its problems cited. For example, working in shifts, a characteristic of industrial production, does not tolerate interruptions in operation in the demand for efficient use of machinery. The artist's observations, studied from life, are condensed into a realistic, sympathetic statement regarding the labor conditions of mill workers during the 1870s. Depicting workers *en masse* was also innovative. The image possesses human dimensions; the workers are its yardstick, and their individuality and dignity are recognizable. Menzel's mill workers are not dwarfed or overwhelmed by gigantic machines. Instead, they are rendered in an objective, detached manner, just as they are in many contemporary, usually graphic, representations of factory work. They exhibit both positive human activity as well as the threat of dependence upon a powerful machine that portends the might of its owner.

The term "heroic modernity," which Walter Benjamin coined in 1938, reflects a concept that Menzel had already formulated in his *Iron Rolling Mill*—the monstrosity of a future machine age in which the individual would be inserted into a small, dependent role—and this contributed to make the painting an artistic document at the peak of his time. Menzel took up the theme twenty years after his friend, the art essayist Friedrich Eggers, enthusiastically reviewed (in the *Deutsches Kunstblatt* in 1852) the operations of the Borsig machine factory in Moabit. In vain, Eggers publicized the discovery of previously ignored themes from the realm of the industrial world and everyday life in the growing metropolis. (Perhaps Menzel was the friend that Eggers mentioned as his guide and the discoverer of these themes.) In his subsequent painting, and in a manner astonishingly similar to Eggers' account, Menzel's inspired belief in progress at the beginning of the prosperous period gave way to a realism that, as the Industrial Revolution drew to a close, boded the formation of the modern proletariat.

In 1855, Menzel had another opportunity to encounter the vast theme of industry. He spent fourteen days in September on a visit to see the World's Fair in Paris. No document remains of his artistic impressions of this trip, but in a sketchbook from that year (Skb. 14, pp. 40–41), next to studies of the Théâtre Gymnase, there are two hasty sketches of blacksmiths at an anvil and of a worker with tongs in front of a steam hammer. Twelve years later, Menzel again stayed in Paris to see the World's Fair. Once more he found art "side by side with industry. White statues spring up between

black machines, paintings are revealed beside rich fabrics from the Orient," commented Théophile Gautier at the time (see Günter Metken, "Fest des Fortschritts," in *Weltaustellungen im 19. Jahrhundert*, Munich: Staatliches Museum für angewandte Kunst, 1973, p. 9). Presumably, the works of the painter and lithographer François Bonhommé, called "Le Forgeron" (the blacksmith), did not slip by Menzel unnoticed. Juxtaposed against the traditional themes presented at the World's Fair, his large format and highly original representations of industry (which were also dispersed as engravings) aroused quite a bit of controversy.

Menzel's first incentive to create his own painterly treatment of industrial labor was offered to him in 1869, when he received a commission from the Heckmann metal factory in Berlin to design an illustrated certificate to commemorate their jubilee celebration. His decision to create a large painting on this theme must also be viewed in close context with a commission his longtime friend and colleague Paul Meyerheim (1842–1915) probably received from Albert Borsig in 1872. Meyerheim, who was already considered a famous artist, was requested to produce seven murals for a pavilion on the grounds of the Borsig villa. (Three of these works are now in the Markisches Museum in East Berlin, and one is in the Eisenbahn-Museum in West Berlin. The remaining three were lost during World War II.) These paintings represent themes not only from the history of the locomotive but also from its manufacture—the first locomotive in Germany was built in Borsig's factory—but none of them depicted the important function of the iron rolling mill. This omitted theme was the one Menzel chose to represent when he began to paint *The Iron Rolling Mill* in 1872.

M.U.R.

50. *Commemorative Sheet for the Jubilee of the Heckmann Company*, 1869

Gouache

50.0 x 61.0 cm

Inscribed at lower left: *Adolph Menzel Berlin 1869*

Provenance: gift of the Councillor of Commerce Georg Heckmann, Berlin, in 1911

Nr. 1777

Bibliography: Berlin, 1905, no. 248; Tschudi, no. 570; Kaiser, *Menzels Eisenwalzwerk*, p. 16ff,; Schmidt, no. 381; Berlin, 1980, no. 58; Hütt, *Adolf Menzel*, p. 150; Vienna, no. 114

Although Menzel did not represent the theme of building construction in a large, exemplary painting, he recognized a powerful and novel motif in industrial labor, and with it the reality of modern capitalism. Unlike many of his contemporaries, Menzel did not find everyday occurrences ugly or repulsive as subjects, so he did not render them in an idealistic fashion. Instead, he discovered in them a theme for his work, one appropriate for that pivotal time of worldwide change. He did not fear critics such as Max Schasler, who rejected the realism of his paintings and considered his talent wasted on depicting the "lyric of the ugly and the poetry of filth" (see *Dioskuren* 15, 1870, p. 150).

Menzel's social and financial standing had improved since he received the royal commission for the "coronation picture." There was no longer a shortage of patrons and buyers from the entrepreneurial and banking worlds. In light of this, Menzel's ability to maintain his artistic independence is all the more remarkable.

In 1869, Menzel received a commission from the Heckmann family in Berlin for a sheet commemorating the fifty years of its operation of iron, copper, and brass works. At this same time the founder of the company, Carl Justus Heckmann, was appointed councillor of commerce. In November 1869, Menzel noted in the book of receipts (unpublished, privately owned) that he kept from 1858 to 1904 "for the Jubil. sheet in gouache 1,983 Taler 20 Silbergroschen."

The artist executed his first studies of industrial production at the Heckmann factory of Schlesische Straße in Berlin (Sketchbook No. 34, 1869–71) in 1869. As early as 1861, Menzel made studies at a blacksmith's workshop for woodcuts illustrating Auerbach's short story "Der Blitzschlosser zu Wittenberg." Then he observed forging processes in a factory. In the two representations of labor included within the arch of the commemorative sheet, Menzel faithfully employed studies of locations and details taken from the sketchbook mentioned above. He proceeded by exercizing one of his earlier selection practices: suitable drawings as well as images that previously had been employed were usually marked in pencil with an x and were directly transposed to the composition with little modification.

Through his work as a lithographer, Menzel became familiar with the preparation of such popular dedication sheets, which were created for all kinds of occasions. These sheets, having origins in commercial art, were mostly created as prints, but some were also painted in watercolor or gouache. In their simplest forms, such compositions consisted of a central panel of text or an image within a framework of related designs.

In freshness and originality, the Heckmann commemorative sheet surpasses most of Menzel's works of this kind, such as the diplomas or certificates he produced for journeymen in the 1830s (cf. Bock, nos. 120, 195, 208), the sheet celebrating the Crown Prince's coming of age in 1850 (Staatliche Schlösser und Gärten, Potsdam; Tschudi, no. 218), or the painterly *Certificate of Honorary*

Citizenship from the City of Hamburg to G.C. Schwabe (1887, Kunsthalle, Hamburg; Tschudi, no. 663).

Menzel often made careful preparatory studies for innovative scenes that depicted physical labor, which he then enhanced with plays of light caused by steam and fire. Sketches do not exist for the fanciful designs that frame the Heckmann sheet. (Such border designs had become popular after 1828 in connection with the re-discovery of a prayer book illustrated by Albrecht Dürer for Emperor Maximilian and the two hundredth anniversary of the artist's death.) These designs not only decorate but also direct attention to two aspects of the Heckmann foundry's production processes. At the left, workers smelt metal in a furnace, and at the right, they cast metal. The obvious combination of these realistic and yet painterly images with allegorical and programmatic decorative elements that strongly reflect contemporary taste were later criticized as being discrepant and even presumptuous. In this manner, Menzel linked his own ideas with the interests of the patron. When closely observed, the ornamentation reveals itself as being an intriguing element of the sheet, which Menzel cleverly planned and rendered with a light touch.

The composition is largely defined by a marble architectural structure. Only a suggestion of the factory's facade is seen behind the baroque-inspired decoration. The structure is supported by caryatids and Cyclopes-like figures of laborers wrapped with metal bands, which suggest an association with the sculpture of Laocoön entwined by snakes. Window or gate-like cutouts disclose interior views of factory halls. Forming the center of the composition is a guilded niche in which a winged female figure stands. She points upwards towards the portrait medallion of the company's founder. The names of cities written below the medallion refer to the firm's international business connections.

Attributes of the female figure suggest that she is Fortuna or a patron saint, while her iron crown and the toothed edges of her garment freely allude to the company. Included within the composition is the inscription *Tausend Jahre sind ein Tag—50 aber ein half Jahrhundert* ("A thousand years are a day—but fifty are a half century"), Menzel's variation of Psalm 90, verse 4. Corresponding to this is the adage *Aller Anfang ist schwer* ("Every beginning is difficult"), which appears at the sides of the inscription "Anno XIX." at the bottom of the sheet and in letters that look as though they are wrought from metal. Many references to the forging of metal are incorporated into the composition, along with symbols of the agricultural origins of the family.

Menzel's contemporaries may have been familiar with his symbolic representations. A letter dated 19 October 1869 from Theodor Fontane to his wife relates: "At six [o'clock] in the Rütli [group] at Menzel's where only the pros and cons of Gluck's 'Armida' were discussed. At last, he showed us a new sheet in watercolor (similar to that in Monbijou) [the commemorative sheet for the Crown Prince's coming of age] that he prepared for old Heckmann's jubilee. Brilliant! One of his most beautiful works of this kind, ingenious in its splendid color effects, clearly understandable, successful in every respect. It was a true pleasure for me to be able to squeeze his hand knowingly without saying a word."

M.U.R.

164

50

51. *Carts for Transporting Iron*, ca. 1872

Graphite

22.3 x 30.5 cm

Signed at upper left: *Ad. Menzel*

Inscribed at center of sheet: *Zangenwagen für "packtirtes" Eisen*; diverse measurements in feet and inches

Provenance: acquired in 1906 with the estate of Adolph Menzel

N 1373

Bibliography: Berlin, 1905, no. 3272; Vienna, no. 71, illus.

With a hard, sharp pencil, Menzel drew two carts used in transporting iron masses. Here, he examined a sturdy cart with a long shaft similar to the one in the painting that carries the white-hot mass of iron out of the furnace or is used to transport an iron block. He captured not only a lateral view of the cart but also a glimpse of its underside.

The other vehicle also has only two wheels, but it is equipped with a set of large tongs instead of a base. Menzel drew such a cart in the foreground of a stylistically comparable sketch of a workroom (N 1396). In its background to the left is a flywheel and to the right a cabinet.

<div align="right">M.U.R.</div>

51

52

52. *Great Hall in a Rolling Mill,* ca. 1872–74

Graphite

23.8 x 32.9 cm

Signed at lower left: *Ad. Menzel*

Inscribed at lower edge: *Bei der Walzarbeit alles / Balken und Stangenwerk roth / angeschienen.Alles dahinter / erscheint dunkel. / Alles Gitterwerk oben / auf dieser Seite heller als der / grau Hintergrund.*

Provenance: acquired in 1906 with the estate of Adolph Menzel

N 155

Bibliography: Berlin, 1905, no. 3261; Berlin, 1980, no. 313, illus.; Vienna, no. 72, illus.

Beginning with his work on the commemorative certificate for the Heckmann company, Menzel's interest in the novel subject of factory work grew. The design for a large-format composition had already emerged in 1872, when he visited the Upper Silesian industrial area to make studies of the largest ironworks at that time, the Royal Ironworks (*Königshütte*), founded in 1798. (In the early 1870s, it became the United Royal and Laura Ironworks, the largest corporate undertaking of the banker Gerson Bleichröder.) In addition to the enlightening knowledge he acquired about modern steel production and craftsmanship, Menzel also gained insights into the social problems that accompanied the rapidly developing heavy industry. (One year before his visit, military forces had quelled a workers strike.)

Whether Menzel visited the Royal Ironworks once more is uncertain. Several drawings inscribed "Kön. Eisengießerei 73" and "K. Eisengießerei 74" (National-galerie) were probably executed in the renowned old Royal Iron Foundry on Invalidenstraße in Berlin, which closed in 1874. Stylistically, they closely resemble late figural studies drawn from the model with a soft, crude pencil. The combination of sharp, erratic lines with delicate hatching and stumping is characteristic of a group of sheets certainly drawn at the Royal Ironworks. Two are inscribed "Königshütte 72": *Open-Cast Mining* (Nationalgalerie, West Berlin) and *Landscape with House and Wooden Bridge*, location unknown, reproduced in *Gazette des Beaux-Arts* 2 (1880), p. 721. These same sheets are more closely connected to the studies for the Heckmann jubilee certificate.

This vigorously drawn study of the factory hall during operation corresponds almost exactly to the design of the workspace seen in the painting. Stylistically, the study related more closely to the blast furnace landscapes (N 1389, N 3195) than to the careful drawing of the same hall, with its view of the rolling production line and the machines at a standstill (N 154). This sheet may be included among the group of drawings of the Royal Ironworks.

M.U.R.

53. *Man Pulling a Cart*, ca. 1873–74

Graphite

32.5 x 24.5 mm.

Signed at right center: *Ad. Menzel*

Provenance: acquired in 1906 with the estate of Adolph Menzel

N 156

Bibliography: Berlin, 1905, no. 3264; Kaiser, *Menzels Eisenwalzwerk*, p. 62, illus.;
 Berlin, 1980, no. 314; Vienna, no. 73, illus.

Menzel made several studies for the worker who removes the glowing mass of iron on a two-wheeled cart in the left foreground of the painting (Nationalgalerie, and Nationalgalerie, West Berlin; see *Bestandskatalog*, West Berlin: Nationalgalerie, 1984, nos. 78, 79).

If authenticity took precedence in Menzel's efforts, it follows that, as in his early working methods, he was completely familiar with available representations of industry during his time, especially those found in English and French prints. For example, it is possible that Menzel saw works by the Englishman Godfrey Sykes (1825–1866) while he visited the Belgian painter Alfred Stevens (1817–1875) in Paris in 1867. Menzel met with Stevens many times and even met Degas at his home. Sykes, a designer and engraver of Sheffield cutlery, also painted views of blacksmiths and metal grinding shops. For a time, Sykes and Stevens collaborated.

Menzel familiarized himself with the latest works in English and French journals, and he no doubt knew the graphic work of Gustave Doré, whose volume *London* appeared in 1872. The advent of the photographic snapshot also encouraged greater realism in painting and lent itself especially well to use in journalistic graphic illustrations. Menzel allowed some of his figures of workers to glance spontaneously towards the viewer, which suggests that for the cart puller and the woman carrying food in the painting, he looked for comparisons and earlier examples in commercial art. (See also Donat de Chapeaurouge, "Granvilles Wirkung auf deutsche Künstler um 1850," *Zeitschrift des Deutschen Vereins für Kunstwissenschaft* 24 [1970], p. 182.)

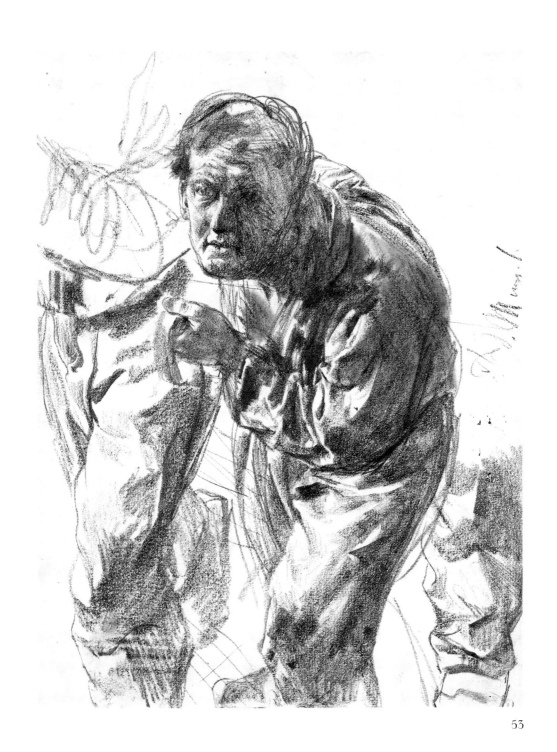

53

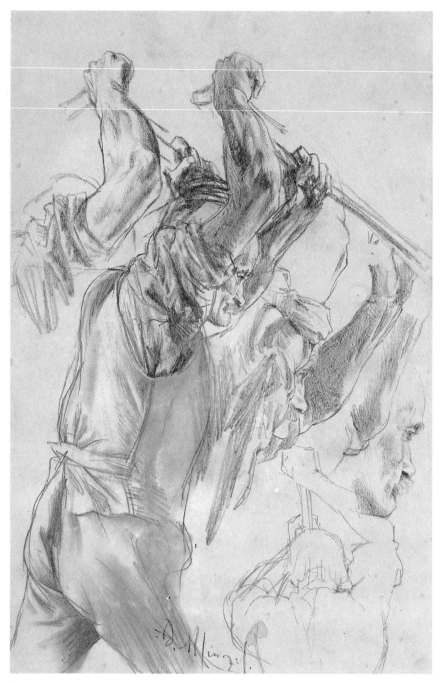

54

54. *Mill Worker*, ca. 1873–74

Graphite and stumping

40.0 x 26.2 cm

Signed at lower center: *Ad. Menzel*

Provenance: acquired in 1906 with the estate of Adolph Menzel

N 4458

Bibliography: Berlin, 1905, no. 3267; Kaiser, *Menzels Eisenwalzwerk*, p. 35, fig.
20; Schmidt, no. 69; Hofmann, ed., *Menzel der Beobachter*, no. 105, illus.

This study of a worker wearing a vest and holding the end of a cart shaft was
copied almost precisely in the painting. Menzel captured the pose of one of the
five workers who form the main group in the mill production line and portrayed
the moment in which the glowing piece of iron is being thrust into the rolling
mill. In the painting, the head of the worker is modified through the addition of a
full beard, a cap, and a cigar in his mouth. It cannot always be clearly determined
whether such studies and sketches derived from models or whether they were
created on the spot. The latter type, mostly rendered in a small sketchbook
format, is much more brief in execution.

This is probably a study from a model. A sketch of the same worker in a vest
offers a comparison (Kunsthalle, Hamburg; see Hofmann, ed., *Menzel der Beo-
bachter*, no. 105, illus.). A third sheet, which portrays the worker wearing an
apron and not a vest (N 4456), is a more vigorous and fully developed drawing
and can be clearly recognized as a study from a model.

M.U.R.

55. *Worker "Washing Up,"* ca. 1873–74

Graphite

32.5 x 24.6 cm

Signed at lower right: *Ad.M.*

Provenance: acquired in 1906 with the estate of Adolph Menzel

N 1371

Bibliography: Berlin, 1905, no. 3269; Kaiser, *Menzels Eisenwalzwerk*, p. 68, illus.;
Berlin, 1980, no. 322; Vienna, no. 75

This study from the model belongs to a small number of figural drawings that focus on the worker who washes his head at the far left of the painting. Menzel also drew several studies from life for the three workers next to him who are washing and dressing. (Most of these drawings are in the Nationalgalerie.) Opposite this group, Menzel indicated a change by including a group of workers eating. In this manner, he pointed out a necessary continuity in factory work: for the greatest possible efficiency, ceasing the operation of machines cannot be permitted.

<div align="right">M.U.R.</div>

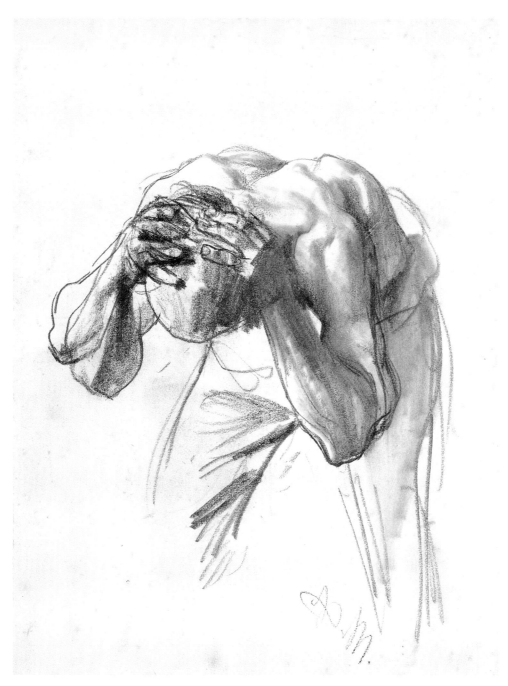

55

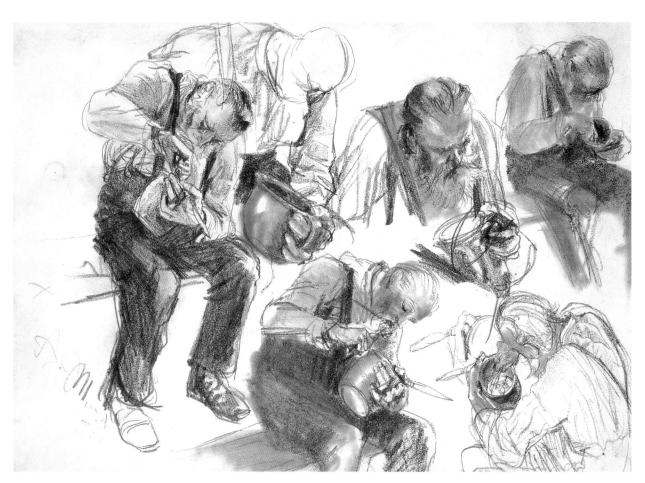

56

56. *Worker Eating,* ca. 1873–74

Graphite and stumping
26.5 x 37.0 cm
Signed at lower left: *A. Menzel*
Provenance: acquired in 1906 with the estate of Adolph Menzel
N 166
Bibliography: Berlin, 1905, no. 3806; Berlin, 1980, no. 319

Several studies from models were rendered in preparation for the group of three workers—two eat and one drinks behind a sheet of iron—and for the woman who brings them a basket of bread. Menzel drew six different poses of a full-bearded, older man who eats with a fork from a earthenware pot and holds his knife at rest in his left hand. That figure is portrayed differently in the painting, where he has only a moustache and his arms encircle the pot, his utensils placed inside, which he holds in his lap. The same model appears in two other drawings (N 1392, N 4447). Two sketches of eating workers (N 3196, N 3197) reveal the conditions that the workers experienced on their breaks, just as Menzel perhaps witnessed them at the factory.

M.U.R.

57. *At the Royal Iron Foundry*, 1874

Graphite

24.7 x 32.7 cm

Signed at lower right: *A.M. 74.*

Various inscriptions

Provenance: acquired in 1906 with the estate of Adolph Menzel

N. 1031

Bibliography: Berlin, 1905, no. 4158

Several studies of an iron foundry should certainly be considered in the context of Menzel's preparation for *The Iron Rolling Mill*, even though they were created at the Royal Iron Foundry in Berlin. Drawings in this group (N 964, N 1149, N 1157, N 2354), including the one shown here, depict a rope winch, a small kiln, and this rather dark hall with small arched windows and a roof structure supported by columns. Except for one sheet that is dated 1873, all are dated 1874 and are inscribed "K Eisengießerei" or "Kön. Eisengießerei." The spatial dimensions differ greatly from the apparently spacious hall at Königshütte and more closely resemble the old Royal Iron Foundry, which had been operating on Invalidenstraße since 1804. August Borsig later expanded the facilities, but then shut down the foundry in January 1874. This fact, coupled with Menzel's interest in the processes of iron manufacture, suggests that he seized the opportunity to make a reserve of images there. These sheets, which exhibit uniformly dense black and somewhat crude pencil strokes, share a simple and objectively rendered composition.

M.U.R.

57

VI. From Later Excursions: Architecture, Sculpture, and Landscapes

(58–70)

58. *Staircase in Mirabell Castle*, ca. 1870

Watercolor and gouache over graphite

40.1 x 26.1 cm

Signed at lower left: *Ad. Menzel. Mirabell b. Salzburg*

Provenance: acquired in 1906 with the estate of Adolph Menzel

N 4459

Bibliography: Berlin, 1905, no. 2250; Tschudi, no. 175, illus.; Berlin, 1980, no. 14, illus.; Vienna, no. 57, illus.

In 1852, Menzel made his first lengthy excursion, which lasted two months. This trip also led him, again for the first time, to Austria and, of course, to Salzburg. He returned frequently to that region, six times in the 1870s alone. Presumably this view of the famous staircase built by Lukas von Hildebrant in Mirabell Castle, the so-called angel staircase, ornamented with putti and sculpture in niches by Georg Raphael Donner and his pupils, originated on or after his trip to Salzburg in 1871. His choice of a complex partial view emphasizes the artistic richness of the balustrade next to the wide stairway. It also suggests a dating for the drawing of around 1870 rather than 1852, when he made his first journey. The somewhat dry application of color, which allows the paper to glimmer through the medium, corresponds most closely to his drawings in color of the late 1860s, as in his studies of armor (N 224, N 910, N 911) or in *The Marble Bath* of 1866 (in Kassel; Tschudi, no. 174, given erroneously as *Leopold's Crown*).

Such a view of a staircase is one of Menzel's more frequently chosen motifs. Rendering the complicated, multileveled space with equally varied light effects in paint or, as seen later, exclusively in pencil appears to have been one of his preferred challenges. Examples are numerous, including these from the National-galerie: *Pommersfelden Palace*, N 4437; *Staircases in Munich*, N 34, N 35; and *Brixen*, N 1156. The series extends from his early through his late work.

M.U.R.

58

59

59. *Interior of a Farmhouse in Southern Germany*, ca. 1873

Gouache

31.0 x 23.2 cm

Unsigned

Provenance: acquired in 1906 with the estate of Adolph Menzel

N 256

Bibliography: Berlin, 1905, no. 5824; Tschudi, no. 601, illus.; Vienna, no. 40,
 illus.

During his summertime excursions to find inspiration for his works, Menzel
enjoyed capturing interior views of farmhouses, barns, or courtyards. He was
particularly drawn to the rural buildings found in the region around Garmisch
and Hofgastein (cf. cat. no. 69).

This image, glowing with the warm, rich color of a softly lit interior of a
wooden entrance hall, offers unique insights and was presumably created in
Hofgastein. The unfinished quality of the figures that hurry up the steps adds to
the excitement in the image, yet the activity of the woman below remains unclear.
The viewer may be convinced that he sees everything, that he recognizes each
gesture and expression, but upon closer examination it becomes apparent that
Menzel stimulated the imagination to complete the scene through the suggestion
of detail. Similar subtleties that approach optical illusion can sometimes be
encountered in Menzel's work, and his rendering of light and shadow begets an
exceptional liveliness. At the time, Menzel was working in Berlin on *The Iron
Rolling Mill*, and his interest in light pervades the composition. The magical
quality of the sheet is evoked through his varying application of gouache. In some
areas, transparent passages were executed with the use of more water; in others
the gouache was applied in a drier form, allowing the white of the paper to figure
in the final effect.

The picture is closely related to a gouache that Menzel painted in 1873 of the
interior of a former inn in Hofgastein (Schäfer Collection, Schweinfurt; Tschudi,
no. 602). There, a peculiar chaos is played out on two levels of one of his
characteristic spaces typified by the steep stairway that leads directly to the slope
of the roof. Heightening the scene to an extreme is the interplay of direct
sunlight, backlight, dusky shadows, and the fire light from the kitchen hearth,
which illuminates each of the figures differently. Added to this and reminiscent of
a still life is a confusion of dishes in the lower part, and drying laundry and
stretched animal skins in the upper part of the image.

From 1872 to 1874, Menzel was often a guest of Magnus Hermann, the Berlin
banker and art enthusiast, at the Villa Carolina in Hofgastein. In addition to
Menzel's immediate relatives, the family of the Berlin painter Albert Hertel,
Hermann's son-in-law, also belonged to the circle that met there socially, at times
making music together, as Menzel's drawings demonstrate.

M.U.R.

60. *Norwegian Oyster Shells,* 1873

Graphite

21.0 x 35.5 cm

Inscribed at lower left: *4. Mai 1873*; at lower center: *Norwegische Fettaustern leere Schalen.*

Provenance: acquired in 1906 with the estate of Adolph Menzel

N 263

Bibliography: Beta, "Gespräche mit Menzel," vol. 2, p. 50; Berlin, 1905, no. 6413

Menzel's younger friend and colleague Paul Meyerheim relates in his memoirs (*Erinnerungen*, p. 54ff.) how the artist was in the habit of visiting his regular haunt, Frederich's tavern on Potsdamerstraße, to have an ample supper usually late in the evening, towards eleven o'clock. At times he would fall asleep for a bit between courses and, upon awaking, would perhaps draw his food which had become cold. Similarly, this plate of oyster shells may have remained on the table after a meal, possibly during his visit to the World's Fair in Vienna, which opened on 1 May 1873. Another drawing (N 262) exhibits a plate of oyster shells on a table, but there the edge of the sheet also functions as the upper edge of the table. Here, Menzel included a pair of hands, a small book, and various glasses, all of which are cropped by the paper edge. In this independent study, the incidental scene nearly resembles a prearranged still life. Continually surprising is Menzel's eye for finding the unusual in the most common objects, which he then supplied with hidden meaning.

As with many of the subjects of his pencil studies, Menzel employed the motif of oyster shells in a historical genre scene. In 1879, he painted the gouache *Oyster Eaters* or *One More!* (location unknown; Tschudi, no. 623), which portrays a baroque cavalier at an inn, sitting with his wine after a meal. On the table lies a pile of oyster shells. It is one of Menzel's many incidental works that he enjoyed giving to friends or that he created to be sold.

<div align="right">M.U.R.</div>

Norwegische Fettaustern.
4 Mai 1873.

60

61. *The Barberini Faun*, 1874

Graphite

40.1 x 26.2 cm

Signed at lower right: *Menzel 74*

Provenance: acquired in 1906 with the estate of Adolph Menzel

Nr. 203

Bibliography: Berlin, 1905, no. 4551; Berlin, 1980, no. 285

Summer trips to Austria in 1873 and 1874 led Menzel to Munich, where he drew two views of the *Barberini Faun* at the Glyptothek. (The second drawing was formerly owned by Ludwig Pietsch; see Berlin, 1905, no. 5385). This sculpture, which was produced during the height of the Hellenistic period and was restored during the baroque era, corresponded well to Menzel's search for the monumental form that he strove to achieve in *The Iron Rolling Mill*, which he began in 1872. In preparation for this painting, he not only drew male nudes from life (cf., for example, N 261, N 1489, N 3134), but he also made several studies from ancient sculpture.

Drawings emerged in 1873–74 that are stylistically related to the *Barberini Faun*. They portray figures of the river gods on the west pediment of the Parthenon (N 215, N 216) as well as other sculptures from the Parthenon of which plaster casts were in Berlin museums. As a preparatory study for a vignette in *Werke Friedrichs des Großen* (Bock, no. 925), Menzel produced in 1846 a delicate drawing with a sharp pencil (N 899) of the sculptures entitled *Kephissos* and *Illissos*. In comparison with these early drawings, Menzel's work of later years and especially that for *The Iron Rolling Mill* demonstrates the degree to which his drawing style turned toward the monumental. The expansive form that he perceived to be the essence of classical greatness is wonderfully revealed in this vigorous drawing of the *Barberini Faun*.

M.U.R.

61

62

62. *The Choir Stalls at the Collegiate Church in St. Gallen,*
1881

Graphite

24.3 x 32.5 cm

Unsigned

Inscribed at lower center: *St. Gallen. Dom. 81*

Provenance: acquired in 1906 with the estate of Adolph Menzel

N 168

Bibliography: Berlin, 1905, no. 3811; Vienna, no. 121, illus.

On his first excursion to northern Italy, a trip he repeated in 1882 and 1883, Menzel visited several towns in Switzerland. The love he developed for baroque and rococo architecture and sculpture on these trips was sparked by his early studies of the period of Frederick the Great and can be traced throughout his oeuvre. In the 1880s and 1890s, the stylistic directions borne by the spirit of the contemporary, new baroque movement must have struck a chord with Menzel.

The Collegiate Church in St. Gallen was the principal work (1762–68) of Josef Anton Feuchtmayer, the master of rococo sculpture in the Bodensee region. Menzel rendered the choir stalls in a vigorous style. The choir's high wall, ornamented with reliefs, extends across the sheet and is crowned in the center by a figure framed by a towering screen of organ pipes in the background. Abbreviated sketching, like that to the left in this sheet and used to suggest further decorative details, appears in another sheet that depicts the wings of the choir stalls in the church in St. Gallen (N 1151). As early as the 1860s, this rapid, linear style, characterized by an almost formulaic manner of rendering essentials, had become evident. This style appeared more and more frequently in Menzel's later years, a counterpart to his last drawings that, in their painterly sensibility, appear to be modeled out of gray and black layers of graphite.

The theme of the church choir stalls seen here recalls Menzel's splendid color drawings of 1869, which capture the magnificence of the choir in the Mainz cathedral. (See Tschudi, no. 568, in a private collection in Eutin in 1955; Tschudi, no. 573, in a private collection in Düsseldorf; and an oil study, National-galerie, West Berlin, not in Tschudi.) On pages 45 and 46 of his Sketchbook No. 33, Menzel sketched the outline of the choir, a practice he often employed in clarifying spatial dimensions.

<div align="right">M.U.R.</div>

63. *Cloudy Sky*, ca. 1880–90

Soft graphite and stumping
23.8 x 33.0 cm
Unsigned
Provenance: acquired in 1906 with the estate of Adolph Menzel
N 1168
Bibliography: Berlin, 1905, no. 3175; Berlin, 1980, no. 287; Vienna, no. 120

The drawing is linked to the tradition of small cloud paintings and studies that played a significant role in Romanticism, especially in Germany and England. Even Menzel, perhaps inspired by the Norwegian artist J. C. Dahl, who was then active in Dresden, paid tribute to the genre in two small oil paintings (1851, Nationalgalerie, West Berlin, Tschudi, no. 72; and an undated painting, Galerie Neue Meister, Dresden, not in Tschudi). Like the tops of the trees in the Berlin oil study, which project into the viewer's field of vision at the lower edge of the image, the roof of a baroque palace ornamented with sculpture is recognizable in this drawing. Although the structure resembles the roof of the Neuer Palais in Potsdam, its identity is not certain. The view of the roof is provocatively shortened, creating extreme tension in the relationship between the tangible and the amorphous forms.

In a study of clouds on pages 73 and 74 of Sketchbook No. 56 (Nationalgalerie), stumped hatching, pure stumping work, and a few brief contour lines combine in a similar manner. This motif was already uniquely conspicuous in his work of the mid-1860s and was often repeated in other sketchbooks of the 1880s and early 1890s. Occasionally calligraphic stylization of the cloud structures confronted his devotion to rendering amorphous forms.

Offering a comparison is a very late drawing titled *Cloudy Sky over a Church Tower* (1887, Nationalgalerie, West Berlin, Nr. 2831).

<div align="right">C.K.</div>

190

63

64. *Spa Garden in Kissingen,* 1886

Carpenter pencil, stumped, scratched; etched?
41.7 x 28.7 cm
Signed at upper right: *A.M. Aug. 86.*
Provenance: acquired in 1906 with the estate of Adolph Menzel
N 274
Bibliography: Berlin, 1905, no. 6619; Vienna, no. 127

In his later years, Menzel explored the modulation of black and gray tones as a
new medium for expression. Occasionally he applied the technique in a style
more rigorously individualistic than that of his contemporaries. (Some might
possibly find it reminiscent of Seurat's drawing style, but otherwise the two artists
differ completely.) Night and twilight became his true subjects, as in this composi-
tion in which the light source (whether moonlight or lamp light) is omitted. An
incline topped with a group of buildings and flanked by an undefined structure
with a house behind it is enveloped in deep shadows that recede like wisps of fog.
Only the boundary between the earth and sky, the roofs and the foliage, is
concretely tangible at the left. The same view is captured in daylight in another
drawing (N 194; see *Adolph Menzel: Gemälde, Zeichnungen,* no. 379, illus. on p.
282), in which the building and the garden grounds with its fountain are clearly
recognizable. Additionally, the same fountain may form the main motif in the
gouache *Spa Garden in Kissingen* (1885, Muzeum Narodowe Poznan, Warsaw;
Tschudi, no. 649).

In contrast, the nocturnal view obscures all edges and softens all boundaries,
blending tangible objects and masses with space. Menzel achieved such effects
through various graphic means. The graphite sits on the paper creating a greasy,
grainy surface, or it appears as a uniformly and densely rubbed black. Stumping
produced a cloudy gray, lightened here and there with a gum eraser. The surface
was repeatedly scratched with the wooden end of the pencil, with the negative
effect of the fine scratches corresponding to the nervous scribbles in graphite.
Menzel's method of layering and interweaving techniques that are often destruc-
tive or stressful to the paper support resulted in a richly differentiated and
suggestive surface.

Bad Kissingen (in the vicinity of Würzburg) was the location of one of Emilie
Krigar-Menzel's preferred spas. Although Menzel did not frequent the baths and
springs, he often accompanied her to the area. There he found themes for a
number of small genre scenes in gouache, such as *Beer Garden in Kissingen*
(1874, Tschudi, no. 609), as well as additional works from the 1880s.

C.K.

64

65

65. *Street in Front of the Spa Hotel in Kissingen after a Rain*, 1889

Soft graphite and stumping

18.1 x 11.7 cm

Signed at lower center: *A.M. 89.*

Provenance: acquired in 1906 with the estate of Adolph Menzel

N 2558

Bibliography: Berlin, 1905, no. 6090; Berlin, 1980, no. 387; Vienna, no. 136

The sharp downward view renders the course of the street impossible and reduces it to one of the graphic structures that fascinated Menzel in his later years. One comparison is an etching by Piranesi (*Le antichità romane e d'Italia*, 1756, v. 3, pl. VIII), which foreshortens the perspective of the pavement of the Appian Way, transforming it into an endless pattern that fills the image. A similar view of a street wet with rain but which includes the base wall of a house is portrayed on page 41 of Sketchbook No. 66 (1890). As the years passed, Menzel increasingly approached amorphous forms in his drawing style. On facing pages 3 and 4 in Sketchbook No. 73, for example, the inscription on the barely recognizable image *Stains on a Lavatory Wall* documents an extreme and sudden turning point in his detailed analytical vision. The drawing is reminiscent of the method, recommended by Leonardo, among others, of creating imaginative shapes from cloud formations and stains on walls. Yet Menzel's interest was not directed towards these manifestations of the imagination but instead towards the random forms themselves, without imbuing them with meaning.

Spa Garden in Kissingen, an 1885 gouache mentioned in cat. no. 64, portrays a straight boulevard from an angled, bird's-eye view that, in general terms, is similar to this drawing. The gouache *Ash Wednesday Morning* (1885, in the Nationalgalerie before 1945, today in the Kaunas Art Museum, Lithuania; Tschudi, no. 653) depicts a similar downward view of a street that is cropped at an angle by the rectangular form of the sheet. Another example of this perspective is found in the pencil drawing *Banks of the Schöneberg* (no. 13 in the auction catalog *Eine Berliner Privatsammlung*, Berlin: Hans W. Lange, 1939).

C. K.

66. *Beer Garden (Inn at the Post Office on the Tegernsee),*
1889

Soft carpenter pencil and stumping

22.9 x 31.2 cm

Signed at lower right: *Ad. Menzel 89.*

Provenance: acquired in 1906 with the estate of Adolph Menzel

N 4446

Bibliography: Berlin, 1905, no. 5239; Vienna, no. 135

In the summer of 1889, Menzel again visited the Franconian spa in Kissingen near Würzburg. On his return trip in early September, he stopped in Munich (among other areas) and then at the Tegernsee in Upper Bavaria. There, he drew baroque details from a cloister church (N 2436, N 2437, N 2440, N 2441, N 3066) and also a table with a tavern stool at an inn (N 2514). Perhaps pages 35–41 of Sketchbook No. 65 (Nationalgalerie) were filled at this site. Beginning on page 37, the drawings include scenes similar to the work shown here, but they did not directly serve as models.

Several variations of this theme appear among his small-format gouaches (Tschudi, nos. 609, 639, 660, 673, 676). Starting in the 1860s, groups of people and crowds outdoors, often in the city, became an ever-recurring theme. This completely developed figural drawing with its miniature-like qualities belongs among the last of those formulated in such a painterly manner before the artist began to focus on narrow details derived from larger views. The open, light-filled space among the branches dominates the scene. As was his frequent practice, Menzel "painted" with the shading stump, applying forceful, heavy black strokes to the hazy gray tones. He suggested infinitely more than he actually portrayed: details disappear into ghostly shadows and an evening melancholy pervades the scene.

C. K.

66

67

67. *Church Wall with Shadows of an Altar Decoration in the Church of St. Augustine in Würzburg,* 1890

Graphite and stumping
20.6 x 12.8 cm
Signed at upper left: *AM. 90*
Provenance: acquired in 1906 with the estate of Adolph Menzel
N 60
Bibliography: Berlin, 1905, no. 2048; Vienna, no. 137

With its baroque style, the bishop's residence must have fascinated Menzel. He had seen it many times on his excursions through Franconia, for it lay not far from Bad Kissingen, which he often visited as his sister's companion. He seldom drew scenes of cities like his 1895 view of the houses of Würzburg nestled in front of the hill and lining the banks of the Main (Nationalgalerie, N 52).

As in so many other respects, Menzel agreed with the later views of his "Tunnel friend" Theodor Fontane in his skepticism of so-called beautiful nature. (Both Menzel and Fontane belonged to the artists-writers circle "Tunnel über der Spree" in Berlin.) When Menzel was not capturing the spontaneous, fleeting moments of human life, he sought the at times abstruse beauty of the animated art of the baroque. In 1890, 1892, 1895, and 1901, Menzel drew not only the bishop's memorial monuments designed by Tilman Riemenschneider in 1498–99 (N 54, N 55, N 56) but also many details from the magnificent late baroque interior of the St. Augustine Church built by Balthasar Neumann. Details from other churches in the city appear among his drawings as well. (See N 57, N 58, N 163, and N 1177, with additional sheets in the Hamburg Kunsthalle and the Karlsruhe Kunsthalle).

In this drawing, executed with pencil and shading stump, Menzel conjured up the ghostly play of shadows on the church wall which were caused by the sculptural forms that decorate one of the rococo altars of the Auvera workshop (cf. N 3456 and N 481 for similarly rendered sheets of the Collegiate Church in Salzburg).

M.U.R.

68. *View of the Collegiate Church of Our Lady at the Old Chapel in Regensburg,* 1894

Watercolor and gouache

40.2 x 26.2 cm

Provenance: acquired in 1906 with the estate of Adolph Menzel

N 4471

Bibliography: Berlin, 1905, no. 5822; Tschudi, no. 626, illus.; Vienna, no. 139, illus.

Once again, Menzel depicted the interior of a baroque church. This view into the Collegiate Church of Our Lady at the Old Chapel in Regensburg emerged after a series of interior scenes in color of almost identical format: the Church of St. Benedict in Salzburg (1871, location unknown, Tschudi, no. 594); the Parish Church in Innsbruck (1872, Lugt Collection, Paris, Tschudi, no. 598; and 1881, private collection, Bühl, Tschudi, no. 628); St. Peter's Church in Vienna (1873, Oblastni Galerie, Liberec, not in Tschudi); and the Cloister Church in Ettal (1875, location unknown, Tschudi, no. 619).

In this drawing, church services have ended and the movement of the dispersing people unites both with the flickering motion of the sumptuous and shining, gold rococo ornaments and with the light streaming through the windows above. It appears as though Menzel did not complete this watercolor. Hasty treatment is especially evident in the rendering of the figures, and the white of the paper shimmers through, untouched by color in several areas. Yet the spontaneity and beauty of the scene are enhanced by this effect, for details do not crowd into the foreground to distract the eye from the overall impression. All this suggests a relatively late date for the sheet. Menzel had included Regensburg on his trip on the Danube in 1852, and he was there several times in the 1870s and 1880s. The Collegiate Church, with its rich rococo ornamentation, was a repeated, favorite stopping point. In an earlier, delicate drawing he masterfully captured the bizarre forms of an oratory (N 1172). On both sides of the watercolor, the oratory appears, growing almost organically and shining with gold.

In 1894, which may well be the date of this watercolor, Menzel again drew details of an oratory, this time frontally and from a somewhat higher viewpoint (N 66). Vigorous and decidedly more lively graphite lines define the southern choir loft and a detail from the structure of the altar in an additional drawing (N 365). The visual angle into the interior of the church fully corresponds to this watercolor. The sheet, dated 1894, includes notes on color: "All marble on the cornices of the columns[:] gray, on the columns[:] yellowish." Heavy, wiping brushstrokes in color at the sheet's edge suggest that this drawing lay on Menzel's worktable as a model and *aide-mémoire* while he painted the watercolor in his studio, a practice common in his working procedure.

M.U.R.

68

69. *Entrance Hall in a House*, 1892

Graphite and stumping

23.0 x 31.0 cm

Signed at lower left: *A.M. 92*

Provenance: acquired in 1906 with the estate of Adolph Menzel

N 269

Bibliography: Berlin, 1905, no. 6567

This drawing was probably created during a summer sojourn in Salzburg. Menzel loved to wander through recessed courtyards and old houses, drawing their often bizarre architecture and exciting plays of light and shadow with a crude carpenter's pencil and a shading stump. Here, he further pursued the subject matter he had sketched in Upper Bavaria and in the Austrian Alps in the 1870s and 1880s, where other complex interiors had attracted his eye. Through his new approach, his style changed from his characteristic dark, sharp line to the softer and more expansive, heavily stumped gray seen in his work of the 1890s.

M.U.R.

69

70

70. *Houses behind Trees*, 1893

Soft graphite and stumping
22.9 x 31.2 cm
Signed at lower right: *A.M. 93*
Provenance: acquired in 1906 with the estate of Adolph Menzel
N 967
Bibliography: Berlin, 1905, no. 4211; Berlin, 1980, no. 395; Vienna, no. 142

Like many drawings from Menzel's late period, this one closely resembles a painting in its completion and sense of continuity. It is one of the last compositions to employ the older Menzel's leitmotif of a city view sketched from a window. Here he draws structures dating from the late *Gründerzeit* in a small (or on the edge of a large) city. In his later years, a network of bare tree branches frequently obstructs the view into the depths, as seen in the famous gouache *Ash Wednesday Morning* (1885, Kaunas Art Museum, Lithuania; Tschudi, no. 653). The format of the pencil drawing *Church behind Tree Branches* (1894, Kunsthalle, Kiel) is nearly identical to this drawing, and both may have been created during the same winter.

C. K.

VII. Late Works

(71–78)

71. *Self-Portrait*, 1882

Soft graphite and stumping

28.2 x 22.3 cm

Signed at center of left edge: *Adolph Menzel 30 Dezember 82*

Provenance: acquired in 1889 from Menzel's art dealer Hermann Pächter of the
firm R. Wagner, Berlin

Kat. 5

Bibliography: Berlin, 1905, no. 355; Schmidt, no. 38; Berlin, 1980, no. 416;
Vienna, no. 122

Menzel seems to have never become comfortable with his own appearance. The
rarity of self-portraits—not a single one is in color!—is astonishing considering the
range of his work and especially the spontaneity of his discovery of themes.
Apparently Menzel preferred to turn away from this ever-available model.

Of the few drawings and graphic compositions that he nevertheless produced of
himself, several are "risky" (in the words of the art historian Claus Korte) in that
they are clearly problematic self-portraits. The drawing shown here was executed
three weeks after the artist's sixty-seventh birthday and a few months before he
was named vice chancellor of the Peace Division of the Order Pour le mérite. (He
became its chancellor only two years later.) In the portrait, Menzel appears sternly
objective, even official, and brings to bear the authority of the frontal view and the
conventional bust portrait. The head was notably modeled with great care, with
dense hatching and crosshatching. The forcefulness of his graphic expression does
not diminish until the rendering of the chest area.

Seven years later, when he referred to this drawing in a letter, Menzel pointed
out its "not bearing quite the right resemblance" and that he had "made [it] for a
special occasion." He advised against its use, most likely in the three-volume
work on Menzel by Max Jordan and Robert Dohme, which was completed in
1890.

C. K.

71

72

72. *Three Old Women in Shawls*, 1892

Soft carpenter pencil and stumping

24.4 x 32.4 cm

Signed at upper right: *A.M. 92.*

Provenance: acquired in 1906 with the estate of Adolph Menzel

N 4443

Bibliography: Berlin, 1905, no. 5230a; Schmidt, no. 555; Berlin, 1980, no. 593; Vienna, no. 141.

A new theme revealed itself to Menzel in the last years of his life, when he repeatedly drew people from a close range. Heads fascinated him, as demonstrated by the predominance of this motif in Sketchbook No. 62, which was concluded in December 1893. Professional as well as incidental models (preferably older ones) and people touched by fate in various ways generally sat for him only once. Did he compose scenes with several figures as they sat before him, or did these comparatively large compositions spring from his memory? The latter course corresponds to a familiar practice of the artist (see cat. no. 12). The figures' attire is recognizably that of the city. Perhaps these individuals were from the quarters that then encircled the old city center of rapidly expanding Berlin.

In this drawing, members of clearly different social classes meet. For instance, the lady in the background would have scarcely allowed herself to enter into a conversation with the woman in the knitted shawl. Yet such encounters may have been commonplace in the newly constructed buildings of the period. The proximity of the social elite, who inhabited the houses with frontage, to the poorer classes quartered in the dark and narrow houses behind contributed to the legal justification of the so-called *Mietskasernen*, tenement houses that were erected in large numbers in Berlin in the 1860s.

Menzel often reduced scenes to half-figures, as in this drawing. Compare it with *Fruit Seller in Verona*, a gouache executed eight years earlier (Nr. 1770; Tschudi, no. 648; which also depicts three figures) to note his reduction of anecdotal elements, his study of accessories, and his concentration on the psychological event, including human features and expressions. In retrospect, one may first properly assess the abandoned approach in *Courier Woman*, a half-figure painted in oils (1854, Schäfer Collection, Schweinfurt; Tschudi, no. 92). Her figure is dramatically illuminated in a manner reminiscent of Rembrandt's lighting effects.

In this drawing, it once again becomes clear how Menzel separated the roles of pencil and stump. The graphite was applied later and is clearly differentiated from the soft gray of the stumping. The spatially suggestive wisps of the stumping are almost tangibly reinforced and made more solid by the grainy black. In the center figure, both media were applied equally, while those to the right and to the left demonstrate one or the other media as being predominant.

C. K.

73. *Right Leg of a Man*, 1894

Carpenter pencil and, stumping

28.8 x 41.5 cm

Signed at lower right: *A.M. 94*

Provenance: acquired in 1906 with the estate of Adolph Menzel

N 245

Bibliography: Berlin, 1905, no. 522; Schmidt, no. 545; Vienna, no. 106

Menzel's practice of drawing not only as a preparatory stage before painting but also as an end in itself is most clearly expressed when his attention was directed toward his own body. The perspective that resulted when he did not employ a mirror was not suitable for use in larger compositions. For example, drawings of the artist's hands appear on pages 9 and 11 in Sketchbook No. 24 of 1862–63. Moreover, the grotesque effects caused by perspective and foreshortening continually fascinated him, as the sheet shown here demonstrates. Again the artist served as his own model. The inclusion of the right hand at rest affirms that he easily drew with his left hand. Menzel must have looked into a mirror for the detail at the upper left. An oil study on wood of his own foot—with the big toe conspicuously pointed upward—was painted in 1876 (location unknown; Tschudi, no. 145).

<div align="right">C. K.</div>

73

74. *On the Marienburg*, 1897

Gouache

26.4 x 37.0 cm

Signed along right edge: *Adolph Menzel 97.*

Provenance: acquired in 1906 with the estate of Adolph Menzel

N 4596

Bibliography: *Kunstchronik*, n.s. 9, March 1898, p. 19, col. 316; Beta, "Gespräche mit Menzel," vol. 3, p. 108; Berlin, 1905, no. 344a; Tschudi, no. 679

Late in his life, Menzel created a curious image in gouache, a composition from memory, that has the allure of a fantastic image from a dream. Represented is a view from a low vantage point of the Schwedentor or Marientor of the Marien-burg (once in the province of East Prussia and the seat of the Grand Master of the German Order). The gate was situated on the bank of the small river Nogat between the Grand Master's palace and the central castle—but how the older Menzel transformed it! In his earlier days, he often modified architecture to create effects in his compositions that deviated from purely naturalistic rendering. Various memories appear to be mirrored in this scene. It is the last of his composi-tions to include numerous figures, and even they seem particularly small. Like ants, they crawl upon the walls. Workers return home in the evening by horse and wagon, and in the foreground others carry picks and shovels on their shoulders. (Several life sketches of these individuals are today held by the Nationalgalerie. Also see Menzel's notes on this gouache in the Nationalgalerie Archives.)

Light shines through the gateway in the center of the sheet. Nearby and to the right, a large statue of the Madonna rises up in front of a pilaster crowned with a round battlement. All these architectural features were invented by the artist and spring from a variety of sources. In August 1897, Menzel had visited the painter Rudolf von Alt in Vienna. They were nearly the same age, and Menzel probably knew him from visits to Bad Gastein. Menzel's painting appears to pay homage to the late compositions of this artist. In a similar manner, the work is characterized by an unusual perspective that monumentalizes the architecture through an un-common viewpoint and dwarfs the crowd of people swarming at its base. (See, for example, the watercolor of 1895, *Iron Foundry on Skodagasse in Vienna*, of which further versions arose in 1903; Walter Koschatzky, *R. v. Alt*, Vienna, 1975, fig. 205.)

The statue of the Madonna at the drawing's center is reminiscent of the composition of the commemorative sheet that was created in 1869 for the anni-versary of the Heckmann company (cat. no. 50; Tschudi, no. 570). In that, the figure of the goddess of fortune assumes a similar position. Finally, the picture signifies Menzel's memory of a trip he made to the Marienburg in 1855. At that time he executed drawings of the fortress (see Sketchbook No. 14, p. 80, and Hofmann, ed., *Menzel der Beobachter*, no. 66). An additional watercolor shows the position of the structure with the gate on the bank as seen from the river. The watercolor also exhibits a peculiar perspective that does not correspond to nature and instead alters the relationship of the buildings to each other (Nr. 1738, Nationalgalerie; Tschudi, no. 337).

Menzel made this trip in the summer, before he traveled to Paris to see the World's Fair. There, he completed a commission he had received from Baron von Schön—Menzel had started the designs in the 1840s—for two of the ten figures of the German Order, which were intended to decorate the large refectory in the Grand Master's palace. Executed in the rare water-glass painting technique, they portrayed the Grand Masters Siegfried von Feuchtwangen and Luther von Braun-schweig. (These works [Tschudi, nos. 341, 342] and two preparatory sketches in chalk of 1854 that were formerly in the Nationalgalerie were lost during World War II. Two oil studies [Tschudi, no. 25] are still extant at the Nationalgalerie, as are as several smaller chalk studies of ca. 1846 [Sammlung der Zeichnungen].)

74

The poet Theodor Fontane honored these murals with a poem in a letter dated 31 October 1855. (See Gotthard Erler, ed., *Die Fontanes und die Merckels. Briefwechsel*, Berlin, 1987, p. 21.)

In this gouache of an evening celebration, Menzel, who longed in vain for a commission for a great historical piece, recalled wishful dreams of the past.

<div align="right">M.U.R.</div>

75. *Two Bearded Men and a Woman*, ca. 1900

Graphite

13.2 x 21.1 cm

Unsigned

Provenance: acquired in 1906 with the estate of Adolph Menzel

N 1735

Bibliography: Berlin, 1905, no. 5224

This pencil drawing of three heads belongs to an original and even singular group of Menzel's later sheets that concentrate solely on the representation of human physiognomies. He captured the circumstances of the moment through individual expressions, and these are sometimes indicated merely by brief gestures. The eye contact between the two men was one of Menzel's favorite motifs and was already evident in his work for the Frederick cycle. Perhaps a joke brings a slight smile to the eyes of the younger man and to those of the woman.

Menzel's technique implies a mastery that demanded the utmost from his combined use of pencil and shading stump in order to render a painterly effect.

<div align="right">M.U.R.</div>

75

76

76. *Two Men and a Woman, Behind Them a Man with a Cigar (Disappointed)*, 1900

Soft carpenter pencil, graphite, and stumping

19.9 x 26.6 cm

Signed along upper left edge: *Ad.v.Menzel 1900.*

Provenance: acquired in 1906 with the estate of Adolph Menzel

N 1737

Bibliography: Berlin, 1905, no. 5250; Riemann and Keisch, *Adolph Menzel*, no. 126, illus.

Once again varying social classes encounter one another. A truly Prussian-Wilhelmian burgher looks both authoritatively and defensively towards the men at the right, literally "distancing himself" from the bearded men who are apparently concluding some business. One of them may have money or jewelry in his open hand. (Menzel often portrayed such presumably or truly Jewish men.) The social classes collide with one another even more strongly in *Visit to the Iron Rolling Mill*, a gouache that was also painted in 1900 (private collection, Switzerland; Tschudi, no. 680). Alienation pervades that drawing, which may well be intended as a scene from a loan house. The contrast created at the edge of the conflict also predominates in the composition: no stable spatial relationship can be established between the individual man and the group, which is abruptly forced apart from him as if by a wedge. The middle axis of the composition is filled with motifs, such as a shoulder, an ear, and hair, that deny admittance to the viewer. The figure in profile more than turns away; he focuses his attention downward. In this manner, the artist created a quiet, niche-like space within the group at the right in contrast to the sudden disturbance at the left. Through his long-practiced method of creating compositions from fragments—and indeed in this type of drawing the seams are apparent and the gaps are left unfilled—Menzel was provided to the end with new possibilities, in content as well as composition. This distinguishes the deeply thoughtful and powerful art of his old age from all common genre painting.

C. K.

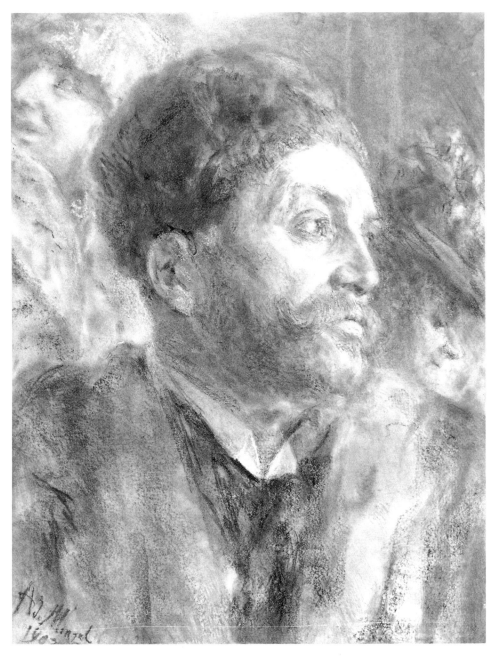

77

77. *Head of a Man Facing Right, Behind Him Two Heads of Women (After the Matinée)*, 1902

Soft carpenter pencil, stumping, and brush and brown ink

26.5 x 20.3 cm

Signed at lower left: *Ad. Menzel. / 1902*

Provenance: acquired in 1906 with the estate of Adolph Menzel

N 254

Bibliography: Berlin, 1905, no. 5238; Riemann and Keisch, *Adolph Menzel*, no. 127, illus.

As in most of Menzel's late drawings, the viewer seems to be placed in the midst of a throng of people—and as the former title indicates, why not among concert guests who struggle to reach the exit? In such situations, encounters are accidental and brief, and attention is permitted to become fixed on a certain subject only momentarily and involuntarily. In any case, Menzel never respected the traditional hierarchy of appropriate subjects for images and its divisions into meaningful and trivial material. Here, the requisite claim to ennoble the subject has also been abandoned, in that the subject has simply become the focal point of the artist's imagery. Indeed, the angled view of the man who turns aside suggests that the passage of time cannot be stopped. Both of the women's heads in the background, which were rendered fragmentarily and are blurred like an unsuccessful snapshot, indicate the rhythm of the hurried movement across the field of vision, threatening the loss of the subject. In addition, the dimensions and the view from below satirize the monumentality of the main figure. The effect is most easily comparable with the work of Degas (who revered Menzel and copied his *Ball Supper*). The composition of a large head in the close foreground and two heads behind looking in different directions, which causes all the axes of movement and the gazes of the figures to contend with one another, is an idea that occurs more often in Menzel's later work and is evident as well in a sheet of 1898 of a woman's head with those of two men. While in the possession of the sculptor Reinhold Begas, the sheet was published as a collotype.

This image's unorthodox drawing technique is striking. In several areas where the black of the graphite did not sufficiently create the desired effect, brush and ink were applied. In other cases, Menzel did not hesitate to scratch systematically into the paper. The blending of different techniques is exhibited at its freest in a large composition of 1896 that served, when reproduced as a collotype, as a frontispiece of a commemorative volume for the jubilee celebration of the Berlin Academy of Arts. It is possible that the Nationalgalerie's drawing was also intended for reproduction.

C. K.

78. *Applauding Man and Woman with a Hat,* 1905

Soft carpenter pencil, graphite, and stumping, scratched
21.0 x 13.3 cm
Signed at upper right: *Ad: Menzel. 1905*
Provenance: acquired in 1906 with the estate of Adolph Menzel
N 1736
Bibliography: Berlin, 1905, no. 5229; Berlin, 1980, no. 404; Vienna, no. 148

In his New Year's letter to the German emperor dated 31 December 1904 (and it is perhaps his last existing letter in general), Menzel made the exclamatory remark: "For me, it is as if each year is one month shorter! and so it was with this year as well! The last hour is at hand!!!" (Wolff, p. 239). The artist died on 9 February 1905. This drawing may well have been his last.

In addition to the applauding hands, which might be those of the gentleman, the positioning and the lighting of the figures bring to mind guests in a theater loge. Menzel's interest in the stage had diminished in his old age. He wrote to Paul Meyerheim on 30 October 1901, "Generally it is of no use for me to visit the theater anymore. I do not laugh at the humorous parts—." Yet the purpose of the letter was a response to Meyerheim's invitation to the theater, which his closest friend would scarcely have conveyed if a refusal were inevitable.

This sheet is also the last variation of a familiar theme in Menzel's art. The distinguishing elements of his chalk drawings of theater guests and concert audiences of ca. 1850 are seen once more, but on a new level. Now they are heightened, simplified, removed from the anecdotal, and shifted to the threshold between the real and the unreal. The unabashed detail view and the division of the sheet into two vertical columns, with the intrusive close-up view of the figure in the foreground and the uncertain blur of the figure behind, are joined here by the line of the woman's illuminated profile.

The efforts of the eighty-nine-year-old man to capture fleeting occurrences are physically perceptible in his almost desperate handling of the paper surface. In addition to the dull, soft graphite pencil and the shading stump, a harder and sharply pointed stylus was also applied. This creates in isolated areas an extremely fine, web-like netting over the stumped tones and between the chalky accents of the carpenter pencil. In the darkest areas, as in the woman's hat, the artist scratched into the paper so forcefully and persistently that its surface is disturbed and the fibers are roughened.

<div align="right">C. K.</div>

78

Chronology

MARIE URSULA RIEMANN

1815 Adolph Friedrich Erdmann Menzel is born on 8 December in Breslau, the son of Carl Erdmann Menzel, a school principal, and Charlotte Emilie Okrusch, the daughter of a drawing teacher.

1818 Menzel's father leaves his position as director of the Educational Institute and establishes a lithographic press.

1823 Menzel's sister Emilie is born on 25 July.

1826 Menzel's brother Richard is born on 3 November.

1828 At age twelve, Menzel exhibits a chalk drawing after Rubens at an exhibition of the "Silesian Patriotic Society" in Breslau.

1829 Menzel's father publishes the illustrations to J.A. Kutzen's *Die Geschichte des preussischen Staates.* The fourteen-year-old Menzel designs eight lithographs for the second part.

1830 The Menzel family moves to Berlin in April. There, the father hopes to find an appropriate education for his son, who demonstrates an early gift for drawing. Menzel works in his father's lithographic business and defers attending the Academy.

1831–32 Menzel receives his first commission, for *Luthers Leben. Ein Bilderbuch für die Jugend,* published by Sachse & Co., Berlin (third edition). He designs seven of the thirteen chalk lithographs.

1832 Menzel's father dies on 5 January. The sixteen-year-old Menzel supports his family by continuing the operation of the lithographic press.

1833 The artist attends a class on drawing from plaster casts at the Berlin Art Academy. He later describes his participation as "half-year, sporadic." Disillusioned, Menzel abandons his efforts and continues his education on his own. While drawing at the Academy in the evenings, he becomes acquainted with the wallpaper manufacturer Carl Heinrich Arnold and soon establishes what will become a lifelong friendship with him and his family. At the Arnold residence, Menzel encounters such renowned Berlin artists as the architect and painter Karl Friedrich Schinkel, the sculptors Christian David Rauch and Friedrich Drake, and the painters Eduard Magnus and Eduard Meyerheim. He also establishes a friendship with the archeologist Adolf Schöll.

 In the fall he obtains his first successful commission through the publisher Louis Sachse: eleven illustrations (pen lithographs published in 1833, dated 1834) for Goethe's *Künstlers Erdenwallen.*

1834 The illustrations for *Künstlers Erdenwallen* receive praise from Gottfried Schadow, director of the Academy of Arts, in his review in the *Allgemeine Preußische Staatszeitung.* Menzel is accepted into the Association of Younger Artists on 22 February. Until 1836, Menzel works on twelve chalk lithographs for *Denkwürdigkeiten aus der Brandenburgisch-Preußischen Geschichte,* published by Sachse & Co.

1835 Menzel's friend Carl Arnold moves to Kassel with his family. Menzel designs and lithographs the title page to the third volume of Athanasius Count Raczynski's *Geschichte der neueren Deutschen Kunst* (published 1841) and border designs for compositions by Prince Anton von Radziwill to illustrate Goethe's *Faust.*

1836 Menzel meets Dr. Wilhelm Puhlmann, a regimental medical officer from Potsdam and director of the local art society, with whom he enjoys a close friendship until Puhlmann's death in 1882. Menzel designs a membership card (pen lithograph) for the Potsdam Art Society in addition to thirty pen lithographs for the children's book *Der kleine Gesellschaft für freundliche Knaben und Mädchen* (written by Emilie Feige and published by Gropius). Menzel studies works by Albrecht Dürer

and those by Venetian, Dutch, and French painters of the seventeenth and eighteenth centuries in Berlin art collections. His first oil painting, *The Chess Game*, is considered by some to be "half-kneaded, half-molded." After producing studies in watercolor, he later comes to prefer the opaque quality of gouache.

1837 His pen lithograph for *Vater Unser* (The Lord's Prayer, published by Sachse & Co.) demonstrates his characteristically fastidious rendering of a given subject.

1838 After producing a pen lithograph for a document for the Mason Journeymen (published by Sachse & Co.), Menzel uses the same technique for a card to commemorate Gottfried Schadow's fifty years of membership in the Berlin Academy of Arts.

1839 Menzel received his first private commission for a painting, *The Judgment Day*. Numerous commissions for illustrations at first prevent Menzel from further attempts at painting.

Until 1842, he works on nearly 400 drawings for wood engravings to illustrate Franz Kugler's *Geschichte Friedrichs des Grossen*, which is commissioned by the publisher J.J. Weber in Leipzig. In addition to intensively studying the historic details of the period of Frederick II, Menzel endeavors to perfect his wood-engraving technique. Dissatisfied with the Parisian craftsmen hired to execute the wood engravings, he gradually recruits skilled technicians in Leipzig and Berlin.

The intermediary for this significant commission, the art historian Franz Kugler, may have introduced Menzel to the literary group "Tunnelüber der Spree" in the late 1840s. Here, Menzel becomes acquainted with Berlin's noted poets, writers, scientists, law scholars, and military officers.

Paintings by John Constable are exhibited at the Hôtel de Russie on the Pariser Platz in Berlin. These perhaps inspire Menzel's pre-impressionistic oil paintings of the 1840s. He attaches so little importance to these works that they do not come to the public's attention until just shortly before his death or after it.

On 3 October, the Menzel family moves from their residence on Wilhelmstraße to Zimmerstraße 4.

1840 The artist takes a trip to the Gutenberg celebration in Leipzig in late June through early July. A twelve-day visit to Dresden included study of the magnificent baroque architecture there; some of the structures still stand in ruins from the destruction of the Seven Years' War. The beauty of the then unpopular style caught Menzel's eye, although art historians did not consider the architecture to be significant until years later.

1841 Menzel enjoys a two-week visit with the Arnold family in Kassel beginning on 12 September.

1842 He commences work on the so-called *Armeewerk*: 436 pen lithographs for *Die Armee Friedrichs des Grossen in ihrer Uniformierung* (three volumes, published by Sachse & Co.; completed in 1857).

1843 Menzel begins work on the 200 wood engravings that will illustrate *Werke Friedrichs des Grossen* (completed in 1849). This commission from King Frederick William IV, who took the throne in 1840, establishes Menzel's contacts with the royal court and with the intermediary for the commission, Ignatz von Olfers, director of the Royal Museums.

The Disturbance is completed in 1846. His first oil painting after a hiatus, this historical genre scene was perhaps influenced by history paintings by the Belgian painters de Bièfve and Gallait, which were exhibited in the rotunda of the museum in the fall.

1844 Menzel frequents the museum's Kupferstichkabinett to study and admire Dutch etchings, especially those by Rembrandt. He produces several studies in etching. He journeys to Breslau, Striegau, and Jauer to visit his Silesian relatives and travels to Frankfurt an der Oder.

1845 At the end of March, the Menzel family moves to Schöneberger Straße 18. Menzel establishes a friendly relationship with the family of Dr. Maercker, who becomes the minister of justice in the summer of 1848. The family lives in the same

building as the Menzels. Friederike Arnold, the daughter of Menzel's friend, visits his family. Menzel feels great affection for her and paints her portrait. He also paints *The Balcony Room*.

1846 Menzel's mother dies on 8 October. Carl Johann Arnold, the son of his friend, wishes to become a painter and visits Menzel from early October until December. Menzel paints a portrait of his brother, as well as *Prince Albert's Palace Garden*, *Building Site with Willows*, and *Storm on Tempelhof Mountain*.

1847 Menzel's siblings move to Ritterstraße 43.

He paints *On the Kreuzberg near Berlin*, *The Berlin-Potsdam Railway* (the first German painting of a railroad), *Bedroom at Ritterstraße*, *Roofs in Snow*, *Sermon at the Old Monastery Church in Berlin*, and *Living Room with Menzel's Sister Emilie*.

On 11 August, Menzel travels through Eisenach (to see the Wartburg) and on to Kassel to visit Arnold, who arranges a commission from the Hessian Art Society for a history painting to commemorate the 600th anniversary of the reigning Hessian dynasty. This fulfills Menzel's long-held wish to be sponsored to paint a historic scene. After staying in Marburg for four days to make studies (10–14 September), Menzel executes the cartoon *Entry of Sophie Brabant with Her Little Son Heinrich into Marburg in 1247*, first in charcoal, and later in black chalk. Its poor reception troubles Menzel for a long time.

1848 On 21 March, a few days after the outbreak of the revolution, Menzel returns to Berlin. On the same day, he witnesses the public honoring of approximately 300 fallen citizens on the front steps of the German Cathedral on the Gendarmenmarkt. Impressed by the revolution, Menzel begins to paint *The Honoring of the Insurgents Killed in March 1848*, which remained unfinished, an indication of the shattering of hopes that the majority of the liberal middle class had placed on the revolution. This year gives rise to smaller paintings with themes from the artist's own life, including *Social Evening at the Maerckers*, *Stairway Landing at Night*, and *The Garden at the Ministry of Justice*; oil studies of the heads of horses obtained from the slaughterhouse; and several oil portraits, among them *Mrs. Clara Schmidt v. Knobelsdorf*, *Mrs. Maercker*, *Carl Heinrich Arnold*, *Brother at Breakfast*, and *The Electors* (pastel).

1849 The focus of Menzel's interest in painting shifts to the period of Fredrick II. He paints *The Petition*, which he hopes will become "the single kernel of a great ear" (letter to C.H. Arnold dated 16 January 1849; Wolff, p. 138). He begins *Frederick the Great's Flute Concert at Sanssouci* (which he resumes in 1851 and completes in 1852) and *Frederick the Great's Dinner at Sanssouci* (completed in 1850).

1850 Friederike Arnold marries.

Summer journey to Dresden, Meißen, Halberstadt, Goslar, Falkenstein Castle, and Baumannshöhle in Rübeland. Several portraits of men emerge in watercolor and gouache: *Major v. Leithold*, *General v. Prittwitz*, *General v. Bieler*, *Writer Heinrich Smidt*, *Dr. Karl Eitner*, and *Dr. Puhlmann*.

Menzel does not believe he is suited to work as a general portraitist. He begins the painting *Frederick the Great and His Followers at the Battle of Hochkirch, 1758* (completed in 1856). He accepts a commission for a series of wood engravings entitled *Aus König Friedrichs Zeit. Kriegs- und Friedenshelden* (begun for J.J. Weber, Leipzig; published in 1856 by Duncker, Berlin).

He produces in watercolor a *Congratulatory Diploma from the City Council of Berlin to Crown Prince Frederick William on His Coming of Age*.

Menzel also becomes a member of the literary group *Tunnel über der Spree* on 20 October (see Theodor Fontane, "Tunnelberichte," in *Autobiographische Schriften* [Berlin and Weimar: Aufbau Verlag, 1982]).

1851 Summer trip in Pasewalk, Stralsund, Rügen Island, and Stettin.

Studies on Stone with Brush and Scraper (six sheets) are published as a portfolio by Meder of Berlin.

Menzel creates a self-portrait, *The Antiquarian*, to be included in the planned continuation of the series.

1852	Using a scraper, Menzel transfers the design of his composition *The Twelve-Year-Old Jesus at the Temple* from his large, transparent painted banner onto stone. He describes this work and his lithographic technique in detail in a letter to C.H. Arnold dated 4 June 1852 (Wolff, p. 156).
	The annual Christmas event for the benefit of needy families of artists is held at the Academy. Large banners by various artists are displayed during the concert given by the cathedral chorus. On 26 December 1851 (Wolff, p. 154f.), Menzel reports to Arnold that he and his friends have finally accomplished bringing forth original compositions instead of the usual copies displayed at earlier performances.
	Menzel paints two pictures for the Parisian art dealer Goupil: *Frederick and the Dancer Barbarina* and *Frederick and the General de la Motte-Fouqué*.
	The Studio Wall at Ritterstraße, oil.
	On his first long study trip (from the beginning of August through mid-October), Menzel travels with his sister to Nuremberg, Bamberg, Munich (Nymphenburg), Salzburg (Hellbrunn), Salzkammergut, Berchtesgaden, and Traunstein. He journeys on the Danube from Donauwörth through Regensburg, Passau, and Linz to Vienna and Klosterneuburg, returning via Prague.
	In December several members of the literary group "Tunnel über der Spree" form a smaller gathering, called "Rütli." Discussions about art and literature are conducted on Saturdays over coffee and cake, occasionally at the home of a member. Menzel, named "Rubens" by Tunnel members, is among the "Ur-Rytlyonen" (original members of Rütli), which includes Friedrich Eggers (an art historian, writer, and professor at the Academy of Arts since 1863), Paul Heyse, Wilhelm von Merckel (Supreme Court councillor and writer), Theodor Fontane, Franz Kugler, Karl Bormann (regional inspector of schools), Bernhard von Lepel (military officer and writer), and Theodor Storm.
	A friendship develops between Menzel and the young painter Fritz Werner, who occasionally executes reproductions and engravings of Menzel's paintings.
1853	Menzel is elected a member of the Royal Academy of Arts on 8 November.
	Trip to Braunschweig.
	From the Old New Synagogue in Prague, oil.
	In Front of the Michaelskirche in Munich, gouache.
1854	To celebrate the 25th anniversary of the Festival of the White Rose in Potsdam, which was first held on 13 July 1829, Menzel produces a commemorative album of ten gouaches for Empress Alexandra of Russia.
	Frederick the Great on a Journey, oil.
1855	The Silesian Art Society commissions Menzel to paint *Oath of Allegiance to Frederick II by the Silesian Society in 1741*.
	A Place for the Great Raffael, gouache.
	He also paints in the water-glass technique two mural portraits of Grand Masters of the Order of German Knights for the refectory at Marienburg.
	Trip to Marienburg.
	Menzel spends fourteen days in September visiting the World's Fair in Paris (which for the first time includes an international painting exhibition), where his *Dinner at Sanssouci* is exhibited. He visits Courbet's "Pavilion of Realism" on Avenue Montaigne near the official art gallery.
	Return trip via Cologne, Brühl Castle, Rheinfels Ruins, and St. Goar.
1856	*The Battle of Hochkirch* is first publicly displayed at the Academy and meets with great success. Menzel is appointed Royal Prussian Professor at the Academy.
	The Théâtre Gymnase, oil.
	Trip to Nice and Lissa.
1857	Menzel is awarded the Great Gold Medal for Art for his *Hochkirch* painting.
	Summer trip to Thüringen, Weißenfels, Griesheim (near Stadtilm), Paulinzella, and Schwarzburg Castle. Return trip via Dresden and Moritzburg (near Dresden).
	Meeting of King Frederick II with Emperor Joseph II in 1769 at the Bishop's Palace in Nice, oil. Menzel obtained this commission for a painting on a Frederician theme in 1855 from the Association for Historical Art.

1858	The painting *Bon Soir, Messieurs! Frederick the Great after the Battle at Leuthen at the Castle in Lissa, the Austrian Military Quarters* remains unfinished because its patron, Baron von Ratibor, finds the theme too vulgar. Menzel wrote to Fritz Werner in March 1856: "I'll travel there [to Nice and Lissa] and observe from nature those sites that still exist . . ." (Nationalgalerie Archives).
1859	Menzel begins the last large painting of the Frederick cycle, *Frederick the Great's Address to His Generals before the Battle at Leuthen* (unfinished). He writes to Adolf Schöll on 1 July 1859, "Once again in my business I am largely engaged in a task which, God willing, I will achieve: namely of Fritz's address to his men before the *va banque* of Leuthen. Here it means painting a moral impression . . ." (see Werner Deetjen, "Adolph Menzel und Adolf Schöll. Ungedrückte Briefe Menzels," *Jahrbuch der Preußischen Kunstsammlungen* 55 [Berlin, 1934] suppl. p. 30ff.).

On 10 May, Menzel's sister marries the Royal Music Director Hermann Krigar. Their common household remains intact.

Summer trip to Altenburg, Bamberg, Rosenheim, Kulmbach, and Kufstein; September in the Tyrol, Fügen in Zillertal, and Innsbruck.

Country Theater in Kufstein, oil.

Student Torchlight Procession, oil.

Chodowiecki Drawing from the Jannowitz Bridge, oil.

Until 1862, several paintings are commissioned by the Berlin collector and Councillor of Commerce E. Kahlbaum. In a few works, Menzel turns his extensive "Frederick" theme towards historical genre scenes from Frederick's period as Crown Prince: *Boating Trip in Rheinsberg*, *Frederick with Pesne on the Scaffolding*, and *Court Ball in Rheinsberg* (all in gouache).

1860	Trip to Rheinsberg in early October, and from there to Neuruppin and Wustrow (Palace of the Zieten).

At the end of the year, he moves into a dwelling that adjoins the homes of his brother and the Krigar family on Marienstraße.

Menzel produces twelve wood engravings for *Berthold Auerbach's "Blitzschlosser von Wittenberg,"* which appears in Auerbachs Volkskalendar 1861.

Investiture at the Mass in the Vestry of the Servetian Monastery in Innsbruck, gouache.

Workman in a Newly Erected Structure, gouache.

1861	From mid-July until mid-August, Menzel visits the mineral springs at Bad Freienwalde in the province of Brandenburg due to poor health.

On 11 July, he writes to Fritz Werner in Düsseldorf that because of his spa treatment he could not attend an exhibition in Cologne, "but I could make it to the Cours in Belgium in time . . ." (Nationalgalerie Archives). He then travels via Magdeburg to Braunschweig, Düsseldorf, Antwerp, Ghent, Bruges, Ostend, Brussels, and returns by way of Cologne. While in Antwerp in September he attends an artists' convention, where Courbet gives a lecture on the theme of realism.

On 12 October, Menzel is informed by Minister Bethmann-Hollweg that he has received a royal commission to paint the coronation of William I in Königsberg. Fritz Werner travels with him to the coronation festivities on 18 October to assist him in rendering color studies. For four years Menzel paints portraits of the participants. The Garde-du-Corps Hall in Berlin's Municipal Palace is placed at his disposal as a studio. The painting is completed on 15 December 1865.

After this commission, Menzel is invited to court festivities.

From this point on, depictions of contemporary society become the main theme of his paintings.

1862	On 6 April, Menzel begins work on *The Coronation of King William I in Königsberg* in the palace's Garde-du-Corps Hall.

At the Opera House, oil.

Berlin Market in Winter, gouache.

1863	On 15 February, an exhibition of all Menzel's work on the period of Frederick II opens at the Academy on the occasion of the centenary celebration of the Treaty of Hubertusburg.

Menzel begins *The Children's Album* for his sister's two children. Fourty-four sheets in gouache emerge over the next two decades and are partially reworked in 1883.

1864 Menzel's brother Richard marries Elise Preuß. Richard had learned photographic techniques but due to poor health had been working as a volunteer on a farm in Oderbruch since 1860. After his marriage, he buys the Gustav Schauer Institute for Photographic Art and Publishing in Berlin, probably with financial assistance from Menzel.

Summer trip to the Elbsandstein Mountains and to Bohemia.

1865 Richard Menzel dies on 14 July.

Menzel moves with the Krigar family to Luisenstraße 24. Summer trip to Rudelsburg, Saaleck, Kösen, the Cloister at Banz, and Würzburg.

Boys Bathing in the Saale River near Kösen, gouache.

1866 In July, Menzel travels into the Prussian-Austrian war zone. From there, on 16 July, he departs for Görlitz, Reichenbach, Turnau, Königinhof, and Horzice. He arrives in Prague on 24 July as rail connections through the war zone are suspended. The opportunity to travel to Pardubitz with Count Stolberg arises. He visits the battlefields of Königgratz and Sadowa-Chlum, where on 3 July the war had been decided in Prussia's favor. At the large military hospital of Königinhof, Menzel draws wounded, dying, and dead soldiers. "I also felt a conscientiousness that finally allowed me no peace, even to smell war! . . ." And after his return, he writes: "From where Schlüter had gotten his arsenal camouflage, I also know now . . ." (letters to his cousin and to Dr. Puhlmann; Wolff, pp. 204 and 205).

In August, Menzel visits his sister-in-law Elise and a photographer in Kassel. He advises them on the establishment of an artists' gallery that would exhibit photographs of paintings at the gallery in Kassel. The first part of a catalog is published by Schauer in December. A large-format photograph of the "coronation picture" is published by Schauer as well. Menzel creates the so-called armory fantasies, watercolors and gouaches of armor that was stored in his studio in the Garde-du-Corps Hall.

Diploma from the City Council to King William I on the Occasion of the Entry of the Troops into Berlin, gouache.

Interior of the Old Synagogue in Prague, gouache.

1867 *Scene at the Ball*, gouache.

From the beginning of June until early July, Menzel visits Paris to see the World's Fair and is accompanied by his friend, the painter Paul Meyerheim, and his sister-in-law Elise. He is invited into the Palace of Industry with Meissonier and Meyerheim. He receives a second medal for his painting *Battle at Hochkirch*, which is exhibited there.

Menzel is appointed Knight of the Legion of Honor at the same time as the German sculptor Friedrich Drake.

He tours the Louvre with the painter Ludwig Knaus. The artist pays several visits to Meissonier in his home in Poissy. (They had become acquainted in Berlin in 1862.) He meets the Belgian painter Alfred Stevens and the painters Ricard and Gérôme. He also visits the exhibition pavilions of Courbet and probably also of Manet.

At the Louvre, oil.

Sunday at the Tuileries, oil.

At an American Restaurant, oil.

1868 A four-week trip to Paris begins in early June. The "coronation picture" and two small genre scenes in gouache, *Guess, Who is it?* and *Should I Open it?* are exhibited at the Salon. Menzel visits Heinrich Heine's grave, whose "slander" he condemns. (See a copy of a letter of January 1869 to the publisher Gentz in Neuruppin in the Nationalgalerie Archives.)

Return trip via Cologne, Hannover, Braunschweig, and Bad Harzburg.

Missionary Services in the Beech Hall near Kösen, oil. (Menzel employs studies from earlier trips in this painting.)

He is appointed an honorary member of the Austrian Academy of Arts.

1869	*Parisian Weekday*, oil (the first large-format portrayal of a busy urban street scene).
	Meissonier in His Studio, oil. In 1867, Menzel had rendered a meticulous drawing of Meissonier sitting in front of his easel. A photograph of this study was published by G. Schauer. Menzel's sister-in-law continues to pursue her plan of 1866 for a Menzel album.
	Old Elephant at the Jardin des Plantes, gouache.
	Summer trip to Cologne, Trier, Coblenz, Boppard, St. Goar, Heidelberg, Darmstadt, Mainz, and Munich. At the first International Art Exhibition in Munich, Menzel again sees Courbet's *Stone Breakers*, which he had seen in 1855 in Paris.
	Choir Stalls in the Mainz Cathedral, watercolor and gouache; also in oil.
	Trip to Neuzelle.
	Commemorative Sheet for the Jubilee of the Heckmann Company, gouache. (This work includes two representations of industrial production at the Heckmann metal foundry.)
1870	Menzel receives the Order Pour le mérite, which was instituted in 1740 by Frederick II and expanded by Frederick William IV in 1842 to "a Peace Division for Science and the Arts." The Viennese Artists' Association exhibits watercolors and gouaches by Menzel.
	Summer trip to the Elbsandstein Mountains.
	Henry VIII Dancing with Anne Boleyn, grisaille in gouache. (It is exhibited as a photograph in the Shakespeare Gallery in Berlin and published by Grote in the fall of 1870.)
	The Menzel-Krigar family moves to Potsdamerstraße 7 in November.
1871	*Departure of King William I for the Army on 31 July 1870*, oil.
	Transport of French Prisoners, watercolor.
	Moltke and *Bismarck*, oil. (These two paintings were created as festive decorations for the Academy of Arts building on Unter den Linden on the occasion of military victory celebrations.)
	Diplomas from the City of Berlin to Moltke and Bismarck, gouache.
	Rest Interval at the Ball, oil.
	Summer trip to Bamberg, Nuremberg, Heilbronn, Munich, Salzburg, Berchtesgaden, Linz (twice), the Cloister at Melk, and Vienna. He also visits the Holbein exhibition in Dresden.
	The Esterházy Cellar, oil.
	Choir and Altar of the Court Church in Salzburg, gouache.
1872	*Memory of the Jardin du Luxembourg*, oil.
	Summer trip to Kissingen, Regensburg, Salzburg, Hofgastein, Werfen, St. Johann, Zell am See, Fügen in Zillertal, and Innsbruck.
	Menzel becomes an honorary member of the Munich Academy of Arts.
	On a trip to Königshütte in Upper Silesia he makes preparatory studies for *The Iron Rolling Mill*, which he begins to paint but does not complete until February 1875. It is the first large painting in Germany to depict industrial production in which the figures of workers, not the machines, dominate.
	In October, he paints *The Studio Wall*, oil. In the center of the composition hangs the death mask of his "Tunnel-friend" Friedrich Eggers, who had died in August. August.
1873	The Prussian government buys paintings that previously had been owned by the Society of the Friends of Art in the Prussian State for the future Nationalgalerie. Among them is Menzel's *Dinner at Sanssouci*.
	Kitchen in Hofgastein, gouache.
	High Altar at the Collegiate Church of Our Lady in Munich, gouache.
	Summer trip to St. Gilgen on the Wolfgangsee, Gastein, and to see the World's Fair in Vienna. Return trip via Eger and Prague.
	American Indian Café at the Viennese World's Fair, gouache.
1874	*Beer Garden in Kissingen*, watercolor.
	Summer trip to Regensburg, Linz, Hüttau, Gosau, Salzburg, Vienna, and Klosterneuburg. Return via Munich and Dresden.

1875	The Menzel-Krigar family moves to Sigismundstraße 3 (the site of Menzel's last studio).
	Menzel, Gustav Richter, and Reinhold Begas are elected to the senate of the Academy.
	Summer trip to Bayreuth, Garmisch, Innsbruck, the Cloister at Ettal, and the Cloister at Banz.
	Mason at Work, gouache.
	Interior of the Cloister Church at Ettal, gouache.
	Traveling Plans, gouache.
1876	Summer trip through southern Germany and Switzerland includes Würzburg, Stuttgart, Rottweil, Constanz, Lindau, Lucerne, Interlaken, Zurich, Sonthofen, Oberstdorf in Allgäu, Munich, and Bayreuth (to see the premiere of *Der Ring des Nibelungen*). Menzel had become acquainted with the music of Richard Wagner the previous year.
	Return trip via Leipzig.
	In October, he travels to Holland to the cities of Amsterdam, Utrecht, Rotterdam, and the Hague. Menzel prepares wood engravings to illustrate the jubilee edition of Heinrich Kleist's *Der Zerbrochene Krug*, which is published in 1877 by Hofmann & Co., Berlin, and features thirty illustrations and four photographs of grisailles in gouache.
1877	Summer trip to Regensburg and the Mondsee.
1878	*The Iron Rolling Mill, Dinner at Sanssouci*, and *The Flute Concert* are sent to Paris to be exhibited at the World's Fair. The imperial government's decision to send 160 works of art comes as a last-minute surprise. (Menzel, like Wilhelm Leibl, also sends works to Paris after the Franco-German War, despite the government's pressure on artists to refrain from exhibiting there.)
	Ball Supper, oil.
	Frederick II at the Tomb of the Great Elector, grisaille in oil.
	He also produces four wood engravings on the theme of Frederick for *Scherr's Germania* (published by Spemann in Stuttgart).
1879	*Diploma from the Academy of Arts to Emperor William I, after the Assassination Attempt in the Year 1878*, gouache.
	Circle of Emperor William I, oil.
	Summer trip to Hofgastein, Salzburg, and Bernried on the Starnberger See.
	Smithy in Hofgastein, gouache.
1880	*Procession in Gastein*, oil.
	Summer trip to Dresden, the Elbsandstein Mountains, and Herrnskretschen.
	Hermann Pächter, art dealer and owner of the firm R. Wagner, takes charge of the sales of Menzel's works until the artist's death. Menzel's connection to Pächter dates to the second half of the 1870s, when Louis Friedrich Sachse, with whom Menzel had a long-standing business relationship, declared bankruptcy after the economic crisis of 1873. Sachse's important collection was auctioned off in 1876.
	His brother-in-law, Hermann Krigar, dies; Menzel writes the obituary.
1881	*Grinding Shop at the Smithy in Hofgastein*, oil.
	Sermon at the Parish Church in Innsbruck, gouache.
	Woman Playing the Spinet, gouache.
	Summer trip via Frankfurt am Main, Freiburg, and Breisgau in Switzerland, to the southern Tyrol and northern Italy. Stops include Interlaken, Geneva, Lucerne, St. Gallen, Fribourg, Nuremberg, Villingen, Baden-Baden, Munich, Innsbruck, Brixen, Bozen, Gries (near Bozen), Meran, Trient, Brescia, Como, and Verona.
1882	Menzel designs decorative patterns in watercolor and gouache for a table service produced by the Royal Porcelain Manufacturer of Berlin to commemorate the silver wedding anniversary of the Crown Prince and his wife.
	Summer trip to Vienna, Berchtesgaden, Munich, Chiavenna, Brescia, Como, and Verona.
	In October, the Nationalgalerie acquires works by Menzel from the estate of his friend, Dr. Puhlmann, who dies that year.

1883	Menzel is appointed vice chancellor of the Peace Division of the Order Pour le mérite.
	Summer trip to Regensburg, Heilbronn, Imst, Augsburg, Garmisch, Zugspitze, and Dresden.
	Munich Beer Garden, gouache.
1884	*The Piazza d'Erbe in Verona*, oil. (Menzel began this painting after his first trip to Verona in 1881).
	Camel Driver in Partenkirchen, gouache.
	Aura Ruins near Kissingen, gouache.
	At the Warm Kettle in Kissingen, gouache.
	To mark the artist's fiftieth anniversary of displaying works at the Nationalgalerie, the museum opens an exhibition of his work on Easter.
	The German Art Association of Düsseldorf awards Menzel honorary membership.
	Summer trip to Kissingen, Kreuzberg (near Kissingen), Hammelburg, Bodenlaube Ruins, Rothenburg, Würzburg, Garmisch, Berchtesgaden, Maria Plain (near Salzburg), and Munich.
1885	A Menzel exhibition is shown at the Pavilion de la Ville de Paris from 26 April until 15 June.
	Summer trip to Kissingen, Interlaken, Bern, Lucerne, Schaffhausen, Rorschach, Baden-Baden, and Dresden.
	Fountain at the Spa Garden in Kissingen, gouache.
	Ash Wednesday Morning, gouache.
	At the Japanese Exhibition, gouache.
	Ornamentation of an Altar, gouache.
	Contribution, gouache.
	Menzel receives numerous honors on his seventieth birthday. The Academy exhibits nearly all his works that are available in Berlin, including studies in the painter's possession. *The Studio Wall* (1872) is exhibited for the first time.
	The artist is appointed chancellor of the Peace Division of the Order Pour le mérite, receives an honorary doctorate from the University of Berlin and honorary citizenship in his hometown of Breslau, and becomes an honorary member of the St. Petersburg Academy of Arts.
	The Berlin Art Society holds a banquet in his honor. Theodor Fontane composes a poem honoring Menzel.
1886	Summer trip to Dresden, Merseburg, Friedrichroda, Meiningen, and Kissingen.
	Market Scene in Verona, gouache.
	Menzel produces a series of three, small historical genre scenes in gouache: *Not Completely Attentive*, *The Letter*, and *Going Home from Church* (completed in 1886). Another finished gouache is *Coffee Time in Kissingen*.
1887	Summer trip to Marienbad, Altenburg, Salzburg, Berchtesgaden, and Munich.
	Japanese Seamstress (In the Japanese Exhibit), gouache.
	Letter of Honorary Citizenship from the City of Hamburg to G.C. Schwabe, gouache.
	Honorary Diploma from the Academy of Arts to Minister of State Gossler, gouache.
1888	The International Jubilee Exhibition in Vienna opens on 3 March (without participation from France). Menzel exhibits *Procession in Gastein* and a suite of watercolors. He receives the gold medal from Austria.
	Summer trip to Bamberg, Munich, Pommersfelden, Sterzing, Kissingen, Dresden, and Merseburg.
	In the White Hall, oil.
	Prague Synagogue, gouache.
	Beati Possidentes, gouache.
	At "Peter's Cellar" in Salzburg, watercolor.
1889	Menzel participates in the Parisian World's Fair, which commemorates the 100th anniversary of the French Revolution. The newspaper *Berliner Politische Nachrichten*, which adheres to governmental opinion (since the beginning of Emperor William II's rule in 1888), writes, "In the widest circles, among the most painful [events] is that a number of German artists have contributed to the Parisian

Jubilee Exhibition. . . ." After a discussion of whether Menzel was among these artists, it continues, "One can scarcely believe it possible that one comes upon names of exhibitors such as Liebermann, Kühl, Achenbach, Leibl, and Uhde, among other Munich painters" (see *Kunstchronik* 24, no. 32 [16 March 1889]).

Summer trip to Kissingen, Salzburg, Munich, Tegernsee, the Cloister at Fürstenfeldt, Regensburg, and Leipzig.

In October, the Nationalgalerie buys from Hermann Pächter 1,305 Frederician drawings, seven oil studies for history paintings, *The Children's Album*, seven designs for the Crown Prince's table service, and the charcoal drawing *Frederick William I Visits a Primary School* (1858).

After the Closing of the Court Party, oil.

Learning Italian, etching for the Berlin Society for Original Etching, no. 4. (Menzel had belonged to its executive board since the organization was founded in 1885.)

1890 *Promenade at the Fountain in Kissingen*, gouache.

Summer trip to Würzburg, Veitshöchheim, and Kissingen.

1891 Summer trip to Fulda, Weimar, and Eisenach. A separate presentation of Menzel's works is included within the Third Annual Munich Exhibition.

Beer Garden in Kissingen, gouache.

1892 In May, following the Munich example, the Academy in Berlin presents separate exhibitions that feature several artists, among them Menzel.

Boat Trip and *An Old Gate in a Park* (*Quiet Corner*) are produced, marking Menzel's last paintings in oil.

Traveling through the Beautiful Landscape, gouache.

Summer trip to Munich, Salzburg, Regensburg, and Würzburg.

1893 Menzel paints *The Confectioner's Shop in Kissingen* (gouache) for the World's Fair in Chicago.

Summer trip to Dresden, Karlsbad, Kissingen, Salzburg, Kassel, Wiesbaden, Bremen, and Hamburg.

1894 In March, the Great Art Exhibition in Hamburg highlights works by Menzel, including *The Studio Wall* of 1872.

In June, Ernst Arnold organizes a Menzel exhibition in Dresden, which includes drawings of the city's baroque architecture that had not previously been seen in public.

Early Hour at the Café, gouache.

Summer trip to Kissingen, Münnerstadt, Salzburg, St. Gilgen, Regensburg, and Karlsbad.

1895 In June, the first event honoring Menzel's upcoming eightieth birthday is held when the royal court sponsors a Frederician costume party in Potsdam and presents a *mise-en-scène* of Menzel's painting *The Flute Concert*.

Summer trip to Kissingen, Würzburg, and Weimar.

The *First International Art Exhibition* is held in Vienna in July; Menzel exhibits *The Studio Wall* (1872).

In December, a large anniversary exhibition takes place; the Nationalgalerie presents prints and the Academy of Arts displays paintings by Menzel, including the premiere of *The Honoring of the Insurgents Killed in March 1848*. Menzel is appointed "Acting Privy Councillor with the title 'Excellency.'" He receives honorary citizenship from the city of Berlin. The arts academies in Paris and London elect him as a member.

On the occasion of Menzel's eightieth birthday, the Academy commissions Reinhold Begas to coin a portrait medallion of the artist.

The Last, created for the Berlin Society for Original Etching, no. 10, signifies Menzel's last printed work.

1896 The Menzel exhibition in Vienna enjoys great public success. Another exhibition of his work is sponsored by the Hamburger Kunsthalle.

The *Annual Munich Exhibition* features Menzel in a separate section.

Summer trip to Kissingen.

1897	*The Marienburg*, gouache.
	Summer trip to the Bodenlaube Ruins and Bamberg.
	In August, Menzel visits Rudolf von Alt in Vienna.

1897 *The Marienburg*, gouache.
Summer trip to the Bodenlaube Ruins and Bamberg.
In August, Menzel visits Rudolf von Alt in Vienna.

1898 Summer trip to Kissingen and Salzburg.
Menzel is named Knight of the Order of the Black Eagle, the highest Prussian order. Consequently he is elevated to noble standing.
Menzel resigns from the senate of the Academy and is simultaneously appointed an honorary member.
The Berlin Artists Society holds a party in honor of Menzel.

1899 Menzel is elected a non-resident member of the Belgian Academy of Arts.
The Nationalgalerie acquires *The Berlin-Potsdam Railway* (1847).

1900 *Visit to the Iron Rolling Mill*, gouache.
Summer trip to Kissingen.
Several works by Menzel are exhibited in Paris at the World's Fair.

1901 Summer trip to Würzburg, Munich, and Salzburg.
The New Domestic Rooster, gouache.
End of the Day of Atonement, gouache.

1902 In October, Max Klinger's *Beethoven* is exhibited in Berlin. Leading a number of artists, Menzel declares his support for the work.

1903 The Berlin Artists Society exhibits drawings and gouches as well as two early oil paintings by Menzel that the public has never seen before: *On the Kreuzberg near Berlin* and *Early Mass*. Critics first begin to play his early work against his later work.
In April, Menzel celebrates his fiftieth anniversary as a member of the Royal Academy of Arts. The position of "honorary senator" is instituted for him.
Menzel creates the watercolor *Frederick the Great on Horseback* for the music program that celebrates the 150th anniversary of the Döberitz military training field (29 May).
The Menzel exhibition in London is well attended in May.
Summer trip to Karlsbad.

1904 Summer trip to Kissingen.
Menzel limits himself to drawing in pencil. He advises Max Reinhardt in the set design and costumes for Gotthold Ephraim Lessing's comedy *Minna von Barnhelm*, Reinhardt's first production in Berlin.

1905 Menzel dies on 9 February in Berlin.
His funeral is held in the rotunda of the Altes Museum on 13 February; the burial follows at the Trinity Cemetery.
On 19 February, Joseph Joachim gives a memorial concert at the Choral Academy. His quartet performs one of Menzel's favorite pieces, the *Cavatina* from Beethoven's Quartet in B-Major.
A large memorial exhibition opens at the Nationalgalerie on 28 March. Menzel's estate is acquired by the Nationalgalerie in May 1906 after lengthy negotiations.

Selected Bibliography

Renate Weinhold's bibliography on Menzel (Leipzig: Seemann Verlag, 1959) systematically organizes and annotates 1,100 references from publications through 1958. Some of the most important references have been selected from this plethora as well as from later publications.

Adolph Menzel. Gemälde, Zeichnungen. Exhibition catalogue. East Berlin: Nationalgalerie, Staatliche Museen zu Berlin, 1980.

Adolph Menzel. Gemälde und Zeichnungen. Ausstellung im Alten Rathaus, Erlangen, 1971. Organized by the city of Erlangen and the Sammlung Georg Schäfer, Schweinfurt. Erlangen, 1971.

Adolph Menzel. Handzeichnungen. Exhibition catalogue. Bremen: Kunsthalle Bremen, 1963.

Adolph von Menzel. Zeichnungen, Aquarelle, Gouachen. Exhibition catalogue. Staatliche Museen zu Berlin, Nationalgalerie. Vienna, 1985.

Ausstellung von Werken Adolph von Menzels. Berlin: Königliche National-Galerie, 1905.

Beta, Ottomar. "Gespräche mit Menzel." In *Deutsche Revue* 23, vol. 2 (1898), pp. 45–58, and vol. 3 (1898), pp. 102–18.

Bock, Elfried. *Adolph Menzel. Verzeichnis seines graphischen Werkes.* Berlin, 1923.

Donop, Lionel von. *Katalog der Handzeichnungen, Aquarelle und Ölstudien in der Königlichen Nationalgalerie.* Berlin, 1902.

Ebertshäuser, Heidi, ed. *Adolph von Menzel. Das graphische Werk.* 2 vols. Munich: Bogner and Bernhard, 1976.

Falkenhausen, Susanne von, Sigrid Achenbach, and Ingeborg Becker, comps. *Adolph Menzel. Zeichnungen, Druckgraphik und illustrierte Bücher. Ein Bestandskatalog der Nationalgalerie, des Kupferstichkabinetts und der Kunstbibliothek Staatliche Museen Preußischer Kulturbesitz.* West Berlin, 1984.

———. *Prints and Drawings by Adolph Menzel. A selection from the collections of the museums of West Berlin.* Cambridge: Fitzwilliam Museum, 1984.

Forster-Hahn, Françoise. "Adolph Menzel's 'Daguerreotypical' Image of Frederick the Great: A Liberal Bourgeois Interpretation of German History." In *Art Bulletin* 59 (1977), pp. 242–61.

———. "Adolf Menzels Eisenwalzwerk. Kunst im Konflikt zwischen Tradition und sozialer Wirklichkeit." In *Die nützlichen Künste*, pp. 122–28. Exhibition catalogue. West Berlin, 1981.

———. "Authenticity into Ambivalence. The Evolution of Menzel's Drawings." In *Master Drawings* 6 (1978), pp. 225–58.

Hermand, Jost. *Adolph Menzel.* Rowohlts monographie no. 361. Hamburg, 1986.

———. *Adolph Menzel. Das Flötenkonzert. Ein realistisch geträumtes Preußenbild.* Frankfurt am Main: Fischer Verlag, 1985.

Hofmann, Werner, ed.; Eckhard Schaar and Gisela Hopp, comps. *Menzel der Beobachter.* Exhibition catalogue. Hamburg: Hamburger Kunsthalle, 1982.

Hütt, Wolfgang. *Adolf Menzel.* Leipzig: Seemann Verlag, 1981.

Jensen, Jens Christian. *Adolph Menzel.* Cologne, 1982.

————, comp. *Adolf Menzel. Realist, Historist, Maler des Hofes. Gëmalde, Gouachen, Aquarelle, Zeichnungen und Druckgraphik*. Exhibition catalogue. Kiel: Kunsthalle Kiel, 1981–82.

Jordan, Max, and Robert Dohme. *Das Werk Adolph Menzels*. 3 vols. Munich, 1885–90.

Jordan, Max. *Das Werk Adolph Menzels 1815–1905*. Munich, 1905.

Kaiser, Konrad. *Adolph Menzels Eisenwalzwerk*. Berlin: Henschel Verlag, 1953.

Kirstein, Gustav. *Das Leben Adolph Menzels*. Leipzig, 1919.

Knackfuß, Hermann. *A. v. Menzel*. Künstlermonographie no. 7. Bielefeld and Leipzig, 1895.

Korte, Claus. "Riskante Selbstspiegelungen Adolph Menzels." In *Sitzungsberichte der Kunstgeschichtlichen Gesellschaft zu Berlin*, n.s. 22 (1973–74), pp. 7–10.

Lammel, Gisold. *Adolph Menzel. Frideriziana und Wilhelmiana*. Dresden: Verlag der Kunst, 1988.

Liebermann, Max, and G.J. Kern. *A. Menzel. 50 Zeichnungen, Pastelle und Aquarelle aus dem Besitz der Nationalgalerie*. Berlin, 1921.

Meier-Graefe, Julius. *Der junge Menzel. Ein Problem der Kunstokonomie Deutschlands*. Leipzig, 1906.

Meyerheim, Paul. *Adolf von Menzel. Erinnerungen*. Berlin, 1906.

Riemann-Reyher, Ursula. *Moderne Cyklopen 1875–1975. Betrachtungen zu Adolph Menzel "Eisenwalzwerk."* East Berlin: Staatliche Museen zu Berlin, 1976.

Riemann, Marie Ursula, and Claude Keisch, comps. *Adolph von Menzel. Zeichnungen, Aquarelle, Gouachen*. Exhibition catalogue. Vienna: Albertina, 1985.

————. *Adolph Menzel. Zeichnungen, Aquarelle, Gouachen*. Exhibition catalogue. Copenhagen: Statens Museum for Kunst, 1985.

Riemann, Gottfried, and Klaus Albrecht Schröder, eds. *Von Caspar David Friedrich bis Adolph Menzel: Aquarelle und Zeichnungen der Romantik aus der Nationalgalerie (Ost)*. Exhibition catalogue. Vienna: Kunstforum Länderbank, and Munich: Prestel-Verlag, 1990.

Riemann, Gottfried, and William W. Robinson, eds. *The Romantic Spirit: German Drawings, 1780–1850, from the Nationalgalerie (Staatliche Museen, Berlin) and the Kupferstich-Kabinett (Staatliche Kunstsammlungen, Dresden), German Democratic Republic*. New York: Oxford University Press, 1988.

Scheffler, Karl. *Adolph Menzel. Der Mensch, das Werk*. Berlin, 1915.

————. *Adolph Menzel*. Berlin, 1938.

Schmidt, Werner. *Adolph Menzel. Zeichnungen*. Exhibition catalogue. East Berlin: Nationalgalerie, Staatliche Museen zu Berlin, 1955.

Trost, Edit. *Adolph Menzel*. Berlin: Henschel Verlag, 1980.

Tschudi, Hugo von. "Aus Menzels jungen Jahren." In *Jahrbuch der Kg. Preußischen Kunstsammlungen* 26 (1905), pp. 215–314.

————, ed. *Adolph Menzel. Abbildungen seiner Gëmalde und Studien. Auf Grund der von der National-Galerie im Frühjahr 1905 veranstalteten Ausstellung unter Mitwirkung von E. Schwedeler-Meyer und J. Kern*. Munich, 1905.

Waldmann, Emil. *Der Maler Adolph Menzel*. Vienna: Verlag Anton Schroll, 1941.

Wolff, Hans, ed. *Adolph von Menzels Briefe*. Berlin, 1914.

Wirth, Irmgard, comp. *Ausstellung Adolph Menzel aus Anlaß seines 50. Todestages*. West Berlin: Nationalgalerie, Staatliche Museen Berlin, 1955.

————. *Mit Adolph Menzel in Berlin*. Bibliothek des Germanischen Nationalmuseums Nürnberg 25/26. Munich, 1965.

_____. *Mit Menzel in Bayern und Österreich*. Bibliothek des Germanischen Nationalmuseums Nürnberg 34. Munich, 1974.

With, Christopher Becker. "Adolph von Menzel: A Study in the Relationship between Art and Politics in Nineteenth Century Germany." Ph.D. diss., University of California, Los Angeles, 1975.